W9-CCX-123

THE POETRY OF TRUTH

Alfred William Hunt and the Art of Landscape

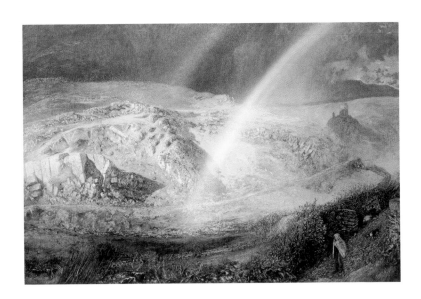

THE POETRY OF TRUTH

Alfred William Hunt and the Art of Landscape

CHRISTOPHER NEWALL

With contributions by SCOTT WILCOX and COLIN HARRISON

ASHMOLEAN MUSEUM, OXFORD

YALE CENTER FOR BRITISH ART, NEW HAVEN

2004

Published to coincide with the exhibition at the Yale Center for British Art, New Haven, Connecticut, USA, 18 September –12 December 2004, and at the Ashmolean Museum, Oxford, 26 January – 3 April 2005

© Ashmolean Museum, University of Oxford 2004

Christopher Newall, Scott Wilcox and Colin Harrison have asserted their moral right to be identified as the authors of this work

All rights reserved. No part of this publication may be transmitted in any form or by any means, electronic or mechanical, including photocopy, recording or any storage and retrieval system, without the prior permission in writing from the publisher.

ISBN 1 85444 196 5

British Library Cataloguing in Publication Data

A catalogue record of this book is available from the British Library

Designed and typeset in Monotype Bell by Geoff Green, Cambridge

Printed and bound by BAS Printers, Salisbury on Gardapat

Cover illustration: Cat. No. 35 *A November Rainbow – Dolwyddelan Valley, November 11, 1866, 1p.m.*

Ash*The*molean

Contents

Foreword

THE PRE-RAPHAELITES are so closely associated with Oxford that it is surprising to learn that none of the original members of the Brotherhood was a student in the University. This was quickly remedied in the 1850s, when two undergraduates at Exeter College, William Morris and Edward Burne-Jones, joined the movement. Among their contemporaries was Alfred William Hunt, a Scholar at Corpus Christi College, winner of the Newdigate Prize (as John Ruskin was before him), and elected a Fellow of his college in 1857. He resigned his fellowship in 1861, married, and pursued a distinguished career as one of the most original landscape artists and watercolourists in Victorian Britain. Hunt's adherence to a meticulous Pre-Raphaelite depiction of nature, fostered by his reading of Ruskin and his growing friendship with that champion of Pre-Raphaelitism, later gave way to a more atmospheric and generalized treatment inspired by Ruskin's other great artistic hero, J.M.W. Turner.

Although Hunt's work appears in histories of Victorian landscape and was recently included in the exhibition *Pre-Raphaelite Vision: Truth to Nature* organized by the Tate, he has not been the subject of a monographic exhibition since the memorial exhibitions after his death. It is highly appropriate that two distinguished university institutions should collaborate in this venture. The Ashmolean Museum holds the largest body of Hunt's work in the world, while the Yale Center for British Art owns what is, perhaps, his single greatest watercolour, *Tynemouth Pier - Lighting the Lamps at Sundown*. In Oxford, the exhibition is one of an occasional series devoted to important local artists and themes; in New Haven, it follows the highly successful show *Victorian Landscape Watercolors* in 1992, in which Hunt featured prominently. The exhibition has been selected and catalogued by Christopher Newall, whose ancestors were among the artist's most important patrons, and whose family name has been associated with Hunt's ever since. Scott Wilcox at Yale and Colin Harrison at the Ashmolean have acted as 'in-house' curators, and have brought great enthusiasm and professionalism to their role. They have been assisted in Oxford by Julie Summers, Exhibitions

Officer; Geraldine Glynn and Chezzy Brownen, Registrars; David Gowers and his team in the Photographic Studio; and at the Yale Center, by Beth Miller, Associate Director for Development and External Affairs; Tim Goodhue, Registrar; Richard Johnson, Exhibition Designer and his installation team; Lyn Bell Rose, Graphic Designer; and Amy McDonald, Public Relations Manager.

 We are enormously grateful to the numerous museums and private collectors who have agreed to lend works to the exhibition. For assistance with the costs of mounting the exhibition in Oxford, we must thank Andrew Williams, and Corpus Christi College, Oxford. We are also indebted to The Paul Mellon Centre for Studies in British Art in London, which awarded Christopher Newall a Research Support Grant to study the Hunt papers at Cornell University.

CHRISTOPHER BROWN
Director, Ashmolean Museum

AMY MEYERS
Director, Yale Center for British Art

Acknowledgements

IN THE MANY YEARS since I first conceived of an exhibition of A.W. Hunt's work, I have incurred numerous debts to scholars, dealers, librarians and curators, and enthusiasts. I am grateful to the following for their help in many ways: Christopher Brown, Timothy Wilson, Julie Summer, and Catherine Casley, Ashmolean Museum; Sir Tim Lankester, Stephen Harrison, and Lorna Swadling, Corpus Christi College, Oxford; Prof. Brian Allen and Kasha Jenkinson, Paul Mellon Centre; Katherine Reagan and Patrick J. Stevens, Cornell University; Amy Meyers, Tim Goodhue, and Beth Miller at the Yale Center for British Art; Elizabeth Barker, Metropolitan Museum of Art, New York; Antony Griffiths, Kim Sloan, and Donato Esposito, British Museum; Tim Batchelor and Ian Warrell, Tate Britain; Dr David Gaimster and Bernard Nurse, Society of Antiquaries; Howard Hull, Brantwood, Coniston; Alex Kidson, Walker Art Gallery, Liverpool; Brian Lang, Mellon Financial Corporation; Colin Simpson, Williamson Art Gallery, Birkenhead; Sylvia Walker, Tyne and Wear Archive Services; George Brandak, University of British Columbia; Francis Marshall, Harris Museum and Art Gallery, Preston;

Patrick Bourne, Fine Art Society; Martin Beisly, Peter Brown, Harriet Drummond, Rosie Stynes, and Tamsin Everden, Christie's; Lucy Brittain and Henry Wemyss, Sotheby's; Dr Chris Beetles and Edwina Freeman, Chris Beetles Gallery; Martyn Gregory; Alastair Laird, Bonham's; Rupert Maas, Maas Gallery;

Sir Dominic Cadbury; Alyson Charles; Hugh Cookson; Prue Cooper; David and Victoria Graham Fuller; Maggie Bell, Crook Hall, Durham; Lady Bell; Hugh Belsey; Harry Boggis-Rolfe; Edward Morris; Rosemary Newall; Richard and Leonée Ormond; Annabel Oxford; Kevin Prosser and Mary Stokes; John Robertson; Baroness Sharples; Prof. Allen Staley; Timothy Wilcox; Andrew Williams; Dr Catherine Wills.

Finally, the Paul Mellon Centre in London awarded me a Travelling Grant to study the invaluable archival collections at Cornell University.

CHRISTOPHER NEWALL
London, June 2004

Lenders to the Exhibition

Birkenhead, Williamson Art Gallery *53*
Birmingham Museums and Art Gallery *52*
Leeds City Art Gallery *24*
London, British Museum *14*
London, The Fuller Collection *29, 34, 43, 45, 49, 54, 55*
London, Tate *12, 30, 60*
London, Victoria and Albert Museum *46, 59*
New Haven, Yale Center for British Art *31, 32*
New York, Metropolitan Museum of Art *41*
Orkney, The Robertson Collection *5*
Oxford, Ashmolean Museum *2, 3, 4, 11, 22, 25, 27, 35, 39, 42, 47, 48, 50, 51, 56, 57, 58*
Pittsburgh, Collection of the Mellon Financial Corporation *28*
Preston, Harris Museum and Art Gallery *1*
Private collections *6, 7, 8, 9, 10, 13, 15, 16, 17, 18, 19, 20, 21, 23, 26, 33, 36, 37, 38, 40, 44*

PHOTOGRAPHIC CREDITS
Photographs are reproduced by courtesy of the following:
(Catalogue numbers in bold).
Birkenhead, Walker Art Gallery **53**, *p.17*
Birmingham Museums and Art Gallery **52**, *p.11*
Cambridge, Fitzwilliam Museum *p.9*
Leeds Museums and Galleries (City Art Gallery) **24**
Liverpool, Walker Art Gallery, *p.17*
London, Agnew's **10**
London, British Museum **14,** *p.32, p.44*
London, Chris Beetles Gallery **9, 16, 29, 34, 38, 43, 45, 49, 54, 55**
London, Christie's Images **13, 20**
London, Maas Gallery *p.1*
London, National Gallery *p.47*
London, Tate **12, 30, 60,** *p.49, p.50, p.60*
London, Victoria and Albert Museum **46, 59**
New Haven, Yale Center for British Art **31, 32,** *p.39, p.40, p.42*
New York, Metropolitan Museum of Art **41**
Orkney, Robertson Collection **5**
Pittsburgh, Collection of the Mellon Financial Corporation **28**
Preston, Harris Museum and Art Gallery **1**

Alfred William Hunt: The Parabola of Pre-Raphaelitism

CHRISTOPHER NEWALL

ALFRED WILLIAM HUNT was one of a group of progressive English artists who introduced a new intensity and meticulousness to landscape painting in the 1850s and early 1860s, adapting the Ruskinian principle of 'truth to nature' to a highly individual form of Pre-Raphaelite observation. Attracted by the colours of stone and vegetation, water and sky, and with an extraordinary capacity for replicating the textures of natural form, whether in oil or watercolour, Hunt demonstrated in his early works a wholehearted devotion to the way particular places looked. From the mid-1860s onwards, he tended to abandon bright local colour in favour of more muted and generalised treatments, and in doing so showed himself receptive to a new aesthetic, which permitted the depiction of nature in terms of atmospheric and

Carte-de-visite photograph of Alfred William Hunt
The Maas Gallery

tonal effects. An artist of great originality, he was nonetheless one of few among his generation to gain inspiration from the work of J.M.W. Turner. His introversion found expression in a succession of views of various places to which he returned again and again, often representing the subject from exactly the same vantage point on repeated occasions. The outcome of these visits is a discreet and yet impassioned evocation of the beauty of the British landscape.

A man entirely without hubris, and for whom the professional life of the artist and the need for self-promotion that went with being a successful Victorian painter were largely alien, Hunt suffered many

frustrations, and was perhaps disappointed not to gain greater renown in his lifetime. A picture of his predicament, as an honest man in a vulgarised and commercial art world, and his personality, in which rare intelligence meshed with diffidence and a willingness to accommodate himself to more forceful individuals – notably John Ruskin – emerges from the letters that he wrote and received and which were gathered together by his daughter, Violet.

Hunt was born in Liverpool, on 15 November 1830, the seventh child and only son of Andrew and Sarah Hunt. His father was a landscape painter and drawing master, who had moved from Warwickshire to Liverpool to take advantage of the expanding art world of the northern city. Gore's *Liverpool Directories* list Andrew Hunt as the proprietor of a drawing academy and artists' repository at a series of addresses in Bold Street.[1] Hunt senior knew David Cox from their days together in Birmingham, and H.C. Marillier describes a painting trip that Cox, Andrew Hunt, and the young Alfred, made together. Cox is supposed to have been impressed by Alfred's precocious talent, saying of him: 'He will carry on what I have been unable to do, for his hands have the delicacy that mine lack'.[2] Andrew Hunt was also an admirer of Turner's painting; Edmund Gosse tells how Alfred 'began to pick out prints of Turner's landscapes' even as a young child, 'and put them by themselves as objects of particular desire'.[3]

Hunt was highly intelligent, and at fourteen won a scholarship to the Liverpool Collegiate School. The principal, the Revd William John Conybeare, fostered his interests in the Bible, classics, and geology. Hunt went up to Exeter College, Oxford, matriculating on 3 February 1848. A few months later, however, on 30 June, he was admitted as a scholar at Corpus Christi College, to read classics. A long letter from Alfred to his father, of 26 March 1851, described his living conditions at Corpus:

> I have migrated into new rooms, the other day – I am now lodged most comfortably – or rather luxuriously – so much so, that I am almost ashamed of myself, for living in such a state of comfort. I only wish my mother or sisters

1 In 1829, the year before Alfred was born, Andrew Hunt's premises were at 96 Bold Street, but by 1834 he had transferred to no.103. Bold Street was laid out in the 1780s, and contains some of the best classical buildings in Liverpool, including the Lyceum Club.

2 Marillier 1904, p. 157. Marillier indicates that the trip was to Ireland, made in the company of Anthony Trollope. There is no other evidence that Cox visited Ireland or knew Trollope.

3 London 1884, p. 8.

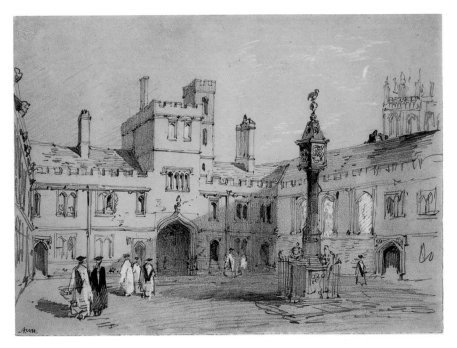

A.W. Hunt, *Corpus Christi College, Oxford, c. 1851–2*. Corpus Christi College, Oxford

could see them – I will send a sketch of my present look-out in my next. The dimensions of my apartments are "five decent strides" in length, and four in breadth (rough measurements) – the bed room is however rather less[,] being only about two arms lengths across – with a mattress which the last occupant (a double first class man, & who is now a great [illegible word] among the "Oratorians") had made, I think on purpose to afflict himself, for it is unyielding as a board. I have only missed one morning chapel since I changed my residence.[4]

In the spring of 1851 Hunt decided to enter the University's principal poetry competition, as he told his family: 'I have been engaged all this term upon a "Newdigate" … I should not give so much time to it, but that I know from those who are able to judge, that I stand a very good chance – But this only makes it more confoundedly provoking, if I fail. I am driven half mad

4 Violet Hunt Papers.

with it sometimes … I am awfully busy just at present, for I have a great
deal to finish in it, before the end of next week!'[5] The prize-winning poem,
'Nineveh', contains descriptive passages that reveal the same fascination
with the mechanisms that had moulded the landscape that imbues his early
paintings. Success in the competition, and what must have been to the diffi-
dent Hunt the ordeal of a public reading of the poem in the Sheldonian,
seems to have brought him prestige, as he explained to his sister Maria,
'You see I have secured the Newdigate at last, much to the surprise of Presi-
dent Fellows & Scholars of CCC [Corpus Christi College] – among whom I
am suddenly raised from obscurity to the highest honour'.[6]

Although there is no record of his exhibiting works between 1849 and
1853, Hunt continued to draw and paint whenever the opportunity arose. In
1850 he travelled in Europe, visiting Belgium, Germany, and Italy; sketches
from this trip survive in the Ashmolean.[7] It was not perhaps clear where
Hunt's academic career was leading; his family and friends may have
assumed that he would take Holy Orders. However, Hunt himself was deter-
mined not to follow this path: 'I'll not go into the church; it's a trembling
concern between popery on the one side & Dissent ten times more bitter
than popery on the other. Besides, I never could bind myself down to any
articles whatsoever, unless considerable license of interpretation or mis-
interpretation were allowed'.[8] In 1852, even before the results of his final
examinations were announced, but with a sense of foreboding that he had
not fulfilled the high expectations that had been held out for him, he seems
momentarily to have been reconciled to the prospect of a clerical life: 'I did
not produce anything above the mark of a <u>possible second</u> a degree wh. I
shall be delighted if I ultimately attain … The fates, I see are leading me
into the Church – I may die "Grand inquisitor" yet?'[9]

Art was becoming ever more important to Hunt in the years following his
graduation. He had begun showing his works at the Liverpool Academy in
1847, long before he was elected a member; his first exhibits were views in
the Lake District and one in Devon. He showed there again in 1848 and

5 Violet Hunt Papers.
6 Violet Hunt Papers.
7 Hunt's passport, issued by
 the Belgian consul in
 London, is among the Ford
 Madox Ford Papers at Cor-
 nell.
8 Violet Hunt Papers.
9 Violet Hunt Papers.

1849, on the latter occasion submitting one of his rare Oxford subjects – a distant view of the town from Hinksey Ferry (untraced). In 1854 he was elected an associate, and two years later a full member. He also made a series of lithographs of picturesque sites in the north-west, showing the churches at Bidston and Wallesey, and the refectory of Birkenhead Priory, which were published by Maclure, Macdonald, and MacGregor in Liverpool in 1854. If Hunt were seriously contemplating a career as a painter, he would have been encouraged to see his oil *Wastdale Head from Styhead Pass* (cat. no. 1) admitted to the Royal Academy in 1854 – an entry to the metropolitan art world that his father never achieved. At the same time, he showed four works at the exhibition of the National Institution at the Portland Gallery.

Even while a student, and in the years following his graduation, Hunt was encouraged in his artistic endeavours by the leading Oxford picture dealer and print-seller, James Wyatt, who since the early 1850s had allowed him to show watercolours and drawings in his shop in the High Street.[10] On one occasion, Hunt told his father that he had 'made the acquaintance lately of no less a person than the "Warden of All Souls", who saw one of my German sketches in the shop, when it was being framed, and immediately asked to see the rest of my sketches. He professed to be very much pleased with them'.[11] The shop attracted people in Oxford who were interested in Pre-Raphaelitism. At the time of Hunt's death in 1896, Burne-Jones reminisced about Wyatt: 'There was a printseller in the town, who I daresay may have been a great humbug, but he was very much looked up to by us because he had seen Millais and Holman Hunt, and we used to go there to hear him speak about them. And one day when I was there a gentleman passed through the shop; and the printseller said afterwards "Do you know who that was?" with great respect and awe. It was Alfred Hunt, and I didn't see him again for hundreds of years after that'.[12]

Wyatt commissioned Hunt to go on a series of painting expeditions to north Wales, reserving the resulting works for sale in his shop. A letter from Wyatt to Hunt in 1859 gives some idea of how the arrangement

10 For Wyatt, see Colin Harrison, *Turner's Oxford* (exh. cat., Ashmolean Museum, Oxford, 2000), pp. 76–85.
11 Violet Hunt Papers.
12 Lago 1981, p. 99.

A Sketching Party on Llyn-Lydan. Inscribed *Llyn Lydan, Sunday morning, Aug 20th 1854.* Ashmolean Museum Oxford (sketchbook no. 1)

worked: 'Dear Sir, I rec'd the three Water Color Drawings quite safe, and send cheque for the same, as stated in your note, viz £42 – I hope you will have a pleasant trip and nice fair weather. I should like to be favored with the option of your drawings when you return. I like these last very much; there is such a variety in what you produce'. Wyatt further complimented Hunt: 'Your drawings have created a desire to see the localities & before I see you again I hope to be pretty well acquainted with the chief features of North Wales. I have been looking over Blacks Picturesque guide to prepare myself a little'.[13] Hunt continued to supply Wyatt with drawings until as late as 1861, even when his prices were rising to a level that made Wyatt uncertain of finding buyers.

Hunt's early landscape painting tells of the excitement that he felt in the experience of mountain scenery that others might regard as inhospitable. In works such as *Wastdale Head*, all human elements are excluded, and dramatic effects of light and shadow indicate uncertain weather. As a boy, Hunt had relished extreme conditions, as on one occasion in 1845 when he visited

13 Violet Hunt Papers.

Dartmoor: 'It was too stormy a day for any one to accompany so I had an opportunity of studying the sublime and beautiful in perfect solitude & <u>unenviable</u> silence. I saw as painters say some splendid effects, for the mountains of Dartmoor would be quite blank or sometimes hidden in mist while a bright gleam of sunshine would light up another part of the landscape'.[14] In his formative years, therefore, and before he had had the opportunity to respond to the Pre-Raphaelite principle of 'truth to nature', Hunt was drawn towards the types of landscape admired by the Romantic artists of his father's generation.

Hunt had surely read the successive volumes of John Ruskin's *Modern Painters*, the first of which was published in 1843 and which contained the famous edict to landscape painters, that they should 'go to Nature in all singleness of heart, and walk with her laboriously and trustingly, having no other thoughts but how best to penetrate her meaning, and remembering her instruction; rejecting nothing, selecting nothing, and scorning nothing; believing all things to be right and good, and rejoicing always in the truth'.[15] Thirteen years later, *Modern Painters* IV – subtitled 'Of Mountain Beauty' – taught that mountain scenery needed to be understood in terms of geological mechanisms, a theme that inspired Hunt in his representations of Welsh landscape showing marks of glaciation. A month after the publication of *Modern Painters* IV in April 1856, Hunt's painting of a mountain subject *The Stream from Lyn Idwal* (untraced) appeared at the Royal Academy. It was, according to Ruskin, 'the best landscape I have seen in the [Academy] exhibition for many a day – uniting most subtle finish and watchfulness of Nature, with real and rare power of composition'.[16] A detailed account of the work followed, which mixed praise for the way 'the mass of mountain in the centre is grandly arranged', and for the '*rents* of cloud, and fading and forming of the hill shadows through them, [which] are magnificently expressed',[17] with criticism of a composition that lacked unity and in which Ruskin felt there were ambiguities of scale. Also from 1856 comes Hunt's watercolour *Cwm Trifaen* (cat. no. 5), which represents a mountain landscape

14 Quoted Secor 1982, p. 12.
15 Ruskin 1903–12, III, p. 624.
16 Ruskin 1903–12, XIV, pp. 50–51.
17 Ibid., p. 51.

within walking distance of Lyn Idwal and which is likely therefore to have originated in the same trip to Wales.

Hunt's movements in the mid-1850s are not clearly established. In 1855, he was awarded his M.A., but apart from keeping in touch with James Wyatt, he had no particular reason to be in Oxford. In 1852, his parents had moved to 31 Oxford Street, a recently constructed thoroughfare of elegant terraces in the residential eastern part of Liverpool, and it was from this address that Hunt sent works to exhibitions until the end of the decade, and from which he continued to make long painting expeditions to north Wales and the Lakes.

In 1857 Hunt embarked on his major oil painting, *The Track of an Ancient Glacier – Cwm Trifaen* (cat. no. 12), which, like the corresponding water-colour, shows the eroded and striated rock surfaces and scree of a Welsh mountain landscape. By painting the subject in oil, he may have hoped to produce a work that would be seen to advantage at the Royal Academy, for this was a medium that was generally more acceptable to the selection com-mittees. Nonetheless, when submitted in 1858, it was rejected.[18] Ruskin heard of Hunt's setback, and wrote a long letter of commiseration, praising the painting in general terms, but also making a point that was to recur with increasing frequency in his comments on Hunt's work. He felt that Hunt was too concerned with the minute detail of the landscape, and not enough with its mass and structure: 'You stipple too much all over, [and] lose all the value of your work by giving too much. You must try and get textures by broader brushes, & by scumbling instead of stippling'.[19] A year later, Ruskin expanded on this theme. In *Academy Notes* of 1859, in the course of a discussion of works by Henry Clarence Whaite and Hunt, he explained:

The execution of the whole by minute and similar touches is a mistake … Nothing finished can be done without labour; but a picture can hardly be more injured than by the quantity of labour in it which is lost … Mr A.W. Hunt's *On the Greta* [is] entirely well meant, but suffering under the same

18 This is the first documented occasion of Hunt having a work rejected by the Royal Academy selection committee.

19 Secor 1982, p. 23.

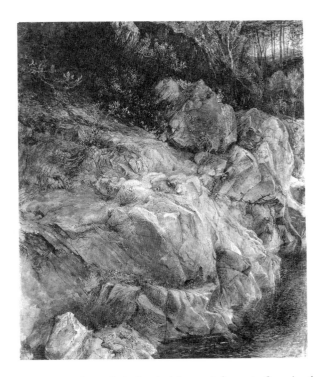

John Ruskin, *In the Pass of Killiecrankie*, 1857. Fitzwilliam Museum, Cambridge.

oppression of plethoric labour. I do not often, in the present state of the English school, think it advisable to recommend 'breadth'; but assuredly both Mr Whaite and Mr Hunt, if they wish to do themselves justice, ought to give up colour for a little while, and work with nothing but very ill-made charcoal which will not cut to a point.[20]

Despite Ruskin's criticisms, Hunt continued throughout the 1850s to paint and draw in a minutely detailed fashion, frequently concerning himself with foregrounds and the textures of natural forms. His *Rock Study: Capel Curig – The Oak Bough* (cat. no. 8), of 1857, may be compared to Ruskin's own *In the Pass of Killiecrankie*, of the same year. Like others of his generation, Hunt turned to nature in a spirit of reverence and a belief that the physical landscape reflected an incomprehensible but divinely ordered creation, which in

20 Ruskin 1903–12, XIV, pp. 229–30.

the process of its meticulous representation might reveal spiritual truths. In 1880 Hunt recalled the formative influences that had operated on him: 'The inroads of the scientific spirit, the invention of photography, the writings of Mr Ruskin, sympathy with the pre-Raphaelite movement in respect of its love of colour, of detail, and of mystic meaning in little things; and perhaps an increase in the number of those who, vexed with great questionings of heart beyond the range of science, turned for solace to the perfectly-ordered beauty of tree and flower – these and other causes combined to give a new force and direction to landscape-painting'.[21]

In 1857 Hunt showed a new willingness to express opinions about works by painters among his contemporaries, and on one occasion to enter the fray of artistic factionalism. On 18 September he protested to his friend William Greenwell about the shallowness of public responses to the new school of landscape painting: 'The rubbish that is written and talked about pictures is insufferable. Why can't people stick to whatever seems to them like nature – and if they are told that this & that is good, and cannot themselves see that it is good, simply withhold their judgment and keep their money in their pockets'.[22] The following winter there was an acrimonious dispute when the Liverpool Academy awarded a prize for the best work exhibited that year to Millais's *The Blind Girl.* A conservative group within the Academy felt that Abraham Solomon's *Waiting for the Verdict* (Tate) was more deserving, and so the battle-lines of a dispute on pro- and anti-Pre-Raphaelite lines were drawn. Alfred Hunt's allegiance to the Pre-Raphaelite cause placed him at odds with his father. So intense was public indignation at the award to Millais that a grant of £200 per annum that had previously been received by the Academy from the Liverpool Corporation was withheld, a decision that jeopardised the survival of the association.

Hunt took it upon himself to ask Ruskin to lend the weight of his opinion in favour of the Pre-Raphaelite cause. He received a somewhat hesitant reply: 'I've been noticing that row for a long time – and if it had not been about a Millais picture, should have had finger in pie long ago – But I don't

21 Hunt 1880, p. 783.
22 Violet Hunt Papers.

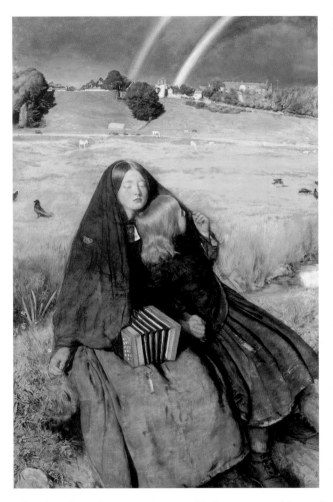

know how. If the Ath:
[*Athenaeum*] won't put
in your letter, neither
would it put in mine –
nor would the Times –
What can I do?'[23] A
further long letter
from Ruskin to Hunt
suggested with mock
cynicism that nobody
should be concerned
that people in Liver-
pool might prefer
Solomon to Millais:
'Let the Liverpool
people buy whatever
rubbish they have a
mind to; and when
they see, which in time
they will, that it *is* rub-
bish, and find, as find
they will, every Pre-
Raphaelite picture
gradually advance in
influence and in value,
you will be acknowl-
edged to have borne witness all the more noble and useful, because it
seemed to end in discomfiture; though it will *not* end in discomfiture'.[24]

The tone of Ruskin's two letters suggests that, by this date, he and Hunt
had met, although this is not otherwise documented. Hunt must surely
have seen the display of Turner watercolours that Ruskin arranged and

John Everett Millias,
The Blind Girl, 1854–6.
Birmingham Museums
and Art Galllery.

23 Violet Hunt Papers.
24 Part of Ruskin's letter to
Hunt, which Hunt sent on
for publication in the letters
column of *The Albion* and
which appeared on 11
January 1858, is given as an
appendix in Marillier 1904,
pp. 260–61.

catalogued at the National Gallery in 1857, and perhaps they met there. The Revd William Kingsley,[25] a friend and early collector of Hunt's works as well as a friend of Ruskin's, is likely to have been the person who brought them together.

The Liverpool Academy was suffering administrative and financial difficulties. On 28 October 1859 Hunt told his future wife, Margaret Raine: 'The Liverpool Academy is on its last legs undoubtedly'; while on 4 December his frustration was clear: 'Such a collection of featherbrains I never saw met for serious business before – with some exceptions of course'.[26] The next day, he reported: 'There is a meeting of the Academy to wind up. We have lost 300 at best this season & already have diminished our capital below the sum of our engagements, i.e. we have not 1000£ left and still have 6 quars at 200 a quar to run. So we must shut up & let the rooms to save ourselves'.[27] Hunt's worries were overstated; the Liverpool Academy survived until 1867, although in a condition of steady decline.[28]

Hunt was beginning to be known as a figure on the periphery of the Pre-Raphaelite circle in London. He was invited by William Michael Rossetti to send works to the exhibition of contemporary British painting that travelled to the United States in 1857-8.[29] Early in 1858 plans were afoot for the establishment of the Hogarth Club, as a place where progressive artists and collectors might gather, and where displays of contemporary painting might be staged. On 10 March, Hunt described the venture to William Greenwell, expressing misgivings: 'The Pre-Raphaelites are meditating a new association & perhaps an exhibition this season of which Holman Hunt "& comrades" pictures are to form the chief attraction – [D.G.] Rossetti asked me to join the club. I think these divisions are most unfortunate – and would if possible prefer standing apart from either side'.[30] Nonetheless, Hunt did join the Hogarth, as a non-resident member.

A man given to worrying about financial matters, and who in the late 1850s was particularly keen to establish himself so that he might marry Margaret Raine, Hunt suffered great anxieties about his professional

25 William Kingsley had known Turner, and was the person who reported Turner's account of being lashed to a mast to observe effects of falling snow when preparing *Snowstorm* (see Ruskin 1903–12, XIII, p. 162).

26 Violet Hunt Papers.

27 Violet Hunt Papers.

28 See Edward Morris, 'The Liverpool Academy and other art exhibitions in Liverpool, 1774–1867', in Morris & Roberts 1998, pp.1–19.

29 See William Michael Rossetti's letter to Hunt, dated 28 February [1858], in which it was suggested that Hunt should send a work or works to the third and final showing of the exhibition, at the Boston Athenaeum (Peattie 1990, p.96). In the event, nothing by Hunt appeared in the exhibition.

30 Violet Hunt Papers.

prospects as a painter. Margaret seems to have tried to jolly him along, but to no avail, as he explained in a letter of 9 January 1859: 'You would not like me to be without a picture at the next Royal Academy Exhibition (that is, if I can paint one) and I must go down to Wales or Cornwall to do it – or if I find my memory strong enough to do it at home … We shall want every penny that can be saved – for I should like to be ready when your friends are willing to give you up – and I have an insane dread of poverty'. He told her frankly how much he needed her: 'You supply exactly what I want – courage – or at any rate, the power of looking on the best side of things & trusting largely when you have done all you can'.[31] Hunt seems to have passed through alternating moods of confidence and pessimism. On 27 March 1859 he was optimistic when he wrote to Margaret: 'My sound reason tells me that with ordinary health, I can be certain of making a living – there is the French war though which I firmly believe will come in our day – but we must run the risk of that';[32] but on another occasion he was gloomier: 'I must get sufficient money & sufficient reputation to enable me to fight against a tendency to my favourite colour, blue'.[33]

Perhaps because he doubted his ability to gain a livelihood by the sale of paintings, he continued to contemplate an academic career. According to Edmund Gosse, Hunt had been 'able to keep up his connexion with Oxford unbroken'.[34] He was elected a Fellow of his old college, Corpus Christi, on 10 November 1857, and regarded himself as fortunate to be 'the first fellow who was allowed to stay in the college without taking orders'.[35] Hunt was expected to be in Oxford during the university terms, and received a stipend for his teaching. When not in Oxford, Liverpool remained his home. However, he seems to have devoted most of the university vacations to painting expeditions. In March 1858 he sent a note to William Greenwell in which various possible destinations for that spring were mooted: 'The balance is in favour of Cornwall & Clovelly at present. The thought of going anywhere in this cold weather is painful. Robinson says that Yorkshire moors would be too bleak for work in the spring'.[36]

31 Violet Hunt Papers.
32 Violet Hunt Papers.
33 Letter from Hunt to Margaret Raine, 27 August 1859. Violet Hunt Papers.
34 London 1884, p. 10.
35 Ibid.
36 Violet Hunt Papers.

In April 1859 Hunt and Margaret Raine planned a journey to Gräfrath, near Düsseldorf in the Ruhr valley, to seek advice on Margaret's poor eyesight from the famous optician de Leuw. From Gräfrath, Hunt was to continue alone, southwards along the course of the Rhine as far as Switzerland. He wrote to Margaret on 19 April 1859: 'You must not dream of keeping me at G. – you don't know how our living depends or will depend upon day-by-day work'.[37] By 25 May, Margaret was installed at Gräfrath and Hunt had embarked on his travels, writing to her from the Hotel Drei Königen at Bernkastel. On 14 July he was at St Goar, on the Rhine south of Koblenz, and later proceeded as far south as Thun in Switzerland. On 2 August 1859 he wrote: 'I shall be in Heidelberg on Friday week – 3 weeks from Gräfrath. Then a week on the Rhein again will complete the time we agreed upon'.[38] Margaret remained in Germany for the following winter, and Hunt went back to explore the Mosel valley in July 1860.

These two expeditions to Germany and Switzerland led to a large number of watercolours and drawings, among them some of the finest Hunt ever made. That he worked intensively while travelling may be judged by the undated letter he wrote to Margaret about new supplies of painting materials: 'I should think you might get good (perhaps English) water colours at Düsseldorf. Winsor & Newton's or Roberson's are the best. I am not in immediate need, but at the present rate of consumption shall be before long. Cobalt Blue. Madder Lake. Burnt Umber. These are very common colours & ought to be procurable at Düsseldorf without the trouble of sending to England – Would they allow such a thing as a small sable brush to be enclosed in a letter here as they do in England?'[39] It seems that, in his travels, Hunt was deliberately following in Turner's footsteps. Certainly, he told his father in a letter from St Goar of 14 July 1859 that the Rhineland in particular reminded him of Turner's painting.[40] However, at Lucerne in July and August 1859 (see cat. no.16), he seems to have tried to find an alternative view to that which Turner had taken, rather than dutifully following the example set by his great predecessor.

37 Violet Hunt Papers.
38 Violet Hunt Papers.
39 Violet Hunt Papers.
40 Violet Hunt Papers.

Among Hunt's pocket sketchbooks are two recording his travels in 1859 and 1860.[41] Even at this early stage in his career, his method was to accumulate notations in pencil and in colour studies, a working method probably modelled in part on Turner's. While drawings such as *Heidelberg* or *Schloss Elz* (cat. nos. 17 and 19) were perhaps begun in the open air and directly from the motif, they were almost certainly completed in the studio, and perhaps after the artist's return to England. In this sense, they represent a departure from the Pre-Raphaelite principle of direct observation.

Hunt returned to England in the late summer of 1859. There was an element of the John Bull even in this most self-deprecating man, and it is clear that he was happy to be back in the familiar countryside of Yorkshire and County Durham (even though he found lodgings cramped and expensive after those in Germany). On 21 August he wrote to Margaret that Rokeby was 'a most lovely spot – all Germany & Switzerland put together would not be worth a mile of Greta from point of view of <u>delightfulness</u>'.[42] Furthermore, for 'physical comfort, the air is really worth breathing – one can be an epicure over it – and thank God, with each full breath, that one is an Englishman. Then there is an undertone of thought suggesting that the beef is good & that I have not seen a flea yet. And if I do see one, it will likely be one of those nasty foreigneering chaps'.[43]

Alfred Hunt and Margaret Raine had known each other since the mid-1850s, having almost certainly first met in the house of William Greenwell in Durham. Her family home was Crook Hall, a mediaeval manor house on the north side of the city. Her father, Dr James Raine, a noted antiquary, had served as librarian to the cathedral until his death in 1858. The couple's courtship was agonisingly slow, and they may have wished for greater privacy than their circle of friends and family allowed them. While Margaret was still at Gräfrath, Hunt seemed to be showing the strain of family life at close quarters, instructing her 'not [to] write to Oxford Street – a foreign letter aroused enmity unbounded inquiry & speculation. And this is Sunday morning & so snowy & nasty that no one can go out – and I am not

41 Sketchbooks nos.189 and
 224 (Ashmolean Museum).
42 Violet Hunt Papers.
43 Letter from Hunt to
 Margaret Raine, 30 August
 1859. Violet Hunt Papers.

allowed to have my own fire in my own room – How I do hate Evangelical-ism'.[44] Hunt worried about Margaret's health and fussed over her safety, as well as his own capacity to earn money: 'You promise me all your life not to go too near the fire with your crinolines – nor to play with fire – to keep out of the way of the carts & horses & postwagons – & to eschew bronchitises – sc. sc. and darling I will engage to get the money & keep a good deal of what I get'.[45] In October 1860 Alfred and Margaret were in London, and planned to look at Turners together: 'The Islington omnibuses I find will suit for the Brompton museum, i.e. the Turner Gallery. If you don't hear from me again & if your arrangements do not impede, would you find your way there on Wednesday? I shall be there anyhow (if I don't hear from you to change my plans) at 11 o clock in the morning but don't care one bit about it'.[46] Their wedding date seems to have been postponed several times, and there was uncertainty about where they should live once married. Before they could marry, Hunt needed to give up his fellowship at Corpus, thus sacrific-ing his stipend and in effect making the final commitment to a career as a painter.[47]

Shortly before the wedding, William Greenwell entered the discussion about where Hunt should live, and what artistic circle he should hope to join, expressing a deep-rooted anti-metropolitanism as well as an antipathy to many of the artists who operated in the capital: 'I am in favour of Alfred's not going to town at present, I never did see what he could gain by it. With all the supposed [illegible word] of London men, there is a good deal of shallowness, pretence & conventionalism among them & in their sold art … I am not sure that a painter is not better away from it, at all events a landscape painter. Turner though in London was not of it. D. Cox [and] De Wint neither lived in London. W[illiam Henry] Hunt ditto. Millais ditto. H[olman] Hunt ditto. Whilst Sir C. Eastlake, Creswick, the Percy tribe, Lee & Witherington are all London'.[48] Hunt was torn, reporting to Margaret his mother's approval of 'the idea of a Durham establishment', but expressing his own view: 'If we can manage London somehow that would be

44 Violet Hunt Papers.
45 Violet Hunt Papers.
46 Violet Hunt Papers.
47 The statute preventing Oxford dons from marrying was not lifted until 1870.
48 Violet Hunt Papers.

A.W. Hunt, *Brignall Banks*, *c.* 1861. Walker Art Gallery, Liverpool

better – but all depends upon the present rate of production and prices continuing'.[49] In the event, following their marriage on 16 November 1861, they settled in Durham, first in lodgings, and later at 21 Old Elvet. They remained in the city until 1865, when they removed to London.

Hunt applied himself to painting subjects in the locality. His watercolour *Finchale Priory* (cat. no. 21) dates from this period, as do many views of Durham itself. On painting trips from Durham, he returned to the village of Brignall and the sloping meadows on the north banks of the River Greta, seen in the oil *Brignall Banks*, Rokeby Park and the junction of the Greta and the Tees, and the town of Barnard Castle. It was Hunt's habit to return to the places he most loved, sometimes repeatedly over periods of many years. No part of England or Wales appealed to him more strongly than the valley of the Greta; nor is any location better or more fully represented in his output of three decades.

Hunt was beginning to gain a wider reputation, and was perhaps progressing towards the professional position that he desired. Before and after his marriage, he sought to reassure Margaret that he was serious about

49 Violet Hunt Papers.

making money from his art. Letters such as the following, dated 9 January 1861, chronicled his sales: 'Mr Plint has kept the Oberwessel Moonlight and sent me a cheque for that & the balance of the large picture. Mr Crofts a London dealer has taken the Grafrath. 24£. Cobern 16.16/- and the small Oberwessel sketch which you liked, for 8.8/-. These are very good prices to get from a dealer[;] he has sent me 40£ on account – he writes like a man whom I may trust. He <u>was</u> Gambart's salesman so is well up in the business. He said he would "place" any amount of my work'.[50] Hunt was more mercantile than he seemed, and yet perhaps should have listened to friends' warnings that there was more to a successful career than money in the bank. William Greenwell may have been seeking to warn Margaret that her married life was going to be a struggle when he told her: 'I am looking forward to seeing Alfred's Scotch drawings with much delight[.] As to his being prosperous let one hope that he never will be in the sense in which Millais & Rossetti are, that is in purchasing wealth by the sacrifice of honesty. He will make as much as any reasonable man should require, & will have a name & reputation better than mere gold'.[51] In 1862 Hunt was elected an associate member of the Old Water-Colour Society, and was represented in their summer exhibition by five works including *Finchale* and *Thun, Switzerland* (cat. no. 15). By the following year, he was recognised as one of a group of 'leading, and we may add illustrious, members of the new school of landscape – a school of industrious detail, gathered in out-door study'.[52] He was elected as a full member of the Society in 1864.

By the early 1860s, Ruskin had withdrawn from publishing commentaries on the annual exhibitions,[53] but there were still occasions when his views on works by contemporary artists were offered or sought. His initial enthusiasm for Hunt's painting evolved into a more complex and critical attitude to his work, while Hunt revealed his own anxieties about Ruskin's response. On 2 September 1858 William Kingsley wrote to console him: 'I return your Ruskin letters; as far as I can see it does not give you any reason for being down. You can easily correct what he finds fault with … I suspect

50 Violet Hunt Papers.
51 Violet Hunt Papers.
52 *Art Journal*, 1863, p. 119.
53 Ruskin's *Academy Notes* appeared each year from 1855 to 1859, and once again in 1875; see Ruskin 1903–12, XIV

that stopping short of definition without giving the idea of vacancy is just one of the hardest things to execute that can be, and which when done right is so sure a sign of the master hand that it has led ignorant people to take mere slap dash for merit'.[54] Ruskin's criticism was evidently damaging: in a note from Hunt to Margaret of 21 August 1859, he was consoled that at least one collector was loyal: '[The Leeds collector of Pre-Raphaelite art] Mr Plint's handwriting is welcome – It is a comfort to see that JR's verdict does not carry everybody with it'.[55] A few days later, Hunt closed a letter with a message for Margaret to pass on to the wife of fellow Liverpool artist James Campbell: 'PS Give my love to Mrs Campbell. Tell her J. Ruskin's a rotten reed to lean upon'.[56] Ruskin had great power, and was not always considerate in the way he exercised that authority; Hunt tried to ignore the shafts of criticism, but felt insecure. At the end of the year, he found himself anticipating Ruskin's barbs and at the same time seeking to defend the importance that he attached to his good opinion, as he wrote to Margaret: 'I am full of anxiety about the Hogarth [where Hunt was exhibiting *Cochem on the Moselle*, lent by William Greenwell, and *The Track of an Ancient Glacier – Cwm Trifaen*, which had been rejected by the Royal Academy], I fear Ruskin will only be confirmed in his opinion of my falling away', and then in a following paragraph, 'I wish I could ask you here – but we are all so queer that it is not a pleasant house. My father won't forgive me for liking Ruskin. It is positively a sore place for him'.[57]

Although there may have been frequent contact between Ruskin and Hunt in the early 1860s, it remains for the most part unrecorded. In the summer of 1864 Hunt consulted Ruskin about two works that he was in the process of selling to Isaac Lowthian Bell, a version in oil of the watercolour of Finchale Priory, and one of the paintings of Bell's iron foundry at Port Clarence (see cat. nos. 21 and 30). Ruskin's reply, of 20 June 1864, mixed praise and criticism: 'I saw your two pictures on Saturday, and was deeply interested by them: I am too weary and careless just now to judge them with any fairness: but the Yorkshire [*sic.*] dell and priory seems to me as

54 Violet Hunt Papers.
55 Violet Hunt Papers.
56 Violet Hunt Papers. Ruskin's disservice to Campbell may have been the omission of reference to his painting *Our Village Clockmaker*, exhibited that year at the Royal Academy, in *Academy Notes*. In a late edition, Ruskin explained that 'by inadvertency, I omitted in the arrangement of these detached *Notes* the reference made to Mr Campbell's wonderful and all but perfect study' (Ruskin 1903–12, XIV, p.239), seeming to imply that he had previously promised that he would draw attention to the work.
57 Violet Hunt Papers.

lovely as anything yet done in landscape by your school – and the forge is nearly as good as possible – a little wanting in fierceness and force – but wonderful in lambency of pure flame and coloured vapour'.[58] Ruskin was, however, increasingly disturbed by works of art that seemed to suffer under what he had called in 1859 the 'oppression of plethoric labour',[59] and so continued: 'I see with regret that you have still not learned to economize in labour; much of the excellent studying of parts in the landscape is utterly thrown away; and I think the sky hurts all: a perfectly cloudless – calm and slightly warmer one would have been delicious. The eye ought to rest quite quietly on the lovely fore-ground'.[60]

A further letter from Ruskin, dated 24 June 1864, expounded the need to draw the elements of the composition together, and the impossibility of harmonising the groupings when all the parts were studied minutely and in isolation: 'I have your nice letter and am so glad you feel that way about light and shade. As for not seeing it – you <u>do</u> the loveliest bits every here and there – only you don't yet put them together nor sacrifice those that must go and die for the rest. I send you four Engravings, perhaps you have seen them already but if you have you can bring them back any time. They are not special in any way, but they are characteristic of true Turnerian foliage and grouping – which is by no means learnt either from Claude or any human thing – but from God and Yorkshire, and when you begin studying form properly, you will find the Divinest groups ready to your hand everywhere'.[61] Ruskin was having difficulties of his own, as he told Hunt (seeking at the same time both to flatter and reassure him): 'I am like to kill myself with vexation every time I take a walk – (even here) – because I can't draw the divine groups of trees that are everywhere – <u>easy</u> as well as beautiful, if only one had time and skill, such as you have'.[62] Hunt was to learn the principles of natural design on the basis of the careful observation of small specimens: 'I <u>suspect</u> you want a course of architectural ornament & design – or at all events of accurate mathematical botany. You may learn how to group or rather to <u>see</u> <u>the</u> <u>grouping</u> of trees on a hill-side, by properly draw-

58 Violet Hunt Papers.
59 Ruskin 1903–12, XIV, p. 230.
60 Violet Hunt Papers.
61 Violet Hunt Papers.
62 Violet Hunt Papers.

ing in perspective a foxglove or clover or any clustered head with all their points right set and shaded. I strongly suspect this to be what you most want'.[63]

Hunt was beginning to feel that he was being deliberately excluded by the Royal Academy. Although he was represented in most of the summer exhibitions until 1862, for the following seven years he showed nothing. It was sometimes said that Ruskin had exacerbated the situation for Hunt and other progressive landscapists by drawing attention in *Academy Notes* to the injustices committed by the hanging committees, who placed their own works prominently and in good light, but exiled the works of non-members to the upper reaches of the walls of the gallery (see cat. no. 6). That Ruskin recognised the Academy as a self-serving institution, and was offended by the willingness of its members to obstruct works by younger artists, is demonstrated by his disparaging comparison in 1864 between works by Hunt and paintings then on display in Trafalgar Square: 'They have nothing in landscape in the Academy so good this year – but it is no wonder they keep such studies out! How do you think a Creswick soot and bitumen tree would look beside it?'[64] Ruskin's letter concluded: 'I hope you will take good care of your health and try in future to produce pictures with less exhausting – though just as attentive labour. The Pictures will look all the better for being done less devotedly'.[65]

In his own highly personal and idiosyncratic way Hunt did come to understand Ruskin's principle that the literal replication of the elements of nature was not a complete artistic purpose. In 1859 Brett's Alpine subject *Val d'Aosta* was shown in Liverpool, following its first appearance at the Royal Academy in London. Hunt wrote to Margaret on 6 October to say that he did not much like the Liverpool exhibition, and 'Brett (the famous historic landscape painter etc)[66] I do not like at all. I would not care to have painted the Val d'Aosta'.[67] Hunt had in mind (or was unconsciously influenced by) Ruskin's critique of Brett's painting, in which he wrote: 'He has cared for nothing, except as it was more or less pretty in colour and form. I

63 Violet Hunt Papers.
64 Violet Hunt Papers. Thomas Creswick (1811–1869) was a much-disliked figure by all who espoused progressive landscape painting. In 1884 Edmund Gosse described him as 'the Upas-tree under whose shadow the Academical patronage of landscape died in England' (London 1884, p. 6).
65 Violet Hunt Papers.
66 Here, Hunt is paraphrasing Ruskin's account of Brett's *Val d'Aosta* in *Academy Notes* (see Ruskin 1903–12, xiv, pp. 234–8).
67 Violet Hunt Papers.

John Brett, *Val d'Aosta*.
Private Collection

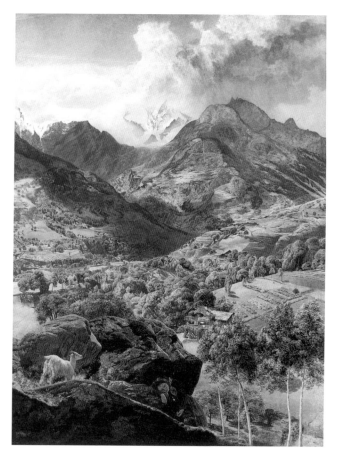

never saw the mirror so held up to Nature; but it is Mirror's work, not Man's'.[68] Hunt, in his artistic maturity, came to believe that authenticity of treatment lay in the evocation of the actual experience of being in the landscape, and thus he sought to describe atmospheric and meteorological effects, and the qualities and fluctuating intensities of light at different times of day, rather than to give an objective view of the physical world. Hunt knew how the Pre-Raphaelites had sought to represent landscape with fresh

68 Ruskin 1903–12, XIV, p.237.

THE POETRY OF TRUTH

eyes and had discarded the conventions of the picturesque, and so in 1880 he explained: 'The world had been too long seen with a pre-conceived idea how it ought to look … It was time, they thought, to try how it would look when viewed with recovered innocence of eye. Little do artists and critics who talk of innocence of that kind know what a strange and bewildering thing it would be to them. None but very determined seekers of the truth know how difficult it is to be entirely free from a conventional or derivative mode, not only of painting, but of seeing the simple facts of nature'.[69] Hunt came to regard the careful observation of landscape as a preparation for works that were addressed to the spiritual and poetical faculty rather than the specta-tor's delight in the replication of the forms of nature. Of mere literalness in landscape he wrote: 'Our hearts are not touched: we admire the artist's extraordinary skill, we are thoroughly grateful to him for reminding us of what he has copied so well; but the admiration and the gratitude and the intellectual joy of examining bit by bit such a picture, make up altogether a pleasure different in kind from that which we derive from a great imagina-tive works of art'.[70]

Turner was, for Hunt, the greatest imaginative painter of all, and one to whose memory he felt an intense loyalty. Edmund Gosse, in his essay on Hunt's art published in 1884, analysed the legacy of Turner's painting to Victorian landscape art: 'This school depends upon the assumption that we cannot paint nature as it is, or even as we see it, but that we must arrange, compose, and translate it. Turner's intention was not to secure truth of fact, but truth of effect. His ideal was not to represent any portion of land or sky as it actually exists, since it actually so exists but for a few seconds, but to reproduce a combination of delicate colour, with intense subtlety of light and shade, in such a way as to recall nature, and seem to the eye to be in harmony with it'.[71] F.G. Stephens concluded that Hunt was 'the legitimate successor of Turner, but, except in strenuously and subtly endeavouring to delineate the effects of light, not his imitator'.[72] Perhaps the high point of Hunt's search for an authentic representation of the outside world, but one

69 Hunt 1880, p. 786.
70 Hunt 1880, p. 785.
71 London 1884, pp. 4–5.
72 'Mr A.W. Hunt's Pictures [at the Fine Art Society]', *Athenaeum*, 1884, p. 94.

which was at the same time carefully organised and adapted to make the subject spiritually charged and exciting to look at, is his view of Tynemouth Pier, *Lighting the Lamps at Sundown* (cat. no. 32).

In 1865 Alfred and Margaret Hunt and their three daughters moved to London.[73] Their home, and Hunt's studio, was at 1 Tor Villas, Campden Hill, a house in Kensington that had previously been occupied by Holman Hunt and for which Alfred Hunt paid a quarterly rent of £30 to its owner, the painter James Clarke Hook. In most years, Hunt spent the summer and autumn in the countryside, his favourite painting regions remaining north Yorkshire, Durham, and Northumberland. In 1869–70 Alfred and Margaret made an extended cruise in the Mediterranean on the yacht of Sidney Courtauld, and in 1877 they sailed up the coast of Norway.[74] Hunt made several tours of the west coast of Scotland in the 1870s, and spent two summers, 1873 and 1874, in the Lakes. In later years, his favourite painting grounds became Whitby, on the Yorkshire coast, and the neighbouring village of Robin Hood's Bay.

In London, Hunt involved himself in the affairs of the Old Water-Colour Society. He persuaded Ruskin to allow his own drawings to be shown occasionally in the annual exhibitions, when very few people knew how remarkable a draughtsman Ruskin was. Letters from Ruskin record his nervous excitement as an exhibitor. In November 1873, for example, he explained his non-appearance at the exhibition's opening party: 'My dear Hunt, I am very conceited about my sketches being placed, and could not behave with sufficient sangfroid at the private view – I shall peep in some day, round the corner'.[75] On occasions Hunt allowed himself to be drawn into public disputes about the conduct and privileges that went with membership of the different art associations, attempting to campaign for the better treatment of landscapists at the hands of the Royal Academy, but finding himself being brushed off by sarcastic and snubbing letters from members to the press. Ruskin regretted that Hunt should have allowed himself to 'be drawn into the maelstrom of modern art associations'.[76] Sadly, Hunt, encouraged by

73 The three daughters were: Violet (b. 1862), Venetia (b. 1864), and Silvia (b. 1865).

74 See sketchbooks nos. 21–6, and, for the trip to Norway, nos. 112–6, 225 (Ashmolean Museum).

75 Violet Hunt Papers.

76 Ruskin's regret that Hunt should have continued to involve himself in the running of the Old Water-Colour Society, with all the frustrations and eventual disappointment that went with this role, was expressed in a letter of 6 November 1873. The paragraph concluded: 'Why not limit yourself to home, – nature, and the National Gallery?' (quoted Secor 1982, p. 67).

Margaret, continued to wish for public recognition and a position within the establishment of the Victorian art world.

Hunt stood for membership of the Royal Academy in 1884. An account of the election in the *Art Journal* announced that his 'non-success [was] due to a feeling of resentment on the part of the Academy at the action of a considerable portion of the press, who, in their reviews of the Exhibition now being held of his work [at the Fine Art Society], loudly proclaimed him as the most deserving candidate'.[77] Two years later, Margaret Hunt seems to have made some kind of overture to the Academy on her husband's behalf. News of this got round, and she was chided for her willingness to abase herself before that unfeeling institution. William Bell Scott wrote to her with chilling candour: 'You surprise me by your persevering addresses to the R.A. Do you think Alfred will paint again such pictures as he did of the foamy rocks, of the Yorkshire coast, of Cormisken, etc. etc. were he a member of that body? Or is it purely a social distinction you desire? To be on a par with all the St John's Wood set? … Is it possible that you respect Burne Jones more now that he sticks the humiliating letters after his name?'[78]

Two years later Hunt again stood for election to the Academy, but after the ballot heard from John Brett that he was unsuccessful: 'We had a great scuffle for you this evening, but I am grieved to say we just missed it. Twice you were neck and neck with another man. Once you lost it to Ford the sculptor, & once to Blomfield the architect. Richmond was the only painter elected, and A. Moore ran him hardest. The landscape men combined strongly on you of course but we are a very small minority'.[79] Hunt found it hard to rise above such vexations; when he died, it was Burne-Jones who recalled him as 'an anxious kind of man – a regular worry-mutton – took life very heavily I fancy'.[80] In 1877 Ruskin had expressed concern about Hunt's physical strength and mental resilience, warning Margaret: 'I am quite certain that a fine nervous temperament like his will not, as he advances in years, bear the strain of <u>continual</u> effort'.[81] Hunt was not a happy or contented man – although he was much loved by his family and

77 *Art Journal*, 1884, p. 94. The notice of Hunt's failure went on to conclude that it was 'Mr Hunt's peculiar method of placing his colours' that influenced members against him, and that, 'such singular qualities as delicacy, refinement, poetry, and an unrivalled power of rendering certain effects of English landscape availing nothing in their eyes against an unacademical method of painting. Many would include in his list of qualifications that he is one of the first water-colour painters of the day, forgetful that proficiency in that branch of the arts has not yet to come to be recognised as of any value in testing an artist's claim to a place in the Royal Academy of Arts'.

78 Violet Hunt Papers. The reference to Burne-Jones was sparked by his having allowed Leighton to persuade him to accept what was in effect an honorary associate membership of the Royal Academy (which he later resigned). Also in 1886, Burne-Jones had been re-elected to the Royal Water-Colour Society, despite his reluctance to re-join an association from which he had resigned publicly in 1870.

79 Violet Hunt Papers.

80 Lago 1981, p 100.

81 Violet Hunt Papers.

well liked by his friends – and he was disappointed to find his subtle and refined view of nature so little appreciated by the wider public.

Hunt's exhibited work, and particularly his drawings shown at the Old Water-Colour Society, was generally received with enthusiasm by the critics, both by F.G. Stephens of the *Athenaeum*, but also by the more conservative *Art Journal*. Year after year, the critics singled out the quality of colour and luminosity in Hunt's work, which they perceived him to have adapted from Turner's watercolours. In 1866 the critic of the *Art Journal* wrote of Hunt's watercolours *Tynemouth Pier* and '*Childe Roland to the Dark Tower came*' (cat. nos. 32 and 37), and of works by George Price Boyce: 'Fire oftimes [Hunt and Boyce] throw into the face of Nature, yet light and colour do they attemper by shade. The drawings of Alfred Hunt, indeed, seem to try, and sometimes to solve, the most recondite of chromatic experiments. Nature is to this painter a kaleidoscope, and earth seems woven as a tapestry and illumined as a rainbow'.[82] In the following years, Hunt was repeatedly acclaimed for his use of colour. In 1867, the *Art Journal* announced that 'the school of polychromatic landscape glows with ever intenser fire. Alfred Hunt … [makes] nature an excuse for pyrotechnic display'.[83] In 1871, the same periodical again invoked Turner in connection with Hunt's work at the Academy: 'The harmony, the vision, the fire of colour are truly Turneresque. Alfred Hunt is the most sensitive and rapturous of our colourists'.[84] Hunt had thought about the balance of colour and form that Turner had aimed for in his watercolours: 'Turner's drawings … might be fairly described as a series of experiments to discover with what system of colours it is possible to give the greatest amount of colour-truth consistently with truth of light and shade, and will always remain more or less unintelligible to those who do not love landscape-colour passionately, and see in its strength, variety and infinite subtlety, means of representing distinct moods of thought and feeling'.[85] In his own watercolours Hunt was careful not to use any colour that was garish: 'Better a thousand times simple monochrome, or such lowness of tone as is hardly one degree removed from it, than a Babel of

82 *Art Journal*, 1866, p. 174.
83 *Art Journal*, 1867, p. 147.
84 *Art Journal*, 1871, p. 176.
85 Hunt 1880, p. 584.

colours in which the language of form is lost, or disgracefully confused. But it cannot be denied that if colour is once admitted, *as colour*, it claims supremacy at once'.[86]

In 1873, when Hunt spent the summer painting at Coniston (see cat. no. 44), Ruskin was worried that the colour in Hunt's drawings was become uncontrolled, and that he was sacrificing form and structure. The implicit accusation was that he was neglecting to draw the masses of his subjects in light and dark and ignoring outline. Ruskin recommended 'rapid pencil drawing of masses – and outlines so far as visible' as a habit to be acquired; 'Everything becomes simple, on that foundation', he wrote to Hunt on 16 June 1873.[87] Ruskin insisted that the form and structure of the landscape should come first, that its colour and brightness of tone was a secondary consideration, and that the two purposes should be discrete. He summed up his view: 'I think if you would resolve once steadily, to construct your pictures <u>at all events</u> firmly in form at the beginning, and not to quit the first arrangement on any temptation, and to make small studies of complete pictures in multitude for practice, you would soon quit yourself of the haunting difficulty of uniting colour composition with form composition. Be sure, at least, that you have one or other, and do not lose both in contention'.[88] The radiant and ethereal quality of Hunt's watercolours of the 1870s, such as *The Stillness of the Lake at Dawn* (cat. no. 44), or the many views of Warkworth and Bamburgh, show how wedded he was to the effects of colour and light.

Ruskin looked back on his futile attempts to reform Hunt in a letter to Margaret Hunt in 1875: 'All the time I had with him at Brantwood [in 1873] I was beseeching him to go through the great discipline of pen outline & light and shade – which he has always <u>shirked</u> – slipped over – for colour'.[89] Ruskin still felt that Hunt was seeking too great an elaboration in his drawings, and that in the process he was losing spontaneity and emotion. Ruskin was of course indifferent to considerations of acceptability, critical success, and the likelihood of sales at the annual exhibitions. In a later letter to Margaret, he explained what he saw as the difference between his own

86 Hunt 1880, p. 581.
87 Quoted Secor 1982, p. 52.
88 Ford Madox Ford Papers (quoted in Secor 1982, p. 72 with errors of transcription).
89 Quoted in Secor 1982, p. 83.

work and Hunt's: 'If I have any advantage over Alfred it is in this utter care-lessness about my own work – I try to show people what is right – and care as much for my books as for a past shout to a man to tell him he was on the wrong road'.[90] Ruskin was becoming unsympathetic to Hunt's morose introspection, as he also told Margaret: 'Alfred is too anxious about his work – What does it matter what any of us do, when Perugino and Angelico are perishing like the fading snow'.[91]

Hunt's trajectory from the obsessive replication of the detail of nature towards the evocation of the landscape, a translation that describes the great pattern of his career, was commented on by F.G. Stephens when comparing the work of Hunt and Brett. He concluded that 'if Mr Brett's workmanship may be called microscopic, that of Mr Hunt, although, at least, as laborious, and far more subtle and tender, is, apparently, generalized to an extreme, and comprehensive in the widest degree'.[92] The increasing abstraction and unity of tone of Hunt's work, and his preoccupation with brilliant effects of light and colour in his later career, may have been more than just an aesthetic response. All his life he was morbidly anxious about his eyesight. In 1859 he explained the difficulty he was having in seeing clearly the townscape of Lucerne, and translating what lay before him into a coherent composition: 'My defective sight will oblige me henceforth to spend an immense time not over the drawing itself but in preparatory lookings – I can only see complex-ity when ordinary people see clear multitudinousness',[93] he wrote to Mar-garet. Later that summer, he wrote again: 'The eyes are pretty well – I may say very well – but I cannot work without my spectacles. Working without them would involve <u>a totally different style & much larger scale</u> – and I <u>cannot</u> <u>make the change all at once</u>'.[94] Throughout his career he carried and used binoculars to inspect the detail of the landscape; and on many occa-sions he expressed the frustration he felt at not being able to see clearly. In 1895, the year before he died, he wrote to Margaret: 'I find that my sight is a real cause of much vexation and trouble … I cannot arrange pictures out of mere variegations of colour; but must find boundaries and edges somehow'.[95]

90 Letter from Ruskin to Mar-garet Hunt, 19 February 1876. Violet Hunt Papers.
91 Violet Hunt Papers.
92 *Athenaeum*, 1873, p .700.
93 Violet Hunt Papers.
94 Violet Hunt Papers.
95 Ford Madox Ford Papers.

In 1884 Edmund Gosse described how Hunt 'carries about a cluster of pocket-books, in which he incessantly notes down scraps of form and notes of colours. He makes innumerable studies in colour before he proceeds to paint a subject which has pleased him, and when he has finally determined upon his scene, he approaches it under various atmospheric effects, and besieges it with every circumstance of astute landscape strategy'.[96] Frequently repeated studies of familiar landscapes from exactly the same vantage point were a necessary preliminary to his more formal compositions. Sketches and colour studies made in the open were taken back to the studio, where they provided the basis for worked-up drawings and paintings. On occasions he would incorporate skies studied in Campden Hill into views done away from London. He took great delight in the particularly brilliant sunset effects that occurred in the autumn and winter of 1883 following the volcanic eruption at Krakatoa, near Java. Hunt observed a clear distinction between the finished work – which might be sent to an exhibition or offered to a client – and the sketch that led up to it. Both were lovingly observed records of the colours and effects that the landscape offered, and if the former were created at one stage removed from the artist's direct experience of nature, they were nonetheless true to the spirit of the artist's vision of landscape.

While staying with the collector William Graham at his house, Urrard, near Pitlochry, in Perthshire, Hunt was asked to show the work that he had in hand, including his working sketches. He seems to have been rather daunted: 'My folio of scratches and blots was opened this morning to my great humiliation – the results so far of so much time and what seemed to me labour are so wretched. Mr Graham was astonished by the amount of unseen work and scaffolding which landscape, as practised by me, required. That was the only idea that the folio gave him'.[97] Hunt's colour studies were private meditations on the textures and qualities of light to be observed in the landscape in the same way that Turner's late colour studies were. Equally, they anticipate in their reduction and abstraction of the forms of nature

96 London 1884, p. 13.
97 Violet Hunt Papers.

Whistler's impressions of coasts and sea or his later watercolour 'nocturnes'.

Hunt's drawings were admired for their subtlety. In 1884 Gosse quoted P.G. Hamerton's account of the painter's technique: 'Few painters have impressed upon me the necessity for delicacy in water-colours so strongly as Alfred Hunt. He has it in the supreme degree, and it is probably owing to this cause, that although he does not often employ bright pigments, but confines himself almost entirely to quiet ochres and the like, his works are brilliant in colour as well as light. The poetry of distance … is dependent upon distinctions between pale tones incomparably finer than the recognised differences in musical notation, and resembling rather those faint, indescribable sounds of murmuring wind or water which come to us from afar'.[98] Violet Hunt recalled her father's manipulation of colour: 'My father's mere manual dexterity was remarkable enough. With those long nervous bird-like fingers he could propel or arrest his brush within the merest fraction of an inch in any given direction, and "place" a dab of colour here or there with the force of a hammer or the lightness of the swish of a bird's wing'. She described the ways he achieved his effect: 'I have seen delicately stained pieces of Whatman's Imperial subjected to the most murderous "processes," and yet come out alive in the end … He sponged [the sheet] into submission; he scraped it into rawness and a fresh state of smarting receptivity'.[99] Thus Hunt combined robustness and surgical precision to achieve truth of description and power of evocation. His later watercolour technique gave unity and atmospheric homogeneity to his views. He continued to build up the surfaces of his drawings in minute touches of different colours, but increasingly he went on to submit the lovingly accumulated detail to processes that would cause the forms and disparate colours to coalesce and fuse. To achieve this, he wet the sheets so that colours would run together and the detail would be masked beneath a gauze-like surface, and he sponged and abraded the surface to get back to a paler tone lit by the brightness of the paper, or he stabbed, scratched, and cut into the surface of the paper to give sparkling highlights of white.

98 London 1884, pp.12–13.
99 Violet Hunt 1924–5, p.32.

Hunt took the greatest care to represent truthfully the exact meteorological and climatic effects of a particular time of day or season. Thus, he made countless separate studies of specific places observed in different conditions of light, a method described by his daughter Violet who accompanied him on painting expeditions: 'He did at least two long tramps a day, one to the Morning subject and one to the Evening subject. Morning and evening were again subdivided, inasmuch as he often put away the early morning sketch for a new "effect" at midday, or a dull early afternoon experiment for a glowing sunset orgy towards evening'.[100] Hunt endured such discomfort while working in the open that his health began to suffer. Margaret and Violet carried cans of tea to him and pleaded with him to come in. Violet's diary recalled how one November she found her 'Poor Papa … quite paralysed with the cold, and so sweet tempered though he must be perfectly wretched. His hands are like the claws of a bird or a leg of a chicken – the skin withered and chapped, the back of his hands one huge sore. He says that the energy or something all gets down into the tips of his fingers'.[101] Only in the late 1880s did Hunt's creative spirit begin to slacken, partly owing to the physical strain of painting outdoors. In July 1880 he wrote to his old friend, F.G. Stephens: 'Sometimes, I feel what I never felt before, a lazy disposition to turn aside from trouble and accept slackness of effort. Not that I have any temptation to do bad work, if I can help it. But I used to feel so strongly that no good work could be done without abounding joy in it; and I am afraid of losing that'.[102] Alfred William Hunt died, following an attack of acute bronchitis, at Tor Villas, on 3 May 1896 – aged sixty-five. He was buried at Brookwood Cemetery on 7 May.

In his lifetime the principal retrospective exhibition of Hunt's work was that held at the Fine Art Society in 1884, consisting of 137 works and representing both watercolours and oils. This aroused considerable interest, and had prompted speculation that he would in due course become president of the Royal Water-Colour Society.[103] In 1893 a display of his works was put on in Chicago, and Hunt and his wife duly travelled there to see it. In the

100 Violet Hunt 1924–5, p. 35.
101 Ford Madox Ford Papers.
102 Hunt's letter is part of the F.G. Stephens Papers, Bodleian Library, Oxford (Bod.38942 MS.Don.e.83).
103 See *Art Journal* 1886, p. 256, on the resignation of Sir John Gilbert as president of the Royal Water-Colour Society: 'The appointment will probably not be filled up until the winter, when it should assuredly fall to Mr Alfred Hunt, who has, we believe, for some time past undertaken the greater portion of the duties of the office'.

Henry Tanworth Wells,
*A.W. Hunt on his
Deathbed.* British
Museum (1936–12–
21–2)

May 4ᵗʰ 1896.

year after Hunt's death, three memorial exhibitions were staged. A display of his drawings was made at the Water-Colour Society as an adjunct to the winter exhibition, as a tribute to one who had given loyal service. Later in the year an exhibition of 138 watercolours by Hunt was staged at the Burlington Fine Arts Club. A larger exhibition, of 205 works, including 31 oil paintings, took place at the Walker Art Gallery in Hunt's native city in the winter of 1897–8, organised by James T. Watts.

In 1897 Cosmo Monkhouse emphasised the twin qualities of the spiritual and the literal in Hunt's art. He was a man 'of an unusually sensitive temperament … [and one who] held a lofty ideal of the function of the artist, and regarded all the mighty and beautiful phenomena of nature as manifestations of the divine. With this high spiritual impressionism he united an intense desire for exact truth of presentation'.[104] What were artists to do at

104 London 1897, p. vi.

a time when they found the mental and physical resources to fulfil the precepts of Pre-Raphaelitism exhausted? Ruskin had been one of the first to recommend breadth and fluidity, in 1851 in his pamphlet *Pre-Raphaelitism*, arguing that 'the freedom of the lines of nature can only be represented by a similar freedom in the hand that follows them'.[105] Hunt's achievement was to adapt the intensity of vision of Pre-Raphaelite method to new, abstract, and aesthetically contained purposes of art. As has been seen, he habitually sketched in the open air and made colour studies of the effects of light that unfolded before him. He held true to the principle that the actuality of a geographical location could only be represented with authenticity following careful observation and thought. In addition, his transcendent and poetic feeling for the beauty of landscape and his long association with particular parts allowed him to capture its more subtle and mysterious aspect, thus combining an inward emotional response to places, which is visceral, with the close knowledge of places of one who had tramped across the landscape in question in all seasons and over many years. Hunt's love of the countryside of north Wales, the Lakes, Yorkshire, Durham, and Northumberland, and the selfless dedication that he gave to the task of capturing aspects of the places he visited, imbues all his works. His work is a celebration of the beauty of the British landscape, with its extraordinary variety of aspect and constant fluctuation of atmospheric and meteorological effect. His paintings and drawings have the power to make the spectator want to see and experience the places represented, not so much to test the artist's responses, but to share the delight that he felt.

105 Ruskin 1903–12, XII,
pp. 388–9.

A.W. Hunt, *Mill on the Dart, Devon, c.* 1850. Ashmolean Museum

THE POETRY OF TRUTH

'Sympathy with Nature': Hunt's Reflections on Landscape Painting in the Nineteenth Century

SCOTT WILCOX

WHEN HIS ARTICLE, 'Modern English Landscape-Painting', appeared in the periodical *The Nineteenth Century* in May 1880, Alfred William Hunt could look back over a career of a quarter century as a landscape painter. He wrote of the changes in landscape painting in his lifetime and assessed the achievements, shortcomings, and potentialities of landscape art in his day. Although the article only indirectly addressed his own work as a painter, it could be seen as his taking stock of the art to which he had devoted his life. In his review, as in his further reflections on the subject, published a decade later in *The Nineteenth Century* under the title 'Turnerian Landscape – An Arrested Art', Hunt contrasted the landscape painting of his time with that of an earlier generation. Although these two articles scarcely constitute a history of landscape painting in Britain, they do provide a sense of how Hunt saw his own work fitting into a larger narrative.[1]

Hunt perceived that towards the middle of the century landscape art had undergone change of a 'vital kind', which he saw as related to Pre-Raphaelitism but earlier in date and wider in scope. At the heart of this 'vital' change was 'a new zeal in the pursuit of truth – a new form of sympathy with nature which seeks naturally for new modes of expression, and for the present leaves on one side those modes which are felt to be things of inheritance merely, and not of true feeling.' (Hunt 1880, p. 783) Together with this greater accuracy and specificity of representation went a focus on new subject matter: 'Various aspects and qualities of nature which were uninteresting pictorially to a former generation have become interesting to this; a careful count of what our fathers would have called minor details is demanded, and certain conventionalities or art-moulds in pictures by which they obtained unity of effect, are entirely unsuited for that purpose now.' (Hunt 1880, p. 780) The revelations of naturalistic landscape in the earlier decades of the century no longer seemed sufficient and had been superseded. In the 1850s the young Hunt had been flush with the sense of pioneering

1 Alfred William Hunt, 'Modern English Landscape-Painting', *The Nineteenth Century*, May 1880, pp. 778-94, and 'Turnerian Landscape – An Arrested Art', *The Nineteenth Century*, February 1891, pp. 214-24, hereafter referred to as Hunt 1880 and Hunt 1891.

and promise, and his watercolours and oils of the period had been perfect embodiments of this change.

In looking back, Hunt neither located himself within that moment nor did he name any of the other landscape painters who shared in it, but he did suggest reasons for the change, citing 'influences of which the great men of the old school just lived to see the beginning – the inroads of the scientific spirit, the invention of photography, the writings of Mr. Ruskin, sympathy with the pre-Raphaelite movement in respect of its love of colour, of detail, and mystic meaning in little things; and perhaps an increase in the number of those who, vexed with great questionings of heart beyond the range of science, turned for solace to the perfectly-ordered beauty of tree and flower – these and other causes combined to give a new force and direction to land-scape painting.' (Hunt 1880, p. 783) Hunt seems to offer his readers a pic-ture of progress in art, of the limitations and conventionalities of the 'great men of the old school,' the landscape painters of his father's generation, being transcended. Yet his comment on artists turning away from the 'great questionings' to find solace in tree and flower hints at a failure of nerve, a disinclination on the part of the younger generation to grapple with big themes.

For Hunt the positive developments in the middle years of the century had not led to a major advancement of landscape art. The gains had to be weighed against some very real losses. At the heart of both Hunt's articles is the recognition that while landscape had moved on from the generation of J.M.W. Turner (1775–1851), John Constable (1776–1837), and David Cox (1783–1859), the failure to understand properly and to capitalize on the les-sons of that earlier generation had led to a general diminishment of the art. Hunt imagined that the observer familiar with the landscape art of earlier in the century 'would see little in the work of to-day to set against the glories of the past.' (Hunt 1880, p. 780) This putative observer was not simply a traditionalist, enamoured of the old and suspicious of the new. Hunt enu-merated the areas in which contemporaries fell short: 'Clearness, simplicity,

swiftness of execution, poetical conception, and unity of design – do these qualities exist in our landscapes now?' (Hunt 1880, p. 783)

Although Hunt's great friend and mentor, John Ruskin (1819–1900), had celebrated the achievements of the older generation of British landscape painters, it was clear that few of the artists of that generation, apart from J.M.W. Turner, had fully satisfied his stringent demands for fidelity to natural fact. They had been too hampered by conventional ways of seeing, of representing, and of composing. Ruskin had looked to the rising generation to fulfill the promise to which this earlier naturalism seemed to point, famously urging young artists 'to go to Nature in all singleness of heart … rejecting nothing, selecting nothing, and scorning nothing.'[2] The attack on conventionalism in the representation of nature spearheaded by Ruskin led a generation of artists to turn their collective backs on the pictorial conventions and compositional frameworks that landscape artists had employed since the seventeenth century. As Hunt put it, 'The world had been too long seen with a pre-conceived idea how it ought to look on canvas.' Artists in the 'first fervour of the Pre-Raphaelite revolt' sought for a 'recovered innocence of eye.' But Hunt continued, 'Little do artists and critics who talk of innocence of that kind know what a strange and bewildering thing it would be to them. None but very determined seekers of the truth know how difficult it is to be entirely free from a conventional or derivative mode, not only of painting, but of seeing the simple facts of nature, and how many a startling and inconvenient discovery breaks in on them when once the effort is made.' (Hunt 1880, p. 786)

In 1865 a critic accused the young wood-engraver turned watercolourist John William North (1842–1924) of displaying 'a morbid fear of conventionalism.'[3] The phrase succinctly and memorably characterizes that preoccupation with rethinking the premises of landscape art shared by North, Hunt, and a number of their contemporaries; it also suggests the desperate straining for novelty of effect, often at the expense of clarity and harmony. Hunt confessed to 'a lingering liking for that most useful and, in reality, lovely

2 Ruskin 1903-12, III, p. 624.
3 *The Spectator*, 4 March 1865, p. 243.

arrangement which Turner took naturally from Claude,' and he reasserted what he called 'power of composition.' Though disdained by many of his fellow artists, 'it is this power, when it is the outcome of great intellectual force and intense feeling, which is the landscape-painter's special gift.' (Hunt 1891, p. 219) As even Ruskin himself acknowledged, no art is possible without some degree of artistic convention, and Hunt concluded, 'We may as well enjoy our conventionalism after all, only taking care that imagination mend it: imagination which is born of love for the thing seen, and energy of intellectual power set to find or to use well all possible means of depicting it.' (Hunt 1880, p. 790)

Focus on the representation of the minutiae of nature was also a consequence of Ruskin's teaching, though Hunt reported Ruskin's disappointment that so many of his disciples 'set their hearts upon pebbles rather than on mountains, and loved to copy textures and veinings rather than contours and sweeping lines.' (Hunt 1880, p. 782) Like Ruskin, Hunt saw a problem not in the exquisite rendering of leaf, pebble, and blade of grass but in the way such delineations shouldered aside or were even perceived as inimical to the broader forms of landscape and in the way that precision could usurp poetry. 'The most elaborate transcript of the forms and colours of nature, without the expression by design of the sympathy or poetical feeling excited by them, is rightly to be called a study, not a picture of landscape.' (Hunt 1880, p. 788)

It was in an attempt to retrieve this sense of a broader, more poetic landscape response that Hunt looked back to the earlier generation. In just a few sentences and a list of names in his first article, Hunt sketched in the contours of the earlier art against which the landscape of the present was to be judged:

We have no Turner: but an age or period may have good work to show without having such exceptional genius as his to be proud of. A whole band of picturesque designers, of whom Stanfield and Harding may be taken as the type, have hardly their equals now. The long line of water-colourists, from Varley downwards – rich in such names as Cox, Havell, Robson, Prout, to take only

James Duffield Harding, *Elementary Art, or, The Use of the Lead Pencil advocated and explained* (London: Charles Tilt, 1834), pl. XXV. Yale Center for British Art, Paul Mellon Collection

some of the most famous – stands, some critics would say, to reproach their successors. (Hunt 1880, pp. 780–81)

There is perhaps a note of condescension in the phrase 'band of picturesque designers.' The well-crafted but slick picture-making practised by Clarkson Stanfield (1793–1867) and James Duffield Harding (1797–1863) had fallen into disrepute, although it had scarcely become extinct, and in the hands of one of their longer-lived contemporaries, William Callow (1812–1908), it would continue into the early twentieth century. In choosing Harding as one of the two artists to represent the type, Hunt may have been acknowledging a personal artistic debt. Hunt's early drawings show that he, like the young Ruskin, was strongly indebted to Harding's drawing style, made widely available through his lithographic travel books and instructional publications.

Hunt put forward the Romantic watercolour painters as the great protagonists of the earlier landscape school. It is telling that he begins 'the long line of water-colourists' with John Varley (1778–1842), one of the founding members of the Society of Painters in Water-Colours, thus making the history of watercolour in Britain synonymous with the history of the Society

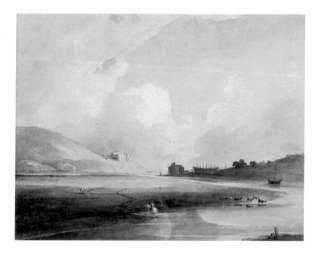

John Varley, *Harlech Castle and Tygwyn Ferry*, 1804. Yale Center for British Art, Paul Mellon Collection

with which Hunt himself had been associated since 1862. Eighteenth-century practitioners, such as Paul Sandby and John Robert Cozens, are excluded from Hunt's list, as they were in the major exhibition at the Grosvenor Gallery in 1877, which one reviewer described as 'illustrating the first hundred years of water-colour painting.'[4] That exhibition began with the work of Turner's friend and rival Thomas Girtin (1775–1802), an artist interestingly not mentioned by Hunt.

In his choice of watercolourists, Hunt would seem to have selected artists characterized by their breadth of vision, their largeness of treatment, and their sure sense of composition: those very qualities that he found lacking in his own contemporaries. Certainly in watercolours such as *Harlech Castle and Tygwyn Ferry*, exhibited at the first Society of Painters in Water-Colours exhibition in 1805, Varley showed a gift for creating effectively simple and grand landscape forms. According to Richard and Samuel Redgrave in their *A Century of Painters of the English School*, first published in 1866, John Varley was 'a perfect master of the rules of composition.'[5] He was also an exceptional teacher, in the work of whose pupils 'lingers most of those great truths that have been acknowledged by all the best artists; and which, if

4 *The Spectator*, 15 December 1877, p. 1579.
5 Richard and Samuel Redgrave, *A Century of Painters of the English School*, 2 vols (London, 1866), I, p. 498.5 Richard and Samuel Redgrave, *A Century of Painters of the English School*, 2 vols (London, 1866), I, p. 498.

they are ignored for a time for mere imitative art, will have to be revived, and again become dogmas if we are to again have great artists in our school.'[6] This comes close to the point of Hunt's essay, and, if we turn to the Redgraves' treatment of the other watercolourists on Hunt's list, we find the Redgraves again and again describing these artists in ways that reinforce the themes of Hunt's critique of later landscape art. Frequently, the Redgraves are explicit in contrasting their historical subjects with contemporary modes and practices to which they were decidedly less sympathetic than was Hunt.

Like Varley, William Havell (1782–1857) was a founding member of the Society of Painters in Water-Colours. The Redgraves commended him for lifting watercolour art 'out of the littleness of the topographic school' and described his early manner as 'large and massive, suppressing unimportant details, and treating the picture for its general effect.'[7] George Fennel Robson (1788–1833) was an interesting choice for Hunt, as he does not seem to have had a reputation in Hunt's time as one of the major figures of the watercolour school. The Redgraves said little about the qualities of Robson's watercolours, only that the 'effect of the atmosphere of our climate Robson diligently studied, and it became one of the distinguishing features of his art.'[8] Yet Ruskin had praised Robson's 'serious and quiet' watercolours as the only expression of 'certain facts of mountain scenery.' With works such as *Loch Coruisk* clearly in mind, Ruskin wrote of 'the solemn flush of the brown fern and glowing heath under evening light; the purple mass of mountains far removed, seen against still clear twilight.'[9] It was perhaps in the deep, rich, and at times strikingly unusual colour and the brooding mountain atmosphere that Hunt saw connections to his own work.

In the watercolours of Samuel Prout (1783–1852), the Redgraves pointed with approval to the 'apparent care [changed to 'ease' in a later edition] and freedom of his execution, and the largeness of his style,' which they contrasted with 'the precision required by the new school.'[10] Ruskin had a lifelong fondness for the drawings of Prout. Yet his admiration was tempered

6 Ibid., I, p. 503.
7 Ibid., I, p. 523.
8 Ibid., I, p. 499.
9 Ruskin 1903–12, III, p. 193.
10 Redgrave, II, p. 493.

George Fennel Robson,
*Loch Coruisk, Isle of
Skye – Dawn.* Yale
Center for British Art,
Paul Mellon Collection

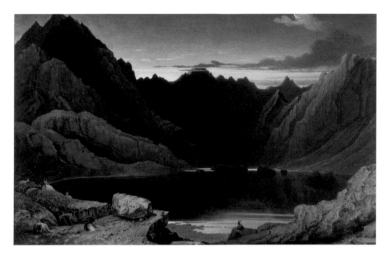

by reservations expressed both in *Modern Painters* and later in his *Notes by Mr. Ruskin on Samuel Prout and William Hunt*, published to accompany an exhibition of drawings at the Fine Art Society in 1879, which would have been fresh in Alfred William Hunt's mind as he drafted his article of 1880. 'Prout is not a colourist, nor in any extended or complete sense of the word, a painter. He is essentially a draughtsman with the lead pencil,' Ruskin had written. Even Prout's draftsmanship in recording the threatened European architectural heritage, which for Ruskin was his great achievement, had its limitations of acuity and comprehension. We can imagine one passage in Ruskin's appreciation striking a responsive chord with Hunt: 'Among our own recent landscape painters, while occasionally great feeling is shown for space, or mystery, there is none for essential magnitude…. In the real apprehension of measurable magnitude in things clearly seen – stones, trees, clouds, or towers – Turner and Prout stand –they two – absolutely side by side – otherwise companionless.'[11]

David Cox (1783–1859) clearly had a greater personal importance for Hunt than any of the others in the string of watercolourists he mentioned; his is the only name that recurs in Hunt's first article and the only name

11 Ruskin 1903-12, XIV, p. 400.

from the group that reappeared in the second. If Harding played a more demonstrable role in the young Hunt's development of a drawing style, Cox stood higher in Hunt's estimation. Although the extent of Hunt's personal association with the older artist is not fully known, Cox was apparently a friend of the artist's father; in the article of 1891, Hunt referred to a conversation with Cox in his later years. For Hunt, Cox was, along with J.M.W. Turner, the great representative of landscape painting in the first half of the century. And, of course, Turner was in a category by himself.

Hunt was by no means unusual in the last quarter of the nineteenth century in his admiration for Cox. A biography of the artist had appeared in 1873. In 1875 the Liverpool Art Club had organized a massive exhibition of the artist's work, and, in the exhibition mentioned earlier of the British Water-Colour School at the Grosvenor Gallery in 1877, Cox had been well represented. Indeed, *The Spectator*'s review of that exhibition cited Cox as 'the most *popular* painter of that period [represented in the exhibition], and one who has since had hosts of imitators.'[12] By the time Hunt's second article appeared, in 1891, a second biography of Cox had appeared, and an even larger exhibition had been mounted in Birmingham to honor its native son.[13]

Yet beyond a shared taste for the Welsh mountains, there is little to link Hunt's approach to landscape or his watercolour style, even in its earliest manifestations, with that of Cox. Cox's use of big, energetic touches of colour to convey the natural dynamism of light and weather, seen in a work such as *The Vale of Clwyd* (fig. 5) of 1848, was antithetical to Hunt's own meticulous technique. And we sense in Hunt's appreciation of Cox, a note of reserve. Presenting Cox as a master of composition, he couches the assessment in terms of the public's attitude rather than his own personal response:

> There came a day, however, not very long ago, when it was discovered that nothing but genius could make the arts and artifices of 'composition' endurable. Turner, Cox, and several others were left unshaken on their thrones, but there was a strong disposition for a time to assign the highest of

12 *The Spectator*, 15 December 1877, p. 1580. After noting Cox's popularity, the reviewer went on to state: 'We hear frequently people who should be judges of Art say disparagingly of modern work that it isn't like Cox, and many people, following the lead of collectors and picture-dealers, imagine there is some weakness in the present style of painting, and that it is really less like nature than this painter's work. Now the truth is that the painting of the present day is really infinitely more like nature than Cox at his best ever was'.

13 The first book-length biography of Cox was Nathaniel Neal Solly's *Memoir of the Life of David Cox*, published in 1873. William Hall's *A Biography of David Cox* appeared in 1880.

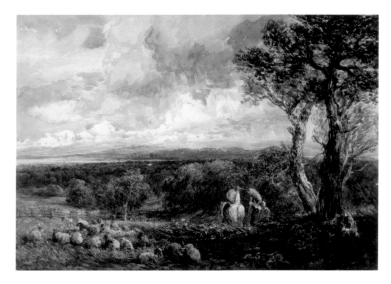

David Cox, *Vale of Clwyd*. British Museum (1915-3-13-23)

these thrones to Cox in right of his greater simplicity of composition. (Hunt 1891, pp. 219–220)

The bold and forceful brushwork of Cox's late style admirably captured certain effects of British weather to perfection, yet that achievement was seen as limited in scope: an almost fortuitous conjunction of style and subject, ringed-in by the artist's limitations. 'Men like Cox and Constable worked hard and well, but, if the phrase may be allowed, it was but a rough-and-ready likeness of nature which they set themselves to win.' (Hunt 1891, p. 221) This perception of Cox as a natural painter, without much in the way of insight or intellectual equipment, Hunt perhaps took from Ruskin.

In the first edition of *Modern Painters* I, Ruskin wrote appreciatively but condescendingly of Cox's art, at one point referring to the artist as 'simple-minded as a child.'[14] Ruskin's most positive comments on Cox's work appear in his *Academy Notes* on the Society of Painters in Water-Colours exhibitions of the 1850s, although generally coupled with warnings that such freedom of handling should not serve as a model for others. But in his *Lectures on*

14 Ruskin 1903-12, III, pp. 253-4.

Landscape delivered at Oxford in 1871, he paired Cox with Constable as representing 'a form of blunt and untrained faculty which in being very frank and simple, apparently powerful, and needing no thought, intelligence or trouble whatever to observe, and being wholly disorderly slovenly and licentious, and therein meeting with instant sympathy from the disorderly public mind now resentful of every trammel and ignorant of every law – these two men, I say, represent in their intensity the qualities adverse to all accurate science of skill in landscape art … .'[15] Hunt never took such a dim view of Cox's art or its influence; he could, however, suggest that Cox, but for limitations of training and infirmities of age, might have created works closer to Hunt's own:

> David Cox is said in his youth to have worked at a forge, or some craft which was more favourable to strength than to delicacy of hand, and, later on, at scene-painting, which was not especially favourable to delicacy of form or colour. Genius profits by its imperfections as well as triumphs over them, and we cannot imagine a wish that so grand a master of breadth and tone should have been one whit other than he was; but I can well recollect a certain fine summer's day, by a silver-bright stream, when he told me (it was in his later years of course) how glad he would have been to possess the fineness of hand which would have made it worth his while to try to deal with the exquisite jewellery of the lichened boulders and the dance of the ripples among them. (Hunt 1891, p. 221)

If one tries to imagine what such a picture must have looked like, it would perhaps be close to Hunt's *Rock Study: Capel Curig – The Oak Bough* (cat. no. 8), painted two years before Cox's death in the area of North Wales that Cox had visited regularly in the summers from 1842 to 1856.

Hunt noted that Cox's simple compositions were 'native wood-notes wild' compared with J.M.W. Turner's 'fully developed symphonies.' (Hunt 1880, p. 784) For Hunt, as for Ruskin, Turner was the hero of the narrative of landscape painting: the most complete master of the older English school of naturalistic painters and the beacon lighting the way for Hunt's generation.

15 Ruskin 1903-12, XXII, p. 58.

Where Hunt parted company with Ruskin was in acknowledging the importance for Turner of those very landscape forms and conventions of Claude that Ruskin had attacked in making his defence of Turner. Hunt wrote that all landscapes of Turner's day had been 'the culmination of a long course of traditional study and practice' of forms invented by the Old Masters and that 'no artist was more strongly imbued with the spirit of this learning than Turner.' (Hunt 1880, p. 784) Yet Turner was not simply recycling, however grandly or subtly, the inherited compositional frameworks of Western landscape tradition. If the presence of Claude can be felt in Turner's work to the very end of his life, there are wholly original compositions such as *Rain, Steam, and Speed* (fig. 6) that have a grandeur, a power, and a sense of inevitable rightness comparable to the Old Masters. It was Turner's achievement to remain true to the great landscape traditions, while rethinking their principles for a modern landscape art. And Hunt, in turn, seems to have set himself the task of emulating this achievement of Turner, while never resorting to simple imitation. The dynamic composition of Hunt's *Tynemouth Pier: Lighting the Lamps at Sundown* (cat. no. 32) is almost unthinkable without the precedent of Turner's *Rain, Steam, and Speed.*

It was as a watercolourist responding to the greatest exponent of the medium that Hunt came most profoundly under the influence of Turner. The harmonious integration of detail and atmosphere in Turner's more finished watercolours spoke directly to Hunt's own concerns, although again his technique never simply imitates Turner's. Turner's watercolour sketches were 'a series of experiments to discover with what system of colours it is possible to give the greatest amount of colour-truth consistently with truth of light and shade,' a process to which Ruskin served as an admirable guide. (Hunt 1880, p. 793)

Hunt concluded 'Modern English Landscape-Painting' with the ringing statement: 'It is only recently that a glimpse of the full scope of landscape art which was gained by the genius of one man, has become the common

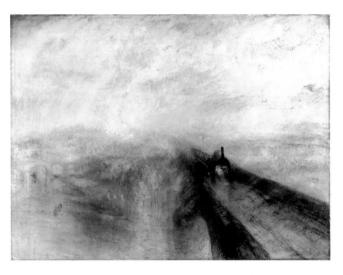

J. M. W. Turner, *Rain,
Steam and Speed*, exh.
1844. The National
Gallery, London.

property of all. We hardly yet perceive how great an equipment of gifts is
required to enable any one to follow in his footsteps, and possess himself of
any portion of the fair land which his eyes discerned.' (Hunt 1880, p. 794) It
is hard to be certain whether he was writing of Turner or Ruskin.

When Hunt returned to his theme in 1891, he made explicit in the title,
'Turnerian Landscape – An Arrested Art', that the artists who had followed
Turner had not significantly advanced the art. Yet he introduced the subject
not with Turner himself but with Ruskin's advocacy of Turner: 'Although
he [Ruskin] has assuredly quickened our perception and love of landscape
beauty – although he has made all the world admit the genius of one
supremely great landscape-painter, it cannot be said that he has made
modern painters see nature as that great artist did, or follow where he led.'
(Hunt 1891, p. 214)

In assessing the state of landscape art in the second half of the nine-
teenth-century, Hunt, either out of tact or political sensitivity, refrained
from naming names. In 1880, he listed the still living watercolourists
Edward Duncan (1803–1882), George Arthur Fripp (1813–1896), and

George Haydock Dodgson (1811–1880) as 'worthy to be ranked with the best of an earlier school,' but then said no more of them, as if their conservative adherence to an earlier style, though to some degree admirable, were an artistic dead end. He made no mention of his contemporaries who were pushing the art of landscape in new directions, such as John Brett (1831–1902), George Price Boyce (1826–1897), John William North (1842–1924), and Albert Goodwin (1845–1942); nor does he mention artists such as Thomas Collier (1840–1891), James Orrock (1829–1913), and Edmund Morison Wimperis (1835–1900), who were consciously reviving the art of Cox and his generation. In his second article, Hunt referred to the admirable painting of watery foregrounds by James Clarke Hook (1819–1907) and of animals by Henry William Banks Davis (1833–1914), but only to contrast their specialized and partial gifts with Turner's genius for creating a harmonious whole. Hunt also linked John Linnell (1792–1882), who had died between the publication of Hunt's first article, in which he is not mentioned, and his second article, with Cox and Turner as a triumvirate of grand old men of the landscape tradition 'in whose hands it attained what, I think, still remains its highest form.' (Hunt 1891, pp. 223–224) But the artist of the second half of the century to whom Hunt accorded the most discussion is Frederick Walker (1840–1875), of whom he asserted, 'I yield to none in admiration of his genius.' (Hunt 1891, p. 217) Yet for Hunt, Walker's genius did not lie in landscape, at least as Hunt defined landscape.

In 'Turnerian Landscape – An Arrested Art,' Hunt made a distinction between landscape proper, which is about the power and beauty of nature, and what he calls idyllic landscape, which has at its heart human interest. As representatives of landscape proper, he named Turner, Cox, and Linnell. The only practitioner of idyllic landscape that Hunt mentions by name is Fred Walker, whose *The Plough* (Hunt refers to it as *Ploughing*) he compares with Turner's *Frosty Morning*. The setting of the ploughman and his team in *The Plough* is not a landscape but 'a mere amplification of the ground which

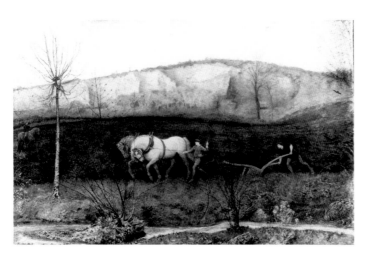

Frederick Walker, *The Plough*, exh. 1870.
© Tate, London 2004

a picture of ploughing required; it is not knit up artistically with either sky or figures.' *Frosty Morning*, on the other hand, is 'a true landscape,' even though Turner's figures are as large in proportion to the picture as Walker's. Turner's figures 'form part of a scheme which in colour unites them, cart, horses, and all, with the morning light, and in form with the leafless trees; with the line of distance – itself cunningly linked to the hedgerow and cart by spaces and depressions – and with the lines of hoar-frost on the ground' (Hunt 1891, p. 217).

Turner's harmony of light and colour in *Frosty Morning* represented an effective response to the perennial problem of balancing truth of colour with truth of light. It was a problem that Hunt felt many of his generation had either shirked or overlooked. 'Perhaps our impressionist friends are aware of it,' he wrote, 'and are feeling their way to deal with it in a rough fashion of their own.' (Hunt 1891, p. 223) It is interesting that Hunt should acknowledge impressionism as holding out some hope for a new revitalization of aspects of the painting of nature; however, for Hunt the salvation of landscape art had to incorporate the advances in naturalistic description of his contemporaries.

J. M. W. Turner, *Frosty Morning*, exh. 1813. © Tate, London 2004

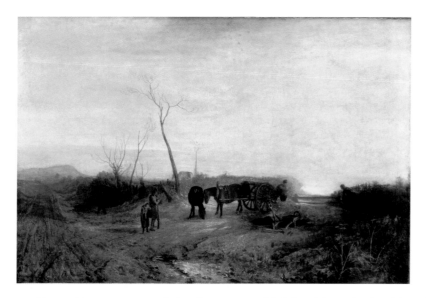

About his own art and the degree to which he felt he had achieved a union of the new heightened naturalism with the harmony, poetry, and breadth of vision that he so admired in Cox and above all Turner, Hunt remained silent. There is a sense of laboriousness or struggle in Hunt's art. Though intellectually rigorous, there is little feeling of spontaneity – of a natural, intuitive quality that must have appealed to him in the works of Cox and Turner and perhaps aroused a certain jealousy or at least longing. In both of his articles, Hunt conveys the sense of an expulsion from the paradise of a simpler, more direct, less intellectualized landscape art. Turner was a great intellect, yet one less painfully self-conscious in his relationship to both the natural world and the landscape tradition. Hunt recognized that the modern landscape painter could not go back; he did not argue for a return to past models or a renunciation of the developments of the last thirty or forty years. What he advocated, and what he at least partially achieved in his own art, was a painting that drew on the varied achievements of the whole century in the sympathetic representation of nature.

The Catalogue

CHRISTOPHER NEWALL

1

Wastdale Head from Styhead Pass 1853

Signed: *AW Hunt*

Oil on canvas, 91.4 x 71.2 cm; 36 x 28 in

HUNT VISITED the Lakes in the autumn of 1853, a painting trip that led to both *Wastdale Head* and the water-colour *Easdale, near Grasmere* (cat. no. 3).[1] Wasdale Head, down which flows the Lingmell Beck to Wast Water, lies between Great Gable and Scafell Pike. Sty Head marks the eastern perimeter of the valley, over which paths lead into the Borrowdale fells. Judging by the direction of light in the painting, the view seems to be looking towards the south or south-east; the upper part of the composition would therefore show the rocky walls of Great End.

Wastdale Head was Hunt's first exhibit at the Royal Academy in London, to which it was sent from his parents' house in Liverpool. It was apparently hung in a position where it was hard to see,[2] and seems to have gone largely unnoticed.

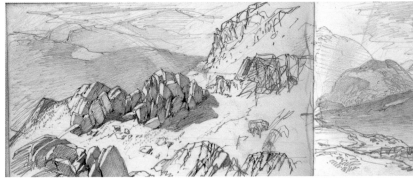

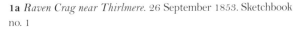

1a *Raven Crag near Thirlmere.* 26 September 1853. Sketchbook no. 1

Provenance: The artist until at least 1884; his daughter, Venetia Hunt, (Mrs W.A.S. Benson); Sadler Collection; Christie's, 8 February 1924 (110); (…) R. Lewty, by whom bequeathed, 1948

Exhibited: R.A., 1854 (317); R.B.S.A., 1882 (717, as 'Stye Head Pass, Cumberland'); London 1884 (105); London 2000 (194, as 'Styhead Pass, Borrowdale, in Autumn')

Literature: London 1884, p. 10; *Athenaeum*, 19 January 1884, p. 94; *Athenaeum*, 9 May 1896, p.625; Monkhouse 1897, p. v; Marillier 1904, p. 158

1 Also from this trip came an oil entitled *The Little and Great Langdales with Ellen Water and Lochrigg Tarn, from Lochrigg Fell* (Sotheby's Belgravia, 25 March 1975 (146)).

2 Edmund Gosse said that the work was 'skied at Trafalgar Square', and was seen in 1884 at the Fine Art Society exhibition 'practically, for the first time' (London 1884, p. 10).

Harris Museum and Art Gallery, Preston

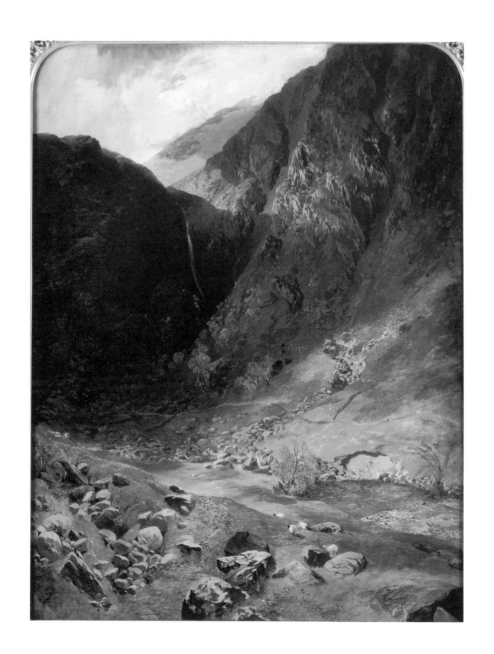

WASTDALE HEAD FROM STYHEAD PASS

2
Valley and Mountain Landscape c.1853

Signed and indistinctly dated: *AW Hunt 18..*
Watercolour, 26.1 x 38.3 cm; 10⅛ x 15⅛ in

T HIS APPEARS to be another drawing from Hunt's visit
to the Lakes in 1853. The distinctive 'U' shaped valley is
probably a view down Wasdale, from a vantage point on Sty
Head, looking towards the south-west.

2a *Stickle Tarn.* 10 October 1853. Sketchbook no. 215.

Provenance: Miss Annie
Symonds, by whom bequeathed,
1938

Ashmolean Museum,
Oxford. Symonds Bequest,
1938 (WA 1938.37)

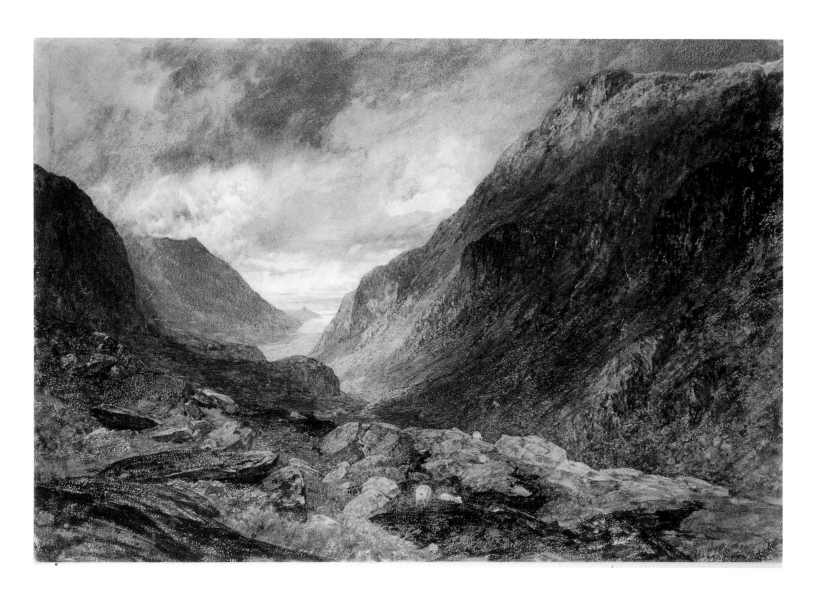

3
Easdale, near Grasmere 1853

Signed and dated indistinctly: *AW Hunt 18..*
Watercolour, 27.5 x 38.5 cm; 10⅞ x 15⅛ in

ALTHOUGH ILLEGIBLY DATED, this is probably the watercolour called 'Easedale' and dated 1853 shown at the Fine Art Society in 1884. It would therefore have been a product of the same Lakeland painting trip that led to *Wastdale Head from Styhead Pass* (cat. no. 1). Studies of Easdale Tarn dated to 10 October 1853 appear in a sketchbook devoted to a Cumberland tour.[1]

Easdale Tarn is a small body of water, lying below Langdale Pikes, on the eastern side of the mountain. Easdale Tarn feeds Sourmilk Gill, which joins the Rothay River, and which in turn flows into Grasmere.

Provenance: William J. Newall, by 1878 and until at least 1884; Hugh Frank Newall, F.R.S., by 1897; Robert Stirling Newall, F.S.A., by whom bequeathed, 1978

Exhibited: London 1878–9 (955); London 1884 (86); W.A.G., 1884 (566); Liverpool 1897 (54)

Ashmolean Museum, Oxford. Bequeathed by Robert Stirling Newall, F.S.A.,1978 (WA 1978.15)

1. Sketchbook no. 215.

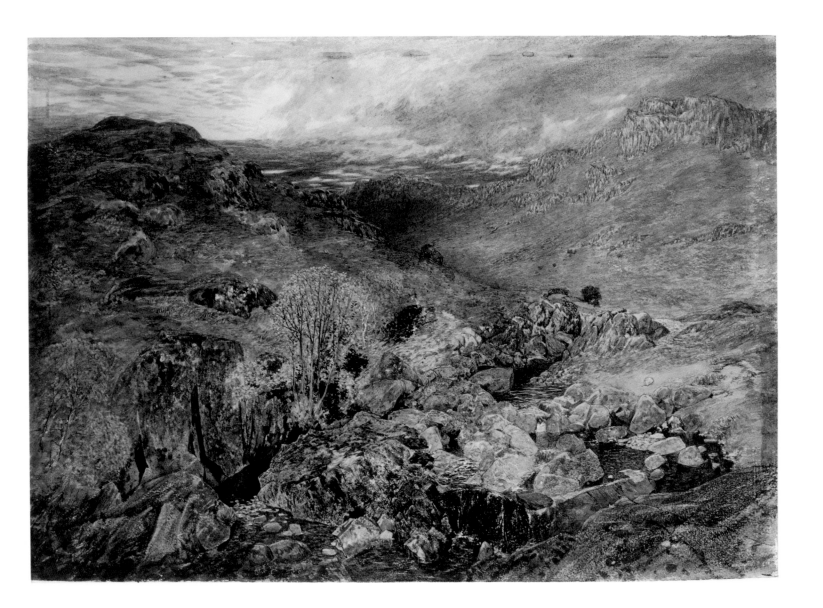

EASDALE, NEAR GRASMERE

4
View of Nantlle, Carnarvonshire 1855

Oil on canvas, 26 x 36 cm; 10¼ x 14¼

NANTLLE IS A SMALL TOWN to the south of Caernarvon in north Wales. It stands on the edge of the Snowdon range, with the mountain itself about six miles to the east. The countryside that lies between Nantlle and the coast to the west is of a rolling character, with winding lanes and trees. Close to the village is the Nantlle Uchaf lake, from which flows the Llyfni river.

Hunt's early visits to north Wales were encouraged by the Oxford printseller James Wyatt, who had created a market for his drawings of mountain landscapes. It seems that Wyatt contributed to the costs of these expeditions, and took a great interest in the particular locations that Hunt visited – at least to be able to explain to potential buyers where the places were. The two had presumably first known each other while Hunt was an undergraduate. The precise date of his first sponsored trip to Wales has not been established, but this view of Nantlle was doubtless the result of one of these expeditions. From the same painting expedition came *The Stream from Llyn Idwal, Carnarvonshire* (untraced), which Wyatt submitted on Hunt's behalf to the Royal Academy in 1856, and which received fulsome praise from Ruskin.

Provenance: Charles J. Moss, by whom bequeathed, 1914

Ashmolean Museum, Oxford. Bequeathed by Charles J. Moss (WA 1914.2)

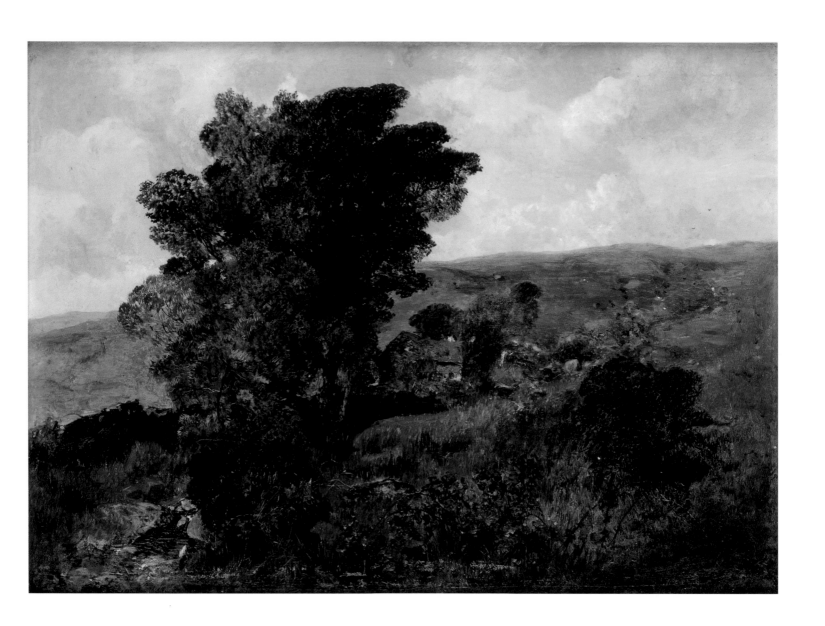

VIEW OF NANTLLE, CARNARVONSHIRE 59

5
Cwm Trifaen 1856

Signed and dated: *AWH 56*
Watercolour, 26.7 x 38.7 cm; 10½ x 15¼ in

Cwm Trifaen shows the hollowed upper end of a valley in Snowdonia. Surfaces of granite, smoothed and striated by the flow of ice in epochs of glaciation, are seen in the foreground, while elsewhere the ground is scattered with rock scree, loosened by the action of frost. The view is taken towards the south-west, with the peak of Glyder Fach appearing through mist on the horizon, and the flank of Tryfan showing on the right.

Hunt visited north Wales in 1855 (see cat. no. 4), and again in the following year. His particular interest in mountain subjects and the processes of physical geography may have dated from his years at the Liverpool Collegiate School, where the geologist and Bible scholar the Revd William John Conybeare was the principal. More immediately, in the fourth volume of *Modern Painters*, published in April 1856, John Ruskin sought to define laws of beauty on the basis of an observation of natural phenomena. Ruskin believed that all forms of landscape were to be seen as integral to the whole, subject to stupendous forces and moulded together into dense and complex patterns.

Cwm Trifaen was either commissioned by, or pre-sold to, William Greenwell, a canon of Durham cathedral and family friend of Hunt's future wife, Margaret Raine. Although dated '56', it was still in hand the following year. On 27 February 1857 Greenwell wrote to Hunt at his parents' house in Oxford Street, to propose a visit: 'I think I shall be able to get to .

Liverpool for one or two days at the end of March, you will be at home then, at work after Cwm Trifaen, which I hear from R [James Raine] is going to be a work worthy of yourself and the place. I hope those dogs at the Academy may do you justice this year'.[1] A letter from Hunt to Greenwell of 18 September 1857 shows that he was continuing to work in the mountains of Snowdonia (having perhaps by then embarked on the oil version of the subject, cat. no.12): 'Dear Greenwell[,] I am in the land of damp – of fog and mist – I know it to my cost. We have had nothing but … rain for the last fortnight – now the weather is holding up for a time, but the cold (in Cwm Trifaen) is unendurable. I've composed my epitaph – to be graven on the biggest stone of the biggest moraine there – We've survived "hanging" only to come to this … As soon as I have extricated myself from Cwm Trifaen I shall run away hence – these Indian matters [the rebellion in northern India against the East India Company that had broken out in the summer of 1857] make a man ashamed of grumbling … but campaigning here is really no joke'.[2] On 10 March 1858 Hunt wrote to Greenwell again: 'I think that it would be better not to exhibit the water-colour [presumably cat. no. 5]. It would give those fellows an excuse for mounting my picture as high as Hamon. Ruskin will see it in Durham better probably than he would in London. I can count on getting Cwm Trifaen [either cat. no. 5 or 6] finished now'.[3]

Provenance: William Greenwell, until at least 1884; William Kingsley, by 1897; (…) Phillips; Peter Nahum, from whom purchased by the present owner

Exhibited: London 1878–9 (964); London 1884 (80) (where mistakenly dated '1867'); Liverpool 1897 (135); New Haven 1992 (29); London 2004 (87)

Literature: *Athenaeum*, 11 October 1873, p. 470

The Robertson Collection, Orkney

1 Violet Hunt Papers.
2 Ibid.
3 Ibid.

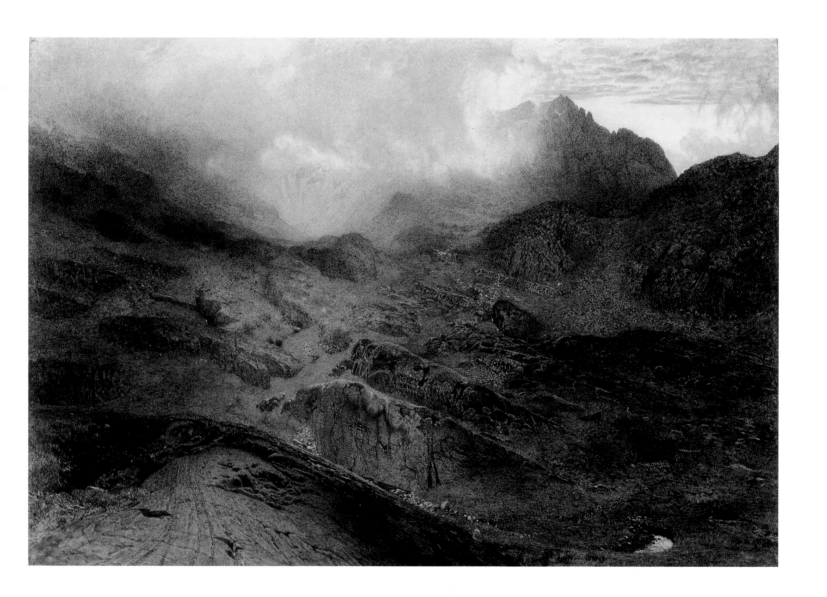

CWM TRIFAEN

6
Snowdon, after an April Hailstorm c.1857

Watercolour, 34 x 50 cm; 13⅜ x 19¹¹⁄₁₆ in

Tʜɪs ᴡᴀᴛᴇʀᴄᴏʟᴏᴜʀ sʜᴏᴡs the precipitous west flank of Snowdon, with the long ridge called Crib y Ddysgl running towards the north forming the horizon. The area in front of the massif is Cwm Glogwyn, while in the middle distance on the right is one of the three small lakes that lie in the bottom of the cwm – Llyn Nadroedd, Llyn Coch, and Llyn Glas. Hunt's vantage point was presumably somewhere on the col which forms the north-west edge of the cwm and over the steep edge of which flows a stream known as the Afon Goch. The view is the classic one, towards the south-east, although Hunt had climbed to a higher altitude and had reached a more forbidding painting environment than many of his predecessors.[1] Dense storm clouds are seen to the south, while light breaks through in the eastern sky.

Snowdon, after an April Hailstorm was shown at the Royal Academy in 1857. Ruskin described the meteorological effect in his account of the exhibited watercolour in his *Academy Notes*; what he considered to be 'a very remarkable drawing, and the best study of sky that I can find this year' was 'notable especially for its expression of the *consumption* of the clouds – not their driving away, but melting away in the warmer air'.[2]

With *An April Hailstorm* at the Royal Academy were two further works by Hunt, *Time and Tide* (a view of Harlech, now untraced), and *'When the Leaves begin to turn'* (a woodland subject, later in the collection of R.S. Budget, sold Christie's, 11 June 2004 (93)). Ruskin was outraged by the way these two paintings and the watercolours were displayed in Trafalgar Square, where they could hardly be seen. As part of his discussion of *'When the Leaves begin to turn'*, he speculated 'I do not know what kind of feelings the inferior painters of such subjects have whose works, by chance or right, are on the line this year in the principal rooms; but I think that if I had painted some of those well-shown foregrounds, I would rather have dashed my hand through my picture at once, than have left it in a good place while such a work as this was on the ground'.[3]

1 Richard Wilson, for example, painted Snowdon from the east in c.1765–6, but took a vantage point on the shore of Llyn Nantlle (versions in the Walker Art Gallery, Liverpool, and Castle Museum, Nottingham).
2 Ruskin 1903–12, XIV, p. 117
3 Ibid., pp. 116–7

Provenance: William Kingsley, by 1884 and bequeathed to his god-daughter, Silvia Hunt, Mrs Fogg-Elliott; by descent to the present owner

Exhibited: R.A., 1857 (761); Paris 1867 (Groupe 1, Classe 2, 38, as 'Snowdon après la grêle en avril'); London 1884 (61); London 1897 (28); Liverpool 1897 (115)

Literature: London 1884, p. 11; Ruskin 1903–12, xiv, p. 117

Private collection

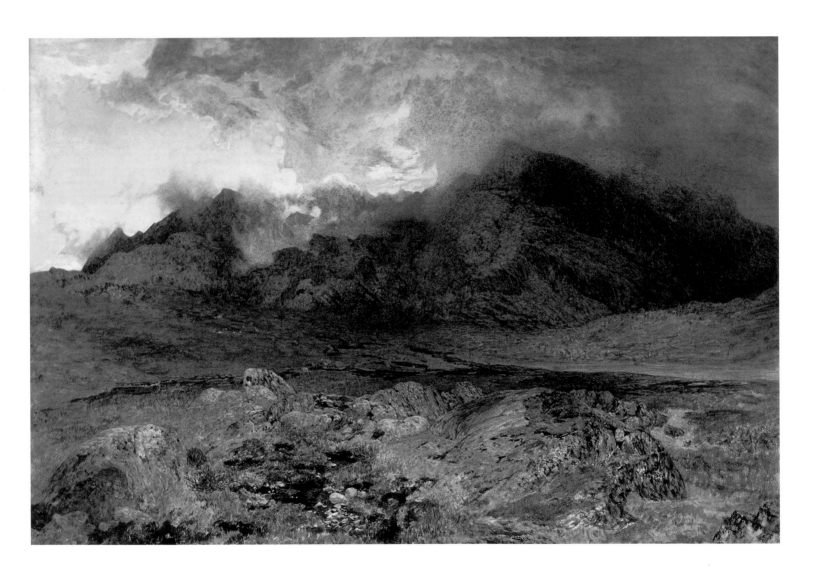

SNOWDON, AFTER AN APRIL HAILSTORM

7

Cornel Rhos – Spring 1857

Oil on canvas, 35 x 50.5 cm; 13⅞ x 19⅞ in

PRESUMABLY FROM THE SAME Welsh expedition as *Rock Study: Capel Curig – The Oak Bough* (cat. no. 8), *Cornel Rhos – Spring* shows a mountain stream flowing among lichen-covered boulders. 'Rhos' is a farmstead a mile to the south-east of Capel Curig and close to the hamlet of Pont-Cyfyng. The weather appears to be closing in, with storm clouds masking the distant hillsides. On more than one occasion, Hunt had cause to complain of what seemed to him the constant downpour that he experienced in Wales, blaming the weather for his own artistic difficulties. On 17 February 1859 he wrote to Margaret to say that a Welsh watercolour he was working on was 'turning out only tolerable. The old faults – Wales is a restless – fitful turbulent & unfinished place'. However, he still loved the mountains of Snowdonia; they had been 'the first sketching scenery I ever saw – and I cannot help the influence of that first sight'.[1]

Cornel Rhos – Spring was part of the distinguished collection of Pre-Raphaelite landscapes formed by the industrialist and metallurgist James Leathart, who lived in Gateshead on Tyne. Other landscape artists represented in his collection were William Davis, John William Inchbold, and Mark Anthony. In addition to the present oil by Hunt, Leathart owned a watercolour of *Lucerne* (see cat. no. 16). Leathart visited Hunt at his parents' home in Oxford Street, Liverpool, on some occasion in the late 1850s,[2] and was said to be interested in buying works by the artist that came up for sale from the collection of the Leeds stockbroker and philanthropist, Thomas Plint.[3] However, in later years, he seems to have been content to allow fellow north-easterners to take over as the main collectors of Hunt's work. It is likely to have been Leathart who recommended Hunt in the mid-1860s to Robert Stirling Newall, who was his neighbour at Low Fell, Gateshead.[4] By the late 1860s, Leathart was becoming increasingly reluctant to buy Pre-Raphaelite landscapes, as Inchbold found.[5] A few years later, he began to dispose of paintings from his collection, partly because of financial difficulties. Leathart still owned *Cornel Rhos – Spring* in 1884, when he lent it to the Hunt exhibition at the Fine Art Society, but had sold it by 1897.

1 Violet Hunt Papers.
2 In an undated letter from Hunt to Leathart, Hunt explained that he had sent off two drawings that Leathart had bought when they had met. One of these was probably *Lucerne* (cat. no. 16) (James Leathart Papers).
3 In an undated letter from William Greenwell to Margaret Hunt, he expressed dismay that James Leathart might buy works by Hunt at the Plint sale at Christie's in 1862: 'I am horribly annoyed at it though possibly Alfred may take it philosophically, but I think if that beast Leathart were to get *Time and Tide* [an oil view of Harlech] for £50 ... I should regret L. getting it more than anyone for he absolutely is entirely without taste, & is so vainglorious about his "refined" feelings' (Violet Hunt Papers).
4 James Leathart and R.S. Newall were neighbours at Low Fell, Leathart living at Bracken Dene, and Newall at Fern Dene (both houses are now demolished).
5 See Christopher Newall, *John William Inchbold – Pre-Raphaelite Landscape Artist* (exh. cat., Leeds City Art Gallery, 1993), pp. 19, 56, 58–9.

Provenance: James Leathart, until at least 1884; Hugh Frank Newall, F.R.S., by 1897; Robert Stirling Newall, F.S.A.; bequeathed to the Society of Antiquaries, 1978; from whom purchased by the present owner, 2004

Exhibited: London 1884 (103); Liverpool 1897 (194, as 'Cornel Rhos, near Capel Cûrig')

Private collection

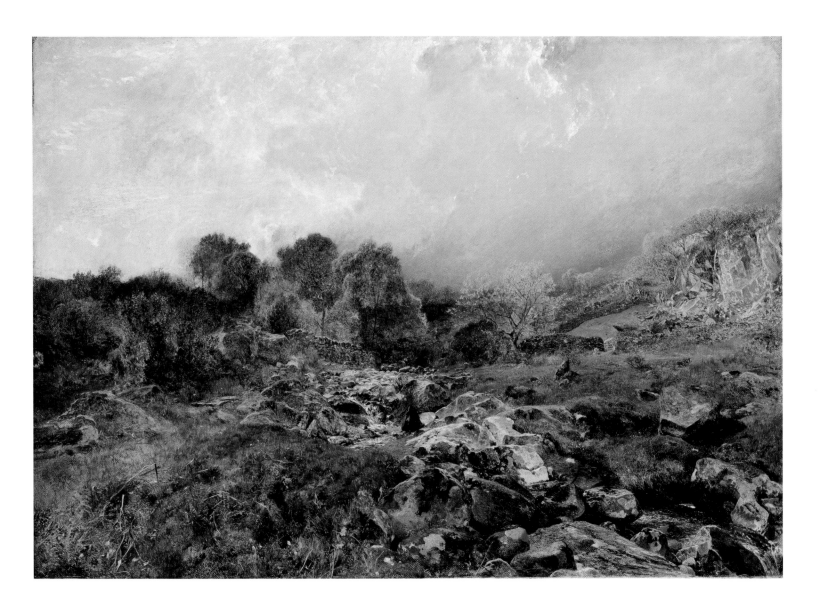

CORNEL RHOS — SPRING

8
Rock Study: Capel Curig – The Oak Bough
1857

Signed and dated: *AW Hunt 1857*
Watercolour, 25.7 x 37.2 cm; 10¼ x 14⅝ in

THE FRESH GREEN OF the oak leaves that form a canopy in the upper right part of the composition, and which lends colour to the filtered light cast over the eroded rock surfaces below, indicates that this drawing was made in early summer. No information survives about where Hunt stayed during his expedition to north Wales; then, as now, Capel Curig provided accommodation for travellers to the central ranges of Snowdonia.

The subject of the drawing is probably somewhere along the Llugwy river, which flows eastwards through Capel Curig, or one of the many tributary streams that cascade down the flanks of the Carneddau and Glyder ranges that rise to the north and south of the valley respectively. This was a landscape that Hunt had explored the previous year, when working on his watercolour *Cwm Trifaen* (cat. no. 5), the vantage point of which is some three miles to the west of Capel Curig, and which had inspired his oil *The Stream from Lyn Idwal* (untraced), exhibited at the Royal Academy in 1856.

The Oak Bough is a drawing that demonstrates Hunt's close adherence to the theory of landscape that Ruskin was promulgating in the late 1850s. In June 1857 Ruskin issued his manual of instruction for the use of professional and amateur artists, *The Elements of Drawing*. Whether or not Hunt had read (or was reading) this new text when he was painting *The Oak Bough*, passages in the book correspond closely to the type of subject in the watercolour. In the second chapter, Ruskin described particular subjects that he felt would reward the artist: 'If you live in a mountain or hill country, your only danger is redundance of subject. Be resolved, in the first place, to draw a piece of rounded rock, with its variegated lichens, quite rightly, getting its complete roundings, and all the patterns of the lichen in true local colour'.[1] Later in the book he described a variety of natural forms, from which he extrapolated aesthetic principles. For example, he drew the reader's attention to the painting of tree boughs, insisting on careful observation so as to 'feel the springiness of character dependent on the changefulness of the curve … For *all* tree boughs, large or small, as well as all noble natural lines whatsoever, agree in this character; and it is a point of primal necessity that your eye should always seize and your hand trace it'.[2]

Although Hunt was one of the artists whom Ruskin most frequently upbraided for attempting over complex subjects dependent on detailed observation, he does seem to have understood Ruskin's plea for simpler and less ambitious – and yet nonetheless truthful – landscape subjects. In the autumn of 1857 he wrote to William Greenwell: 'I do not think it is possible to have too many perfectly simple studies – transcripts … it would not matter what name was in the corner of the picture, so that the weeds – stones etc. which composed it would stand simple naturalistic tests'.[3]

The Oak Bough followed *Cwm Trifaen* into William Greenwell's collection. Hunt later borrowed it back to send to the Royal Academy: in an undated letter to Hunt, Greenwell wrote that he '[would] bring the Oak Bough with me at the end of March[;] that will be in time for the Academy will it not?' In the event, it was not shown; Hunt may have felt that the scale and delicacy of the work would not have been seen to advantage at a Royal Academy summer exhibition; or perhaps it was rejected by the selection committee. In February 1860, Hunt again wrote to Greenwell asking whether he would be willing to lend the drawing to the forthcoming Society of British Artists exhibition (where once again it did not appear). Greenwell later sold the drawing to his old friend and fellow clergyman, William Kingsley, who in turn gave or bequeathed it to his god-daughter, Silvia Hunt.

1 Ruskin 1903-12, XV, p. 110.
2 Ibid., XV, p. 179.
3 Ibid.

Provenance: William Greenwell; William Kingsley, by 1884 bequeathed to his god-daughter, Silvia Hunt, Mrs Fogg-Elliott; M. Amerye Fogg-Elliott; Norman D. Newall; his sale, Christie's, 14 December 1979 (191), where purchased by the present owner

Exhibited: London 1884 (92); London 1897 (46); Liverpool 1897 (171); London 1983 (32); New Haven 1992 (31)

Private collection

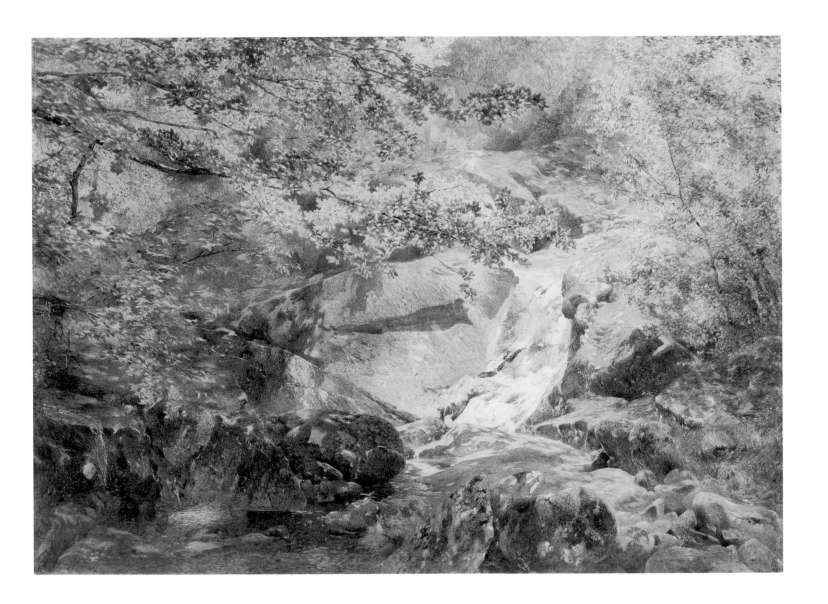

ROCK STUDY: CAPEL CURIG — THE OAK BOUGH 67

9

Harlech Castle – at Night 1856

Watercolour, 25.4 x 38.1 cm; 10 x 15 in

HARLECH WAS BUILT for Edward I (1272–1307) by his military architect, James of St George, as part of the chain of ten castles with which the English king intended to invest and control the rebellious Welsh. The building occupies a superb defensive position, with immediate access to a harbour (in the thirteenth century the sea approached the very foot of the rocky platform upon which the castle is built), so that it could be supplied or reinforced by sea. On its eastern or land side – from which direction attack was most likely to come – a pair of gateways and a double drawbridge provided defence. The fortress was built from a Cambrian granite, known as Harlech grit, quarried from the ground around the castle which was to form the moat. In the rebellion of 1294 against Edward's power in Wales, thirty-seven men defended it against an entire army. In the early 1400s Owen Glendower succeeded in taking the castle, against an occupying force of just forty soldiers – the so-called 'Men of Harlech' – and even then he would not have achieved his purpose without the crucial assistance of the French fleet, which cut off supplies from the sea. At the time of the English Civil War, Harlech remained strategically important and readily defensible; in 1647 it was to be the last Royalist position in Wales to fall to the Parliamentarians.

This view of Harlech shows the castle from the land side. The painter's vantage point was in the fields to the south of the town.

Private collection

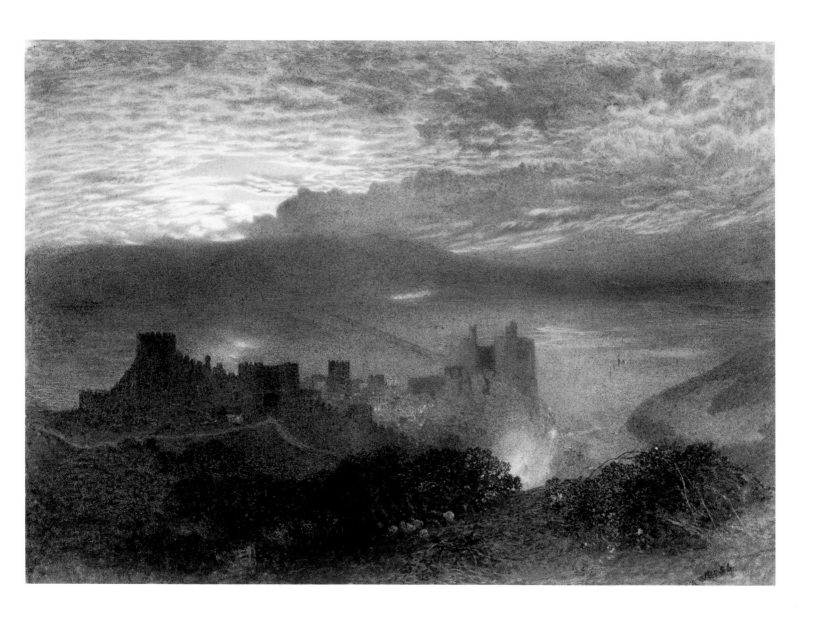

HARLECH CASTLE – AT NIGHT

10

Harlech Castle, North Wales late 1850s

Watercolour, 34 x 53 cm; 13¼ x 20⅞ in

I N W H A T W A S T O B E C O M E one of his favourite and most frequently repeated views, Hunt shows the massive fortification of Harlech Castle from the south, taking a vantage point on the hillside above the town. The more distant view shows the expanses of fields and dunes to the north, Tremadog Bay, and the estuary of the Dwyryd River. Even further in the distance, evoked by the faintest stain of colour, are the mountains of Snowdonia.

The watercolour is impossible to date precisely. It shows the view on a winter's afternoon: the south-western flank of the castle is bathed in a golden light; the leaves have fallen from the few trees that grow on the windswept headland; and smoke rises in a haze from the houses below.

Provenance: R. Bright, 70 Bold Street, Liverpool, by 1867; James S. Beale, 32 Holland Park; (…) Thos Agnew & Sons, 2003, from whom purchased by the present owner

Exhibited: Paris 1867 (Groupe 1, Classe 2, 38a as 'Château de Harlech'); Agnew, 2003 (72)

Private collection

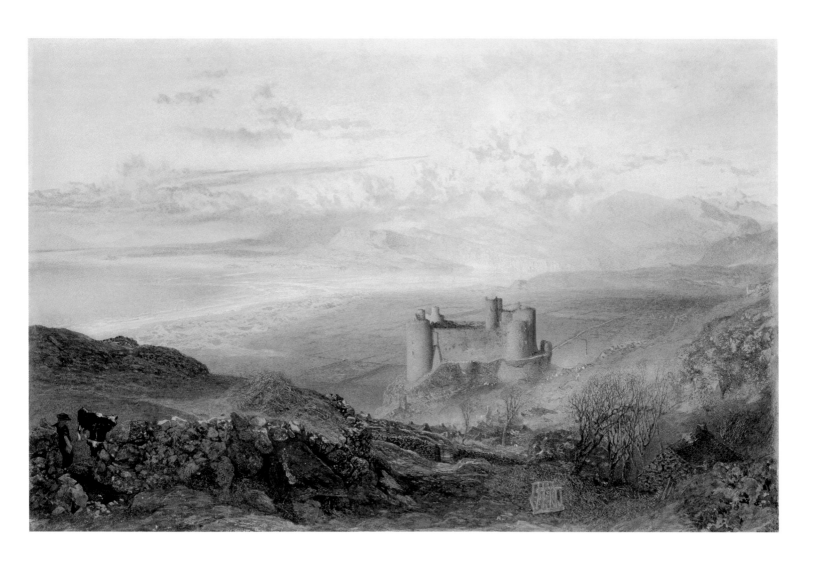

HARLECH CASTLE, NORTH WALES 71

11

Harlech 1857

Signed and dated: *AW Hunt 1857*

Watercolour, 24.6 x 32.9 cm; 9¾ x 13 in

Provenance: Richard St John
Tyrwhitt (?); Miss Mary
Tyrwhitt, by whom presented,
1945

Ashmolean Museum,
Oxford. Presented by Miss
Mary Tyrwhitt, 1945 (WA
1945.92)

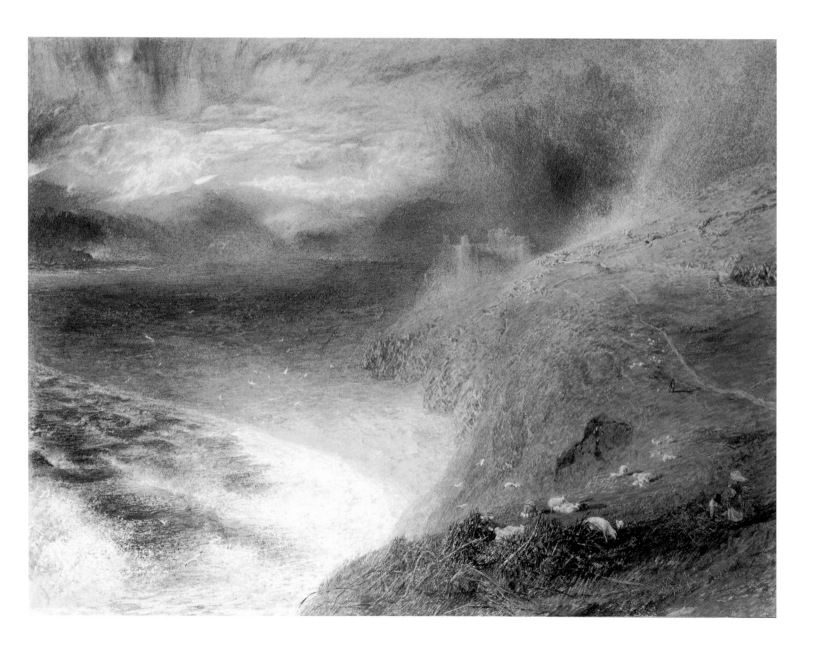

HARLECH 73

12

The Track of an Ancient Glacier – Cwm Trifaen 1857–8

Oil on canvas, 60.3 x 90.8 cm; 23⅞ x 35⅞ in

HUNT MAY HAVE begun this view of the glaciated valley or cwm that forms the north-eastern flank of Glyder Fach (compare cat. no. 5) in the autumn of 1857, but he completed it in 1858. In the left foreground is a smoothed surface of the granite bedrock, with fissures showing in the igneous rock and also striations which had been gouged by jagged boulders embedded in the under-surfaces of the glaciers that had lain over the landscape in the last Ice Age. The oil differs from the watercolour in showing in the middleground a boiling turmoil of rock, parts of which are caught in transient gleams of light. Hunt probably worked it up in the studio, on the basis of the watercolour, and of pencil sketches that he had made on the spot in 1856.

In *Modern Painters* IV, published in April 1856, Ruskin described the Alpine landscape on the basis of an understanding of how the mountains had been formed and of his own familiarity with their geological character, data which make clear his own commitment to the contemporary debate about how the face of the Earth reveals past epochs. Glaciation, and indications of phases in the earth's history when the Alpine glaciers had been deeper, more numerous and far longer – as seen in the smoothing of surfaces of rock, or elsewhere by deeply cut striations across strata – are one of the themes of the book. For example, in the chapter 'The Central Peaks', Ruskin explained that 'over the whole of the rounded banks of lower mountain, wherever they have been in anywise protected from the injuries of time, there are yet visible the tracks of ancient glaciers. I will not here enter into detail respecting the mode in which traces of glaciers are distinguishable. It is enough to state that the footmark, so to speak, of a glacier is just as easily recognizable as the trail of any well-known animal; and that with as much confidence as we should feel in asserting that a horse had passed along a soft road which yet retained the prints of its shoes, it may be concluded that the

glaciers of the Alps had once triple or quadruple the extent that they have now'.[1]

Ruskin saw Hunt's painting, the title of which was taken from his text, some time in the spring of 1858, presumably before it was sent to the Royal Academy. On 16 May he wrote to Hunt from France, with observations on a picture that was, in his view, 'of course a wonderful one – very wonderful and [one that had given him] intense pleasure in looking at it, bit by bit'.[2] Even so, Ruskin criticised the work on three grounds: first, that there was a compositional confusion between the lit and shadowed areas; second, that the artist's technique depended too much on the stippling of colour in tiny speckled touches; and third, that Hunt had chosen far too ambitious a subject: 'You have here a waste of stone – every part of which repeats & weakens the rest'.[3] In the event, the painting was rejected by the Royal Academy, perhaps in revenge for Ruskin's remarks about the bad hanging of three of Hunt's works in 1857 (see cat. no. 6).

Hunt seems to have put the painting aside until the autumn of the following year – when he worked on it again, apparently attempting to correct passages that he had introduced in preparation for its submission to the Academy. On 23 November 1859 he wrote to Margaret: 'I am sending Cwm Trifaen to the Hogarth [Club] being on the whole pleased with my attempt to bring it back to its Pre-Academical beauty – for I begin to believe that it really was a fine work before it was spoilt'.[4]

Provenance: Humphrey Roberts, by 1884 (but not included in the sale of his collection at Christie's, 21 May 1908); (…) William J. Newall; his sale, Christie's, 30 June 1922 (83) (56 guineas); (…) Violet Hunt, by whom bequeathed, 1942

Exhibited: Hogarth Club, 1859; Portland Gallery, 1860 (90, as 'Track of an Old-World Glacier'); London 1884 (112)

Literature: Wedmore 1891, p. 106; *Athenaeum*, 9 May 1896, p .626; Marillier 1904, p. 160; Secor 1982, pl. 7; Staley 2001, pp. 196–7, pl. 156

© Tate London 2004 (N05357)

1 Ruskin 1903–12, VI, p. 211.
2 quoted Secor, 1982, p. 22.
3 Ibid., p. 23.
4 Violet Hunt Papers.

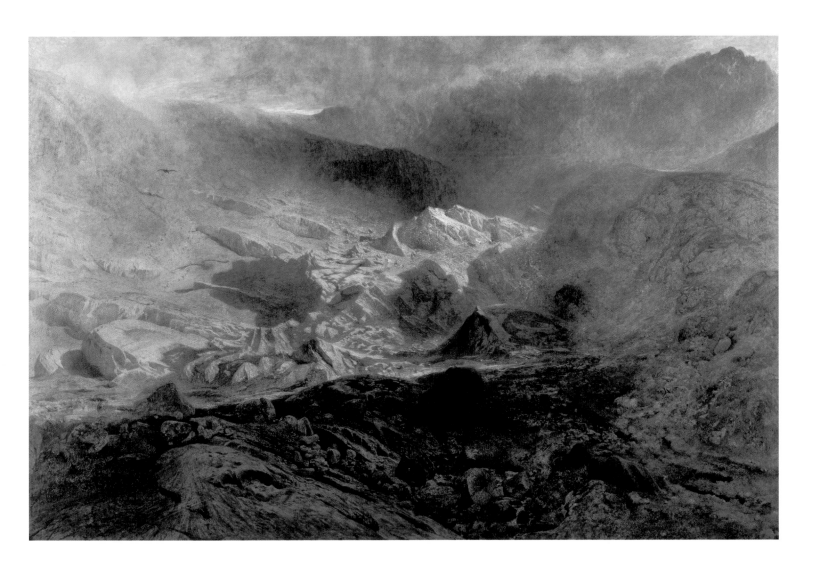

THE TRACK OF AN ANCIENT GLACIER — CWM TRIFAEN

13

A Rocky Stream-bed 1858

Signed and dated: *AWH 1858*
Watercolour, heightened with gum and touches of bodycolour, 27.3 x 38.1 cm;
10⅞ x 15 in

T HE INTENSE GREENS and brightness of dappled sun-
light suggest that this watercolour was made in the high
summer. Although the location of the subject is not indicated,
in August 1858 Hunt was working at Greta Bridge, and stay-
ing at the Morrells Arms. It seems likely therefore that the
watercolour shows the River Greta.

Provenance: (…) Chris Beetles;
David Fuller; his sale, Christie's,
7 April 2000 (14), where pur-
chased by the present owner

Private collection

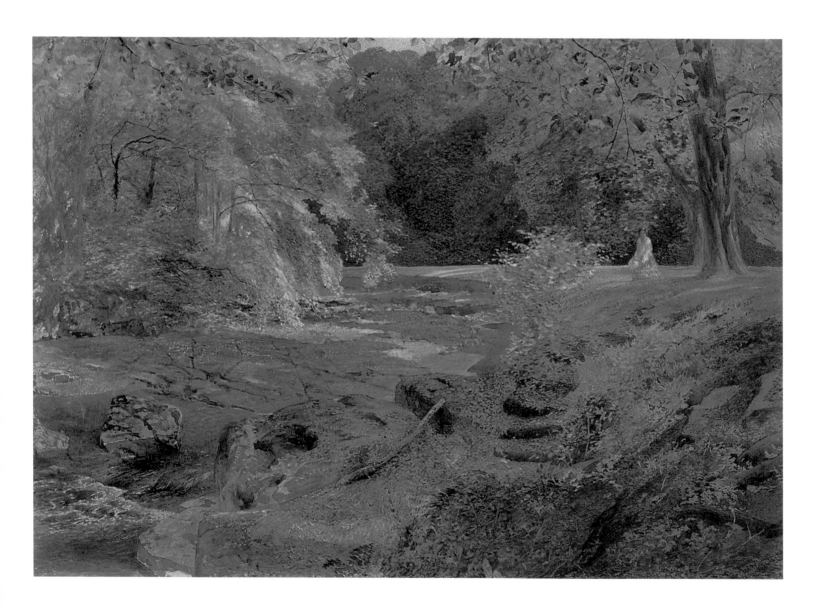

14

The Tarn of Watendlath, between Derwentwater and Thirlmere 1858

Signed and dated: *AW Hunt 1858*
Watercolour with bodycolour and scraping out, 32.2 x 49.2 cm; 12¹¹⁄₁₀ x 19¼ in

SINCE HIS ELECTION as a Fellow of Corpus Christi College, Oxford, in November 1857, Hunt had devoted the university vacations to painting. In the summer of 1858 he worked first in County Durham in August, and seems to have moved on to the Lakes later in the season, perhaps in September. The colour of the bracken in his view of Watendlath certainly suggests that the autumn was coming on.

Watendlath Tarn is a small body of water on the fells to the west of Thirlmere and to the south-east of Derwentwater.

The Watendlath fells lie on the western flank of a long line of mountains running southwards from Keswick and terminating in Langdale Pikes. Hunt's precise vantage point for this watercolour was a hillside known as The Pewits, at the head of Raise Gill (the rocky ravine and cascading beck leading down to the tarn below in the right foreground), looking towards the west. Watendlath is now a property of the National Trust.

Provenance: Charles Booth, by 1897; (…) Sotheby's, 10 April 1969 (161); P. & D. Colnaghi, from whom purchased

Exhibited: Liverpool 1897 (44); London 1993 (173)

Literature: Wilton 2000–2001, p. 51, fig .28

The British Museum, London (1969–9–20–1)

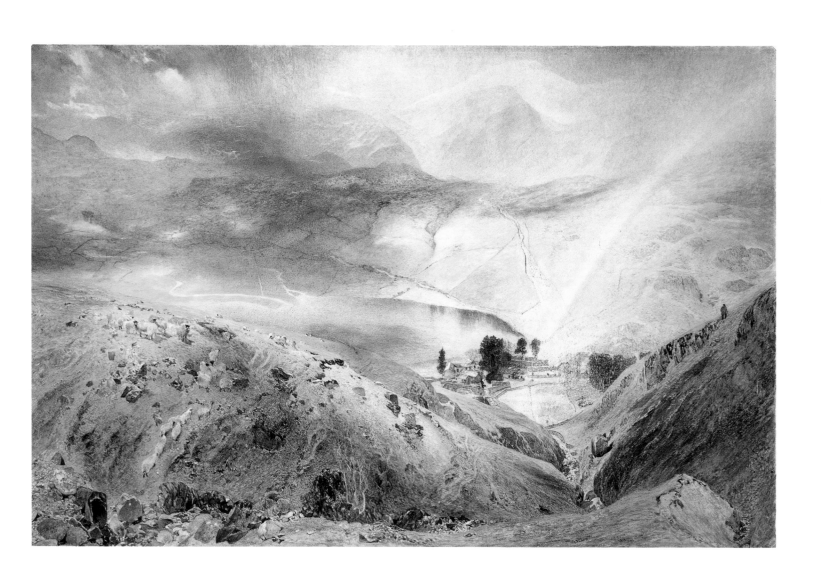

THE TARN OF WATENDLATH, BETWEEN DERWENTWATER AND THIRLMERE

15
Thun, Switzerland c.1859

Watercolour, 24 x 37 cm; 9⅜ x 14⅝ in

THUN STANDS AT THE NORTH-WEST end of the Lake of Thun, at the point where the Aare flows from the lake. Hunt shows the relatively calm water of the lake itself – reflecting the shapes and colours of buildings, mountains and stormy sky – and, beyond a kind of breakwater, the agitated and fast-flowing currents of the river. The two principal buildings shown in the drawing are the Schloss Zähringen, the Romanesque keep and turret, with four attached towers, of which dominates the town; and the Stadtkirche, which has an octagonal bell-tower roofed with distinctive round-patterned tiles. Hunt was, consciously or unconsciously, following in Turner's footsteps. Turner's drawing of Thun, taken from approximately the same angle as Hunt's but from further back,[1] seems to date from a Swiss tour in 1841.

Although not dated, Hunt's view of the town of Thun was almost certainly the outcome of the same painting expedition that produced his watercolour *Lucerne* (cat. no.16). No mention is made of a visit to Thun in surviving letters to Margaret, but we do know that he intended to travel quite quickly from Lucerne to Heidelberg, and then back to Gräfrath, in August 1859, so he may well have gone there first.

Thun was shown at the Old Water-Colour Society in 1862, the first year of Hunt's associate membership. Presumably it did not sell, and was therefore available to send on to the exhibition of the Liverpool Academy.[1]

Provenance: Daniel Oliver, F.R.S., by 1884 (?); Hugh Frank Newall, F.R.S.; Walker's Galleries; (…) Julian Hartnoll; Sotheby's Belgravia, 12 December 1978 (44), where purchased by the present owner

Exhibited: O.W.-C.S., 1862 (221); L. A., 1862 (700); London 1884 (1, as 'Thun – Morning') (?)

Literature: *Athenaeum*, 26 April 1862, p. 567; *Athenaeum*, 9 May 1896, p. 626

1 Wilton 1979 (1504).

Private collection

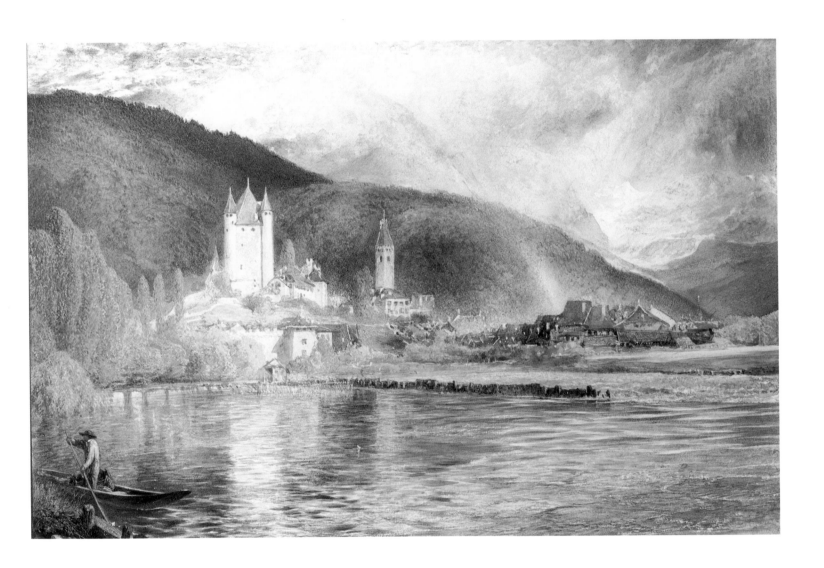

THUN, SWITZERLAND

16

Lucerne 1859

Watercolour, 31 x 48.5 cm; 12⅕ x 19¼ in

Hunt's vantage point in his view of Lucerne was
the bridge crossing the Reuss at the centre of the city.
The ranges of buildings on the left are those that line the
north bank of the river; the early seventeenth-century façade
with dormer windows and a tower is the Altes Rathaus. At the
centre of the composition is the Kapellbrücke, the famous cov-
ered bridge that runs for 200 yards across the Reuss close to
the point where it joins the lake. Standing beside it is the
octagonal tower known as the Wasserturm, with its distinctive
red tiled roof. In the distance to the east, about six miles away,
is the Rigi, on the north-western side of Lake Lucerne.

Hunt was in Switzerland during July and August 1859, and
wrote a series of letters to Margaret at Gräfrath in Germany.
On 3 July he explained the difficulties he was finding in locat-
ing a suitable vantage point from which to paint the city:
'Turner confound him has gone & done the finest view in the
only way in which it can be done – and my eyes do trouble me
sadly when I come to architecture, & details of that kind'.[1]
Nonetheless, in August Hunt could report to Margaret: 'This
place is … beautiful to look at certainly – and one which I
could get something very good out of after three weeks
study'.[2] Among the Turner drawings that Ruskin had put on
display at the National Gallery in London in 1857, and which
he had described in catalogue notes, was a series of views of
Lucerne. Hunt's own view of the town broadly corresponds to
that which Turner had made in 1843, entitled *Lucerne: Moon-
light*,[3] then in the collection of H.A.J. Munro. Ruskin owned a
further sketch by Turner that shows some of the same
architectural elements as Hunt's watercolour.[4] It may well

be that in planning his tour of Germany and Switzerland,
Hunt had in mind places that he knew from Turner's draw-
ings, or which had been specifically recommended to him by
Ruskin. Hunt may have remembered Ruskin's fears, expressed
in the fourth volume of *Modern Painters*, that the town would
be spoilt by new buildings ('I can foresee, within the perspec-
tive of but a few years, the town of Lucerne consisting of a
row of symmetrical hotels round the foot of the lake, its old
bridges destroyed, [and] an iron one built over the Reuss').[5]

Hunt sold two drawings – almost certainly including cat.
no. 16 – to James Leathart, as is recorded in an undated letter
from the artist, written from his parents' home in Liverpool: 'I
have forwarded this day by passenger train the two drawings
which you said you would like to have when you were in Liver-
pool. The price of the two will be 15.15.£'.[6] Some years later
he wrote to Leathart to ask whether he might borrow one of
the two: 'Would you do me the favour of lending me the draw-
ing of "Lucerne" which you have of mine for exhibition this
year [?] I should be very much obliged to you if you would'.[7]
In 1864 Hunt had been elected a full member of the Old
Water-Colour Society, and presumably he wanted to show
what he regarded as his very best drawings, even including
one that was by then five years old and which would not be for
sale. Leathart agreed to the loan,[8] and the watercolour was
admired for 'the force and brilliancy as well as the truth [that]
commend it to all'.[9]

1 Violet Hunt Papers.
2 Violet Hunt Papers.
3 Wilton 1979 (1536).
4 Ibid., (1471).

5 Ruskin 1903–12, VI, p. 456.
6 James Leathart Papers, University of British Columbia.
7 Ibid.
8 For some reason, record of the appearance of this drawing at the 1864
 exhibition is omitted from the lists of Hunt's exhibits that are given in Hunt
 1924–5.
9 *Athenaeum*, 30 April 1864, p. 618.

Provenance: James Leathart; Fine
Art Society, by 1884; Norman
Charles Cookson, by 1897; (…)
Bonham's, 22 July 1981 (161);
Chris Beetles, from whom pur-
chased by the present owner

Exhibited: O.W.-C.S., 1864 (127);
London 1884 (39 or 67); London
1897 (7); Liverpool 1897 (106)

Literature: Newall 1987, p. 16, pl. 8

Private collection

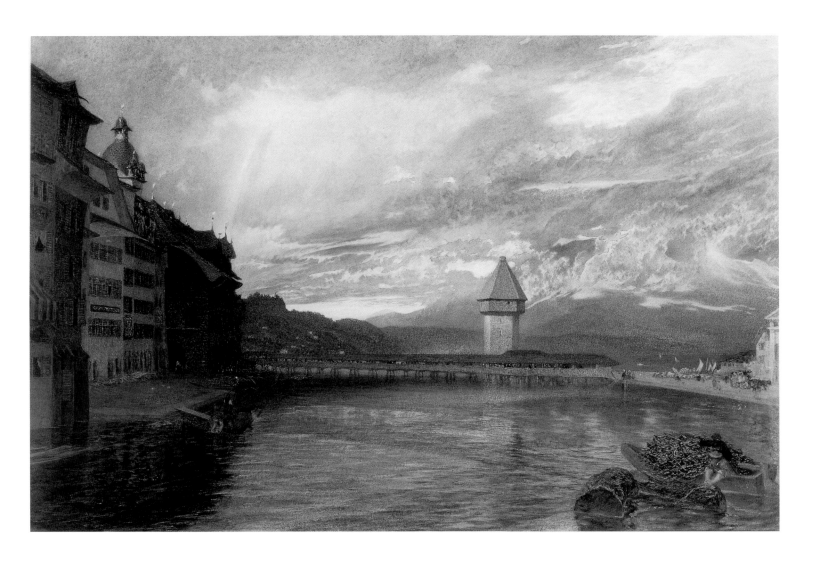

83

17

Heidelberg 1859

Watercolour, 27.7 x 40.7 cm; 10¾ x 16 in

Hᴜɴᴛ ᴠɪsɪᴛᴇᴅ ʜᴇɪᴅᴇʟʙᴇʀɢ in August 1859, in the course of his journey through Germany and Switzerland that summer. His vantage point was the north bank of the Neckar close to Neuenheim, looking towards the east. The majestic stone bridge that crosses the Neckar is on the left, and in the town itself is seen the tower of the Heiliggeist-kirche. Standing above the town is the great Renaissance castle, once the residence of the Electors Palatine but sacked in 1689 by the armies of Louis XIV of France.

The view of the city was one that had been taken by many artists before Hunt, notably by Turner, whose two ambitious watercolours of the early 1840s – *Heidelberg, with a Rainbow*, and *Heidelberg, Sunset*[1] – are close in angle and perspective to Hunt's, although taken from a greater distance and offering a wider panorama. Hunt may have known one or other of these watercolours, or the splendid engraving *Heidelberg from the Opposite Bank of the Neckar*, made by Thomas Abel Prior after Turner's *Heidelberg, with a Rainbow*.[2] He may also have noticed the five sketches of the town that Ruskin included in the display of Turner drawings at the National Gallery in 1857, although none of these corresponds closely to the view taken by Hunt.

F.G. Stephens saw *Heidelberg* in 1873, and described it in one of a series of articles on private collections in the *Athenaeum*: 'An amazing amount of learning, care, and skill has been employed in this effect, which is so truly rendered, that every inch of the water can be studied and the source of its splendid colouring detected, and yet nothing can be broader and finer as a whole'.[3]

1 Wilton 1979 (1377 and 1376, respectively).
2 see Powell 1995, pp. 197–8.
3 *Athenaeum*, 27 September 1873, p. 408.

Provenance: Robert Stirling Newall, F.R.S., by 1884; Mary Newall, by 1897; Frederick Stirling Newall; Lionel Newall; (…) Christie's, 14 May 1985 (166), where purchased by the present owner

Exhibited: London 1884 (85); Newcastle upon Tyne 1887 (919); London 1897 (9); Liverpool 1897 (127); Newcastle upon Tyne 1989-90 (55); Tokyo 1993 (211)

Literature: *Athenaeum*, 27 September 1873, p. 408

Private collection

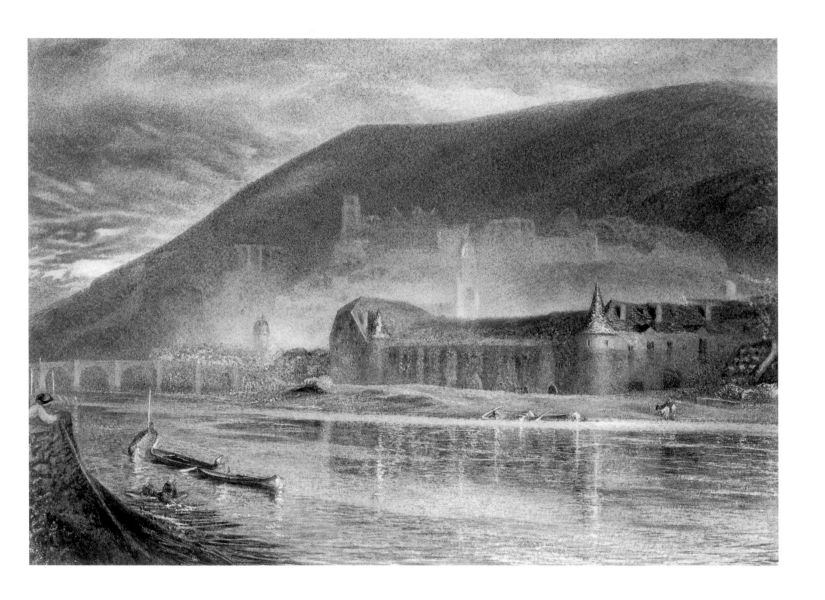

18

A Bend of the Moselle - Brodenbach 1860

Signed and dated: *Alfred Hunt 1860*
Watercolour and bodycolour, with scratching with a reversed brush,
25.2 x 36.5 cm; 9¾ x 14⅜ in

H UNT RETURNED TO GERMANY in the summer of 1860, to see Margaret, who had remained at Gräfrath since the previous year, and to look for new painting subjects in the Rhineland. Brodenbach is a small town on the south bank of the Mosel River, about ten miles from the river's confluence with the Rhine at Koblenz. Hunt was there in July 1860,[1] just prior to his visit to Burg Eltz (see cat. no. 19), which is six miles to the east. The landscape appears almost autumnal, with foreground grasses dried out by the heat of the sun, and with knapweed and yarrow among the wildflowers. Late season haymaking is taking place; on the right a figure carries mowed grass on a pitchfork. Hunt has indicated terraces, running horizontally on the distant hillside – presumably planted with vines. Despite the evident quality of the work that Hunt did in Germany in 1860, he was as ever wracked with doubts, as he explained to Margaret in a letter of 17 July: 'I can't talk about my work dearest. I am only spoiling bits of paper, and only keep myself from getting blue over said bits of paper by beginning ever new ones, and steadily resolving to do my best & to think that I have done so'.[2]

Hunt later sent this drawing of Brodenbach, with four others, to James Wyatt in Oxford for display in his shop in the High (a number '4' inscribed on the drawing's margin beneath the mount presumably dates from the time of this shipment). Any drawings that Wyatt did not think he could sell were to be sent on to another dealer, a Mr Crofts. Hunt wrote to Margaret on 14 January 1861: 'I find that Wyatt has taken the large Gräfrath and that Moselle sketch of an ugly surly piggish-shaped hill with meadow flowers in the foreground'.[3] By this time Hunt expected higher prices for his drawings, making Wyatt somewhat less enthusiastic about such consignments, as the painter explained: 'He says he is afraid my prices now will not admit of much margin for profit & interest etc. so that you may put sold "on your list" against the "Brodenbach" and the "Cobern Village" at 14.14/ each'.[4]

1 A letter written to Hunt at Brodenbach, from Margaret at Gräfrath, and dated 4 July 1860 (Violet Hunt Papers), provides this date.
2 Violet Hunt Papers.
3 Ibid.
4 Ibid.

Provenance: With James Wyatt, 1861; (…) Sotheby's Belgravia, 8 March 1977 (27), where purchased by the present owner

Private collection

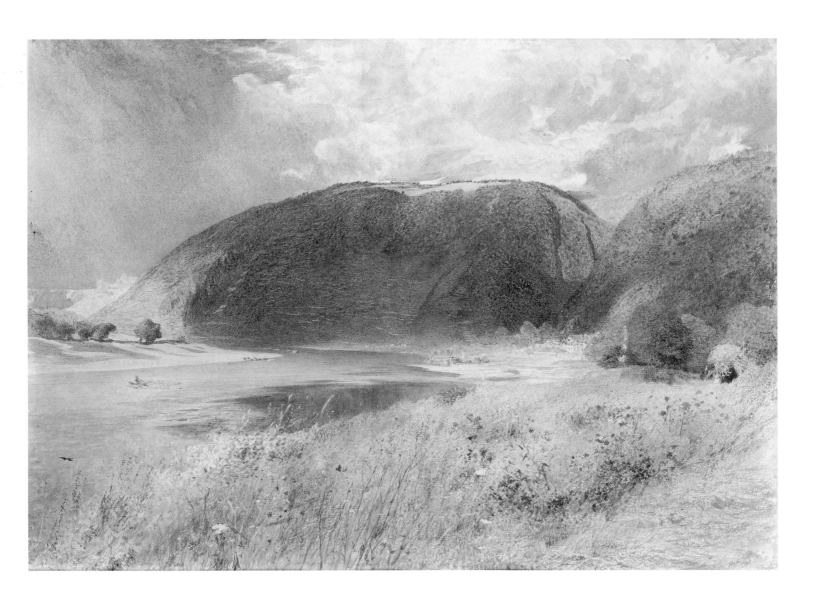

A BEND OF THE MOSELLE — BRODENBACH

19

Schloss Elz 1860

Watercolour, 46 x 60 cm; 18¼ x 23¾ in

O N 26 JULY 1860 MARGARET wrote to Hunt: 'I am glad you got my letter so quickly and so very glad that Schloss Elz pleases you'.[1] Burg Eltz, where Hunt had found the fabulously romantic castle, stands in the narrow, sinuous, and steep-sided ravine of the Eltz about four miles from its confluence with the Mosel at Moselkern. The view is towards the north-west, from a vantage point that allows the castle and valley bottom to be seen from above. Light from the western sky shines over the high roofs of the castle and defines the outline of the great rock upon which its twelfth-century foundations were laid. At the right of the composition, on the summit of the northern flank of the Eltz valley and directly opposite the schloss, can be seen the remains of the Trutz Eltz or Baldeneltz, a fortification built in 1331 by Archbishop Baldwin of Trier when he laid siege to Burg Eltz, which was the ancient demesne of the Counts of Eltz. In the ravine below is the bridge that provided the only access to the castle, its shape outlined against the sunlit meadow beyond.

Turner visited Burg Eltz twice, in 1840 and *c*.1841–2, on the second occasion exploring the valley below and walking all round the rock on which the castle stands. One of his sketches[2] shows the building from a similar angle to Hunt's view, but from a much lower position. Most other artists who visited the place seem to have been content to paint or draw the castle from a point close to the Trutz Eltz, perhaps because a convenient viewing platform had been constructed there. Clarkson Stanfield used this vantage point to make drawings that led to a lithograph in his *Sketches on the Moselle, the Rhine, & the Meuse* (1838), while Turner sketched from the same position in 1840.[3] In about 1867 Cundall & Fleming photographed the castle, but again from a position to the north and from a vantage point directly above the bridge.[4]

F.G. Stephens greatly admired Hunt's watercolour. In an account of the collection of Edward Quayle, of Claughton near Liverpool, he wrote: 'We regard this as a masterpiece by one of the most poetic and original of our landscapists, working in the best of his youthful prime. Even Turner, who painted the Schloss … hardly surpassed the fineness and infinite variety of the colours and tones of the atmosphere, or graded them with more subtlety'.[5]

1 Violet Hunt Papers (Margaret spelt the place name without a 't', which also how it was given in the catalogues of the four nineteenth-century exhibitions in which the drawing was shown).
2 Wilton 1979 (1334); Powell 1995 (112).
3 See Powell 1995, pp. 151-2, for an account of this visit, and reproductions of the two sketches that he made of Burg Eltz from close to Trutz Eltz.
4 See *Viktorianische Photographie* (exh. cat., Neue Pinakothek, Munich, 1993), p. 71.
5 *Athenaeum*, 18 September 1886, p. 377.

Provenance: Edward Quayle; Gilbert W. Moss, by 1897; William J. Newall; Doreen Berry, by whom bequeathed to the present owner

Exhibited: O.W.-C.S., 1863 (151); Manchester 1887 (1317); London 1897 (72); Liverpool 1897 (136); Munich 1993 (58); Madrid 1993 (58)

Literature: *Art Journal*, 1863, p.119; *Athenaeum*, 18 September 1886, p. 377; Dibdin 1897, p. 34

Private collection

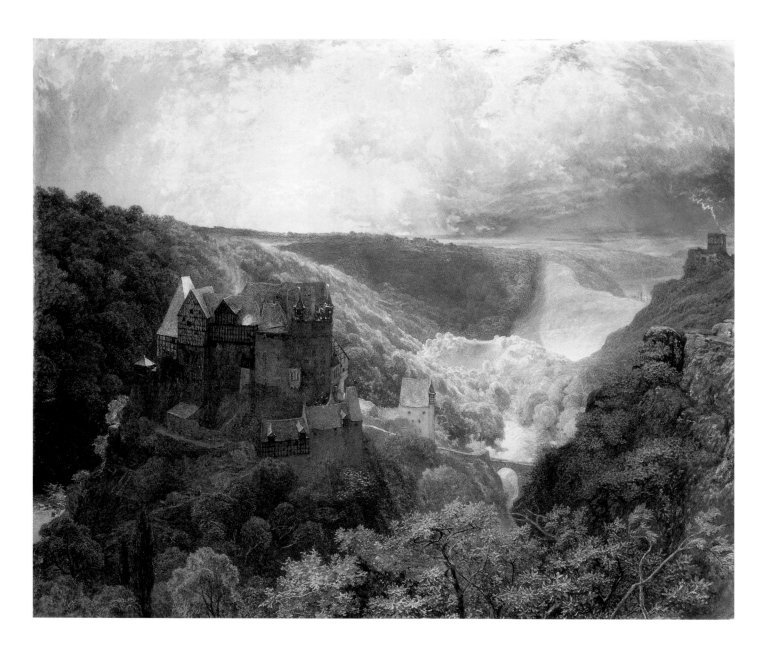

SCHLOSS ELZ

20
*Rhine – Steam-Tug with Barges c.*1860

Signed : *A.W. HUNT*, and inscribed on reverse: *Rhine. Steam tug with barges*
Pencil and watercolour, heightened with gum Arabic and with scratching out,
19 x 27.9 cm; 7⅛ x 11 in

T HE SPECIFIC LOCATION of this extraordinary view of
the Rhine, with a brilliantly coloured sky and with
points of light from distant settlements reflected in the surface
of the water, is not identified by an inscription or in its exhib-
ited title. It may, however, be recognised as a view from the
west bank of the river close to Koblenz, with the massive mili-
tary fortifications of Ehrenbreitstein on the left horizon. The
flotilla of boats being hauled by the tug may be connected with
the bridge of boats that provided a means of crossing the river,
and which had been sketched by Turner in 1841.[1] Hunt may
have been looking across the river at a diagonal to the main
direction of flow, thus gaining a near southerly view, and
giving an impression of great width. Alternatively, he may
have been looking towards the east, witnessing an effect of
early morning light rather than that of evening.

On occasions throughout his career Hunt painted and drew
effects of half light, ranging from his night view of Harlech
through to *Bay of Naples – A Land of Smouldering Fire*, but
also including the watercolour of Tynemouth Pier (cat. nos. 9,
32, and 41). This fascination with the landscape suffused with
darkness, or as light intensifies or diminishes at morning or
evening, was shared by other progressive artists among the
post-Pre-Raphaelite group, such as John William Inchbold,
George Price Boyce, and James McNeill Whistler.

Provenance: (…) Phillips, *c.* 1989;
Chris Beetles; David Fuller; his
sale, Christie's, 7 April 2000
(44), where purchased by the
present owner

Exhibited: O.W.-C.S., 1862–3
(411)

Private collection

1 See Powell 1995, pp. 188–9.

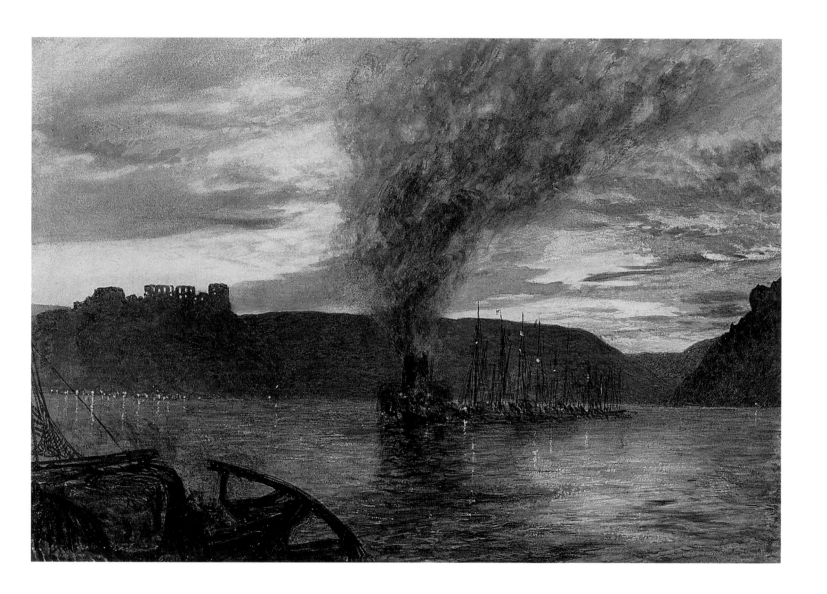

21
Finchale Priory 1861

Signed and dated: *AWH* [in monogram] *1861*
Watercolour and bodycolour with scratching out, 32.2 x 48 cm; 12¹¹⁄₁₆ x 18⅞ in

F INCHALE PRIORY STANDS on a wide bend of the
River Wear north of the city of Durham. In Hunt's
watercolour, the river itself is out of sight, although spray can
be seen rising from rapids. The monastery and priory church
of Finchale date to the late twelfth century. The choice of sub-
ject indicates Hunt's fascination and increasing familiarity
with the old buildings of Durham and Northumberland. Mar-
garet Hunt's father, James Raine, gave a detailed description of
Finchale in his book *The Priory of Finchale* (1837). Margaret
recalled an occasion in her childhood in the 1830s when her
father had been visited by the poet Wordsworth: 'He dined at
Crook Hall (about two or three o'clock) and then walked to
Finchale Abbey, three miles off, with my father'.[1]

Ruskin saw what seems to have been an oil version of the
present subject,[2] along with one of Hunt's industrial subjects,
in the summer of 1864. Hunt hoped to sell the two paintings
to the Middlesbrough iron-master Isaac Lowthian Bell, and
appears to have canvassed Ruskin's view of them so as to be
able to reassure his patron that the works met with the critic's
approval. Ruskin's initial response was to say that the 'York-
shire [*sic*] dell and priory seems to me as lovely as anything

yet done in landscape by your school',[3] and in due course he
wrote an enthusiastic account of the two works for Hunt to
show to Bell, but sent with it a further confidential note for
Hunt only in which he criticised the Finchale sky: '<u>Entre nous</u>,
the sky spoils your Yorkshire view – it wanted a dead quiet
one – and, my dear boy – how <u>can</u> you think that an oak tree
will ever pay you for painting it – it is utterly unmanageable
and formless always'.[4]

Hunt's daughter Silvia lent a watercolour of Finchale to
the memorial exhibitions at the Burlington Fine Arts Club
and Liverpool in 1897, but this was apparently of smaller
dimensions than cat. no. 21.[5] In both catalogues the drawing,
which may have been a preparatory study for the larger water-
colour, was dated to 1859. The present watercolour dates from
the early summer of 1861, and was first exhibited in 1862, at
the Old Water-Colour Society in the first year of Hunt's asso-
ciate membership. Bell's oil was dated 1862 in the catalogue of
the Fine Art Society exhibition in 1884, so was perhaps
worked up from the watercolour.

1 Quoted Secor 1982, p. 26.
2 This was presumably the painting (now apparently destroyed) that Isaac
 Lowthian Bell lent to the Hunt exhibition at the Fine Art Society in 1884,
 where it was given the title 'Finchale Abbey'. It was enthusiastically
 described by F.G. Stephens in his account of the works of art at Washington
 Hall (*Athenaeum*, 18 October 1873, p. 501).
3 Violet Hunt Papers (the entire text of Ruskin's previously unpublished letter
 is given on pp. 19–20).
4 Quoted Secor 1982, p. 28.
5 Catalogue no. 135, and with dimensions given as 6⅞ x 12¼ in. At Liverpool it
 was no. 143.

Provenance: William J. Newall
(but not in his sale, Christie's,
30 June 1922); Geoffrey Stirling
Newall; by descent to the pres-
ent owner

Exhibited: O.W.-C.S., 1862 (233);
L.A., 1862 (660); New Haven
1992 (31)

Literature: *Athenaeum*, 26 April
1862, p. 567; *Athenaeum*, 9 May
1896, p. 626; Marillier 1904,
p. 160; Newall 1987, p. 64, pl. 43

Private collection

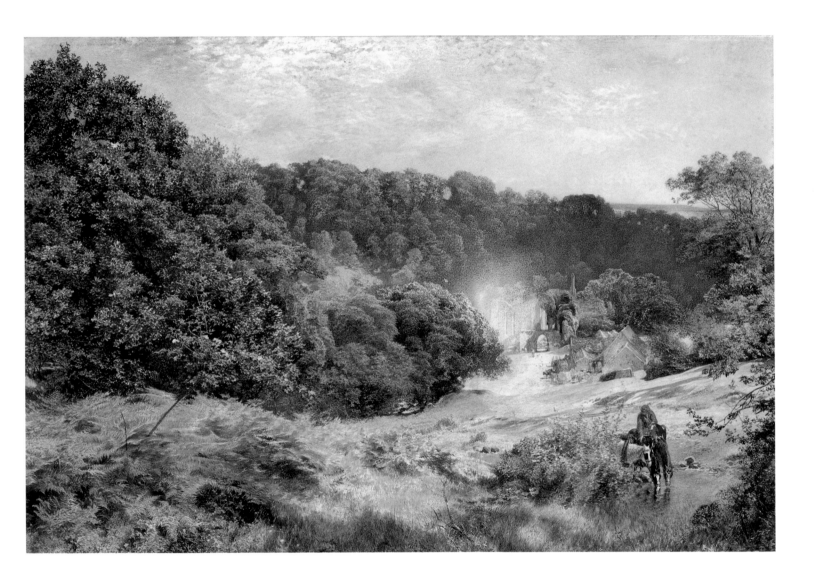

FINCHALE PRIORY

22
Harlech 1862

Signed and dated: *AW Hunt 1862*
Watercolour, 20.3 x 30.2 cm; 8 x 12 in

I N 1862, the Hunts were living in Durham, but sketchbooks
and the works he showed at the Old Water-Colour Society
that year indicate that he visited the Lakes, north Wales, and
north Yorkshire.[1] Among the exhibits was a work entitled
'Harlech Castle', which may have been cat. no. 21, or a water-
colour from an earlier visit.

Provenance: (…) Robert Stirling
Newall, F.S.A., by whom
bequeathed, 1978

Ashmolean Museum,
Oxford. Bequeathed by
Robert Stirling Newall,
F.S.A., 1978 (WA 1978.13)

1 See sketchbooks nos. 12, 216–17.

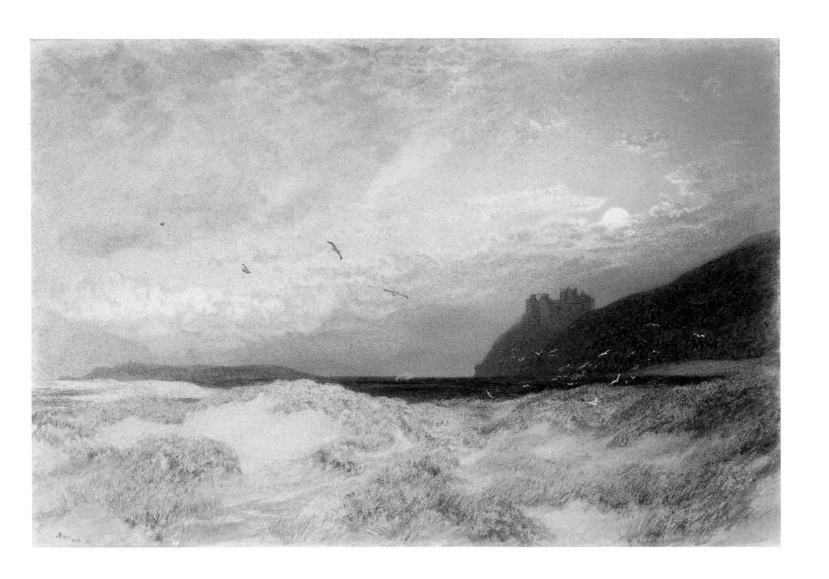

23

Barnard Castle 1862

Signed and dated: *AW Hunt*
Watercolour, 26.7 x 36.8 cm; 10⅛ x 14⅜ in

H UNT'S VIEW SHOWS part of the ruined curtain wall
and, further to the right, the circular keep of Barnard
Castle, which stands on a rocky outcrop overlooking the River
Tees. The building is essentially Norman, but was refortified
and ornamented by Anthony Bek, Bishop of Durham, in the
early fourteenth century. A weir breaks the surface of the
water far below, while beyond, a long reach of the river, with
densely wooded banks, stretches away to the north-west of the
town of Barnard Castle. This is a location about 22 miles from
Durham, where Hunt and his family were then living. Barnard
Castle was described in detail in the fourth volume of Robert
Surtees's *The History and Antiquities of the County Palatine of
Durham* (1816-40), edited and completed by Margaret Hunt's
father, James Raine.

Even after the Hunts moved to London in 1865, the land-
scape and buildings of County Durham and north Yorkshire
remained dear to his heart, and where he often returned. In
August 1877 Ruskin wrote to Margaret: 'I'm heartily glad
you & Alfred are there [in Durham] – Barnard [Castle]
before the mills were built was the grandest river & castle but
next to Richmond & Durham, and may still be travelled
somehow …'[1]

Provenance: Joseph Hutchinson;
William J. Newall; Norman D.
Newall; his sale, Christie's,
14 December 1979 (171), where
purchased by the present owner

Exhibited: O.W.-C.S., 1863 (70 or
235); London 1897 (14); Tokyo
1993 (212)

Literature: *Athenaeum*, 2 May
1863, p. 592

Private collection

1 Quoted Secor 1982, p. 91.

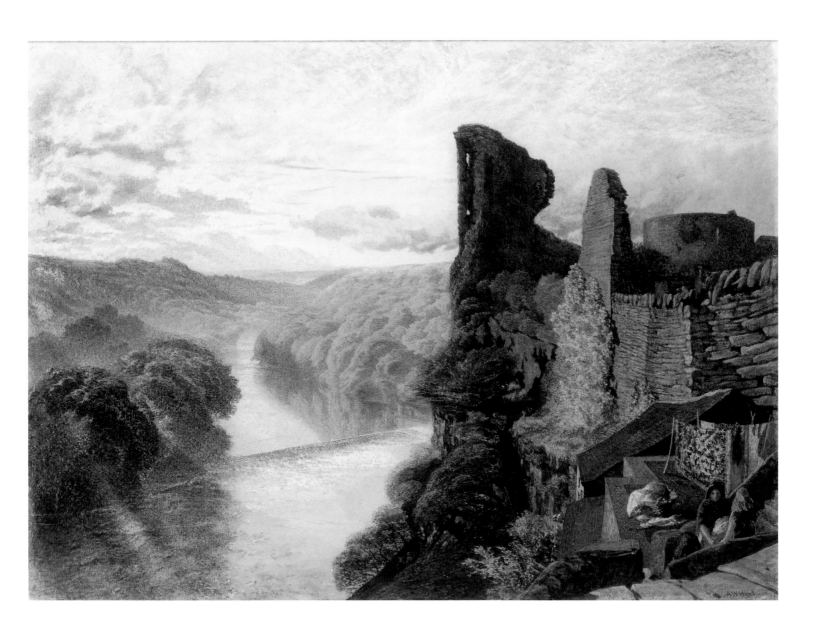

BARNARD CASTLE

24
Charcoal Burners in Rokeby Park c.1862

Watercolour, 26.5 x 37.5 cm; 10⅜ x 14⅞ in

T HIS SUBJECT IS UNUSUAL among Hunt's landscapes in showing no sky, only glimpses of light through the canopy of beech leaves. It was made in the area of countryside that by the early 1860s had become a particular favourite with Hunt. The house and grounds of Rokeby Park are on the south bank of the Tees about two and a quarter miles down-stream of Barnard Castle. The Greta joins the Tees at Rokeby, near the village of Brignall. The present drawing was shown at the Old Water-Colour Society in the summer of 1863, along with another entitled *Rokeby*, which is probably the 'River Landscape' now in the British Museum.

Provenance: Presented by Leeds Art Collections Fund, 1926

Exhibited: O.W.-C.S., 1863 (297)

Leeds Museums and Galleries (City Art Gallery)

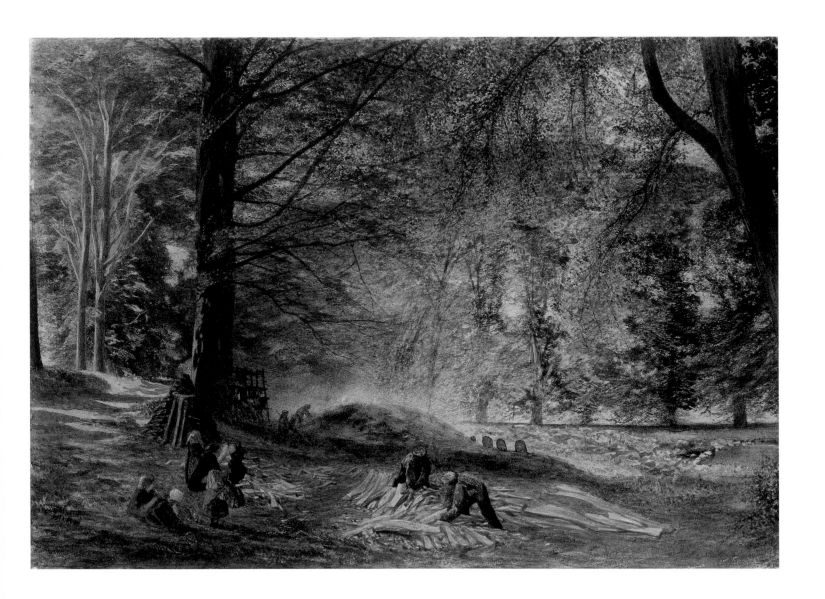

25
*Martin's Hill, Dockwigg c.*1862

Pencil and watercolour, 31.3 x 49.2 cm; 12⅜ x 19⅜ in

T HE PAPER HAS A watermark from 1862, which may provide a date for Hunt's work at Dockwigg. The site was identified by C.F. Bell, but is otherwise unknown. This is one of many watercolours left unfinished in Hunt's studio after his death, and an example of one of his characteristic procedures, of working up each successive part of the composition in great detail, rather than washing in the whole composition first.

Provenance: by descent from the artist

Ashmolean Museum, Oxford. Presented by Mrs W.A.S. Benson and Mrs Fogg-Elliott, the artist's daughters, 1918 (WA 1918.7.85)

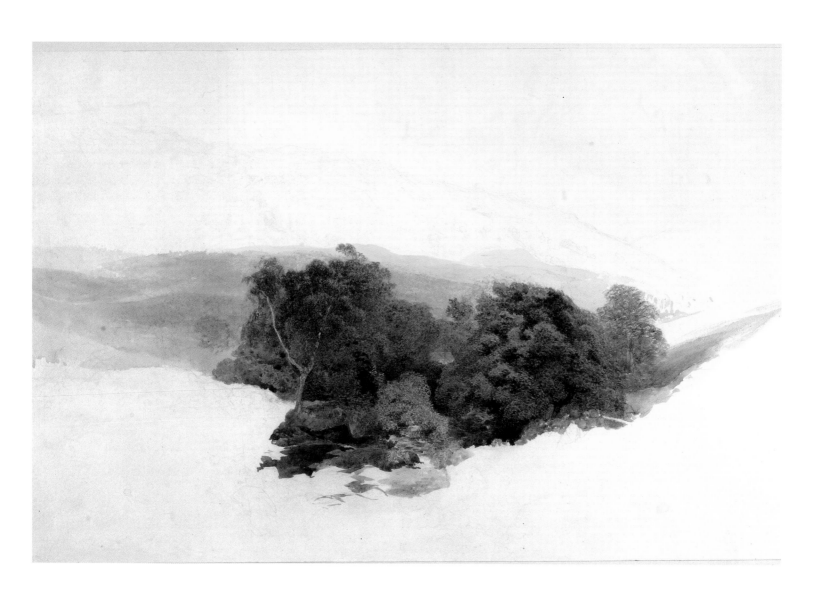

26
Durham, from below Framwellgate Bridge
1865

Watercolour, 48.1 x 68.3 cm; 19 x 26⅞ in

ALFRED AND MARGARET HUNT lived in Durham from the time of their marriage in 1861, until 1865, when they removed to London. Hunt's *Durham, from below Framwellgate Bridge* is one of the most impressive and complete of the many watercolours that he made of Durham during this period. The artist's vantage point was close to the River Wear, just downstream from the bridge that joins the western part of the town with the historic centre, which rises up on a steep ridge contained within a tight curve of the river and at the crest of which stand both the castle and cathedral. Hunt's view is towards the south, and shows the two arches of Framwellgate Bridge, which dates from the fifteenth century. Above, on the left horizon, is the castle, begun by William the Conqueror on his return from Scotland in 1072, with coal

smoke rising from the chimneys of houses below. At the centre are the three Romanesque towers of the cathedral, softly lit by the winter sun.

Once again, and perhaps with conscious awareness, Hunt was at an exact spot from which Turner had painted. Turner's view of Durham showing Framwellgate Bridge, of *c*.1799,[1] had been made for the painter John Hoppner, and had passed into the collection of the Royal Academy.

Durham, from below Framwellgate Bridge was one of the drawings at the Old Water-Colour Society exhibition in 1865 that Ruskin admired (see cat. no. 29). It later belonged to the antiquary and connoisseur John Wheeldon Barnes, who was the manager of Backhouse's Bank in Durham.

Provenance: Thomas Emerson. Crawhall, by 1875; John Wheeldon Barnes, F.S.A, by 1884; his sale, Christie's, 7 April 1894 (127) (380 guineas to Gooden); Norman Charles Cookson; by 1897, by descent to the present owner

Exhibited: O.W.-C.S., 1865 (37); London 1878–9 (966); London 1884 (24); Berlin 1886; Newcastle upon Tyne 1887 (916); London 1897 (96); Liverpool 1897 (94)

Literature: Athenaeum, 29 April 1865, p. 594; *Art Journal*, 1865, p. 175; *Athenaeum*, 6 November 1875, p. 614; Wedmore 1891, repr. p. 105

Private collection

1 Wilton 1979 (249).

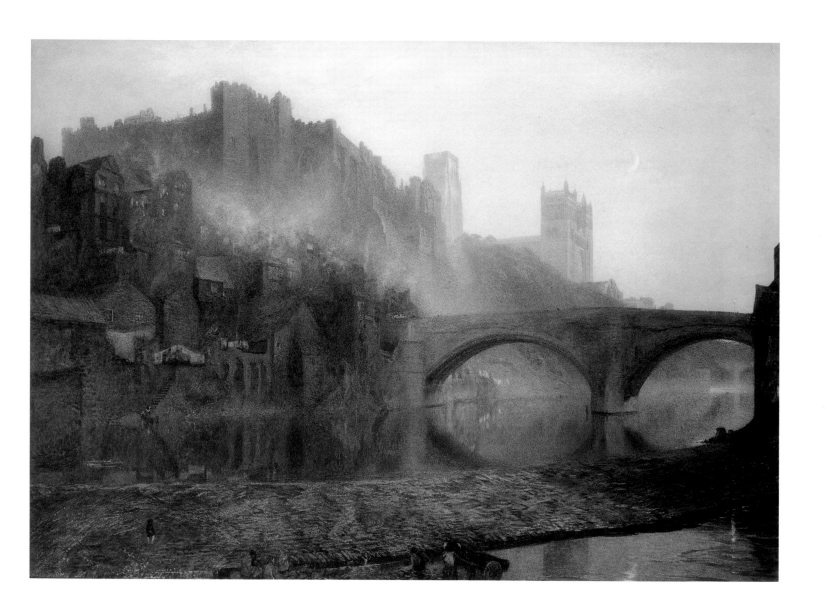

DURHAM, FROM BELOW FRAMWELLGATE BRIDGE

27
*Durham from the Red Hills c.*1860-65

Pencil and watercolour, 33.5 x 50.8 cm; 13⅛ x 20 in

PROBABLY MADE DURING the early 1860s, when Hunt and his family were living in Durham, this sketch, which shows the method by which he built up a composition, shows a distant view of the cathedral from the north-west. This area was described by Surtees: 'To the north of the Red-hills and in the depth of the valley, near Shaw-Wood, is the little mound or hillock called the *Maiden's Bower*'.[1]

1 Robert Surtees, *The History and Antiquities of the County Paletine of Durham*, 4 vols. (London, 1816–40), IV, p. 134.

Provenance: as cat. no. 25

Ashmolean Museum, Oxford. Presented by Mrs W.A.S. Benson and Mrs Fogg-Elliott, the artist's daughters, 1918 (WA 1918.7.82)

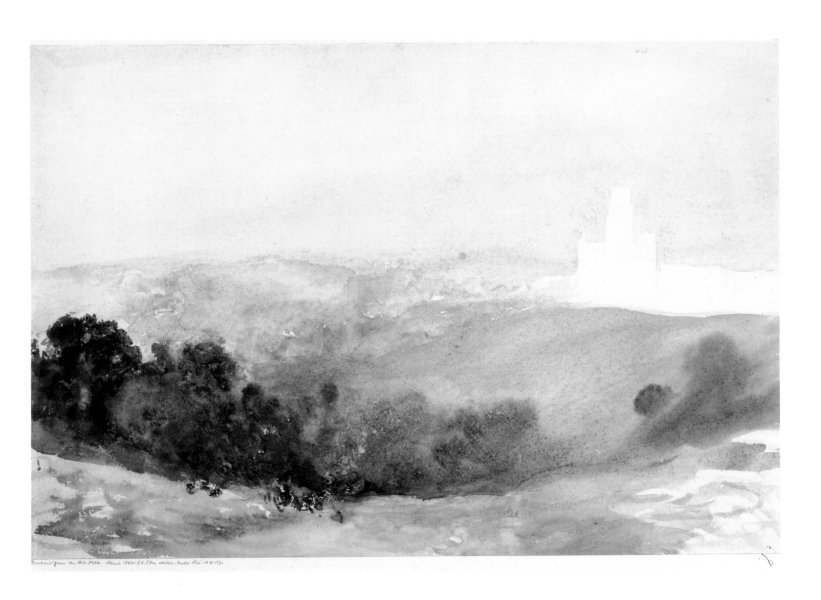

Durham from the Red Hills. About 1860-66. (See Sketch-Books Nos. 14 & 17).

28
Ulleswater 1863

Watercolour, 36.8 x 50.8 cm; 14¾ x 20 in

I N THE EARLY SUMMER of 1863 Hunt was back in the Lakes, an expedition that led to his exhibiting various Lakeland subjects at the Old Water-Colour Society in 1864 – the first year of his full membership. Here, he shows the central reach of Ullswater, from a vantage point on the southern shore somewhere near Kilbert How. The meadows at the centre of the composition are those that run down to the water's edge at Sandwick, while the steeply rising hill beyond is Hallin Fell, on the right of which is the road entrance to Martindale. On the far side of the lake is the rocky headland at Gowbarrow, which marks the break between the middle and northern reaches of the lake. Hunt's other Lakeland exhibit of 1864 was a view of Matterdale, which is the fell above Gowbarrow. The two drawings may have been intended as loosely complementary subjects. Certainly they were linked by the reviewer of the *Art Journal*, who noted that 'Alfred Hunt has for some time walked in eccentric courses, but now at length, in two remarkable drawings ... he bids fair to reach the summit towards which his steps have tended'.[1]

Ruskin had seen the works that Hunt exhibited in London in the summer of 1864, even before the painter asked him for a testimonial to the quality of particular items as a means of reassuring Isaac Lowthian Bell, who had appeared as a potential purchaser. Thus, Ruskin wrote to Hunt on 25 May 1864: 'I shall have the greatest pleasure in looking at the pictures because I am sure I shall like them with all my heart. That is a most lovely and wonderful drawing that you have in the Water-colour [Society exhibition] (Ullswater)'.[2]

Provenance: Robert Stirling Newall, F.R.S., by 1884; Mary Newall, by 1897; (...) Norman D. Newall; his sale, Christie's, 14 December 1979 (178); Martyn Gregory, from whom purchased by the present owner

Exhibited: O.W.-C.S., 1864 (26); L.A., 1864 (142, as 'Ulleswater – Midday'); London 1884 (27); Newcastle upon Tyne 1887 (917); London 1897 (97); Liverpool 1897 (53)

Literature: *Athenaeum*, 30 April 1864, p. 618; *Art Journal*, 1864, p. 171; *Athenaeum*, 27 September 1873, p. 408; *Spectator*, 23 January 1897, p. 124; Dibdin 1897, p. 34

Collection of the Mellon Financial Corporation, Pittsburgh

1 *Art Journal*, 1864, p.171.
2 Quoted Secor 1982, p.27.

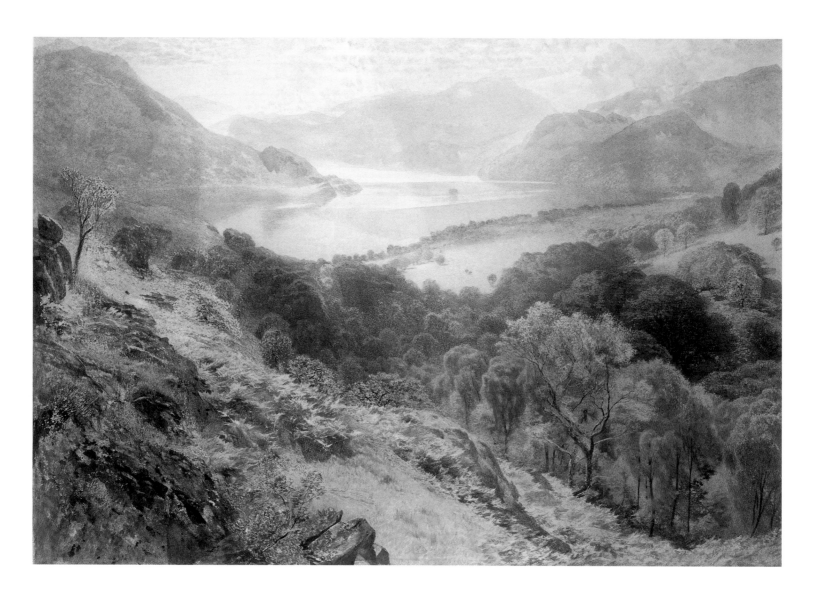

29
*Ambleside Mill, Lake District c.*1863

Pencil and watercolour, heightened with gum Arabic, with scratching out,
40.3 x 33.4 cm; 15¾ x 13¼ in

THIS DRAWING OF THE MILL at Ambleside probably comes from the same visit that Hunt made to the Lakes that led to the view of Ullswater (cat. no. 28). The town of Ambleside is at the head of Windermere, some six miles to the south of his vantage point on the shore of Ullswater.

Turner had drawn the mill in his early career, in a watercolour that was shown at the Royal Academy in 1798.[1] Whether or not Hunt was aware of this precedent, a comparison between the two drawings is informative about the location, for in the Turner drawing an overshot millwheel is seen against the wall of the building on the left, while a wooden conduit carries water to the wheel. These had gone by the time Hunt made his drawing more than sixty years later, although the stone-built houses on right and left are essentially as seen by Turner (and indeed as they exist today).

Hunt made a number of versions of this subject, seeking to capture the complex pattern of textures and shapes in different effects and intensities of light, with and without foliage.[2] A subject of this title appeared at the Old Water-Colour Society in 1864, and another in 1865.[3] A view of Ambleside Mill was included in the 1884 Fine Art Society exhibition,[4] where it was dated to 1862. Sir Lowthian Bell lent a version of the subject to the two Hunt memorial exhibitions in 1897.[5] The Ambleside view exhibited in 1865 was particularly admired by Ruskin, who wrote to Hunt: 'I want to tell you how much I like your drawings this year. I've put off from day to day – wanting to say much – nor can I only say I like the Ambleside, (unsold when I was last there) best of all – the Ulleswater, Gowbarrow next. Then the Durham [cat. no. 26] – but all very much. And that's all I can say today – but I'm ever faithfully yours J Ruskin'.[6]

1 Now in the collection of the University of Liverpool; Wilton 1979 (237).
2 At least one other version of the subject has reappeared in recent years, at Christie's, 4 February 1986 (97), now in a private collection.
3 No. 274 in 1864, and no. 52 in 1865.
4 No. 42.
5 Nos. 38 and 65 respectively.
6 Violet Hunt Papers.

Provenance: (…) Christie's, 10 February 1981 (13); Chris Beetles; David Fuller; his sale, Christie's, 7 April 2000 (18)

The Fuller Collection

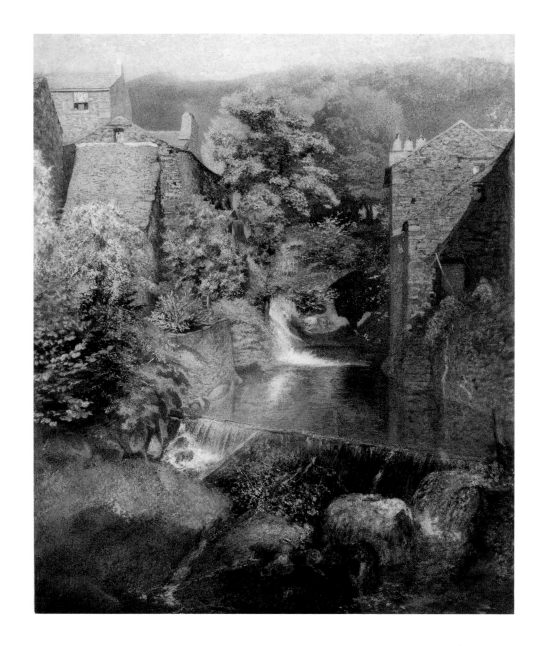

30

Iron Works, Middlesbrough c.1863

Oil on canvas, 43.8 x 64.1 cm; 17¼ x 25¼ in

*I*ron Works, Middlesbrough shows the interior of a foundry with a stream of molten metal coursing down a channel and filling a series of apertures in which it will cool and harden to make blocks of pig iron. This is almost certainly a view of the iron-smelting works that the industrialist Isaac Lowthian Bell (later Sir Lowthian Bell, Bart) had set up at Port Clarence, on the River Tees between Middlesbrough and the North Sea coast.

Bell owned at least two industrial subjects by Hunt, *Drawing the Furnace of a Durham Iron-works* and *Blast Furnaces after Tapping*, which were both described by F.G. Stephens in his account of Bell's collection in the *Athenaeum*.[1] They presumably resulted from a visit that Hunt made to Lowthian and Margaret Bell in about 1863. The second was shown at the

Old Water-Colour Society in 1864, while a sketch, entitled *Tapping Blast-furnaces*, appeared at the Society's winter exhibition in 1864–5. William Bell Scott commented wearily in a letter to James Leathart: 'This last seems to represent a town on fire, with figures, women in green shawls as far as they can be made out, where the workmen ought to be, a kind of thing wherein one sees the worst influence of Turner'.[2]

Painterly looseness and glowing colour characterise *Iron Works, Middlesbrough*, which presumably also derived from the visit in 1863. In the summer of 1864 Ruskin saw one or both of Bell's factory subjects, and subsequently wrote to the artist: 'the forge is nearly as good as possible – a little wanting in fierceness and force – but wonderful in lambency of pure flame and coloured vapour'.[3]

1 *Athenaeum*, 18 October 1873, p. 501.
2 James Leathart Papers
3 Violet Hunt Papers (the entire text of Ruskin's previously unpublished letter is given on pp. 19–20).

Provenance: The artist; his daughter, Violet Hunt, by whom bequeathed, 1942

© Tate London, 2004 (N05358)

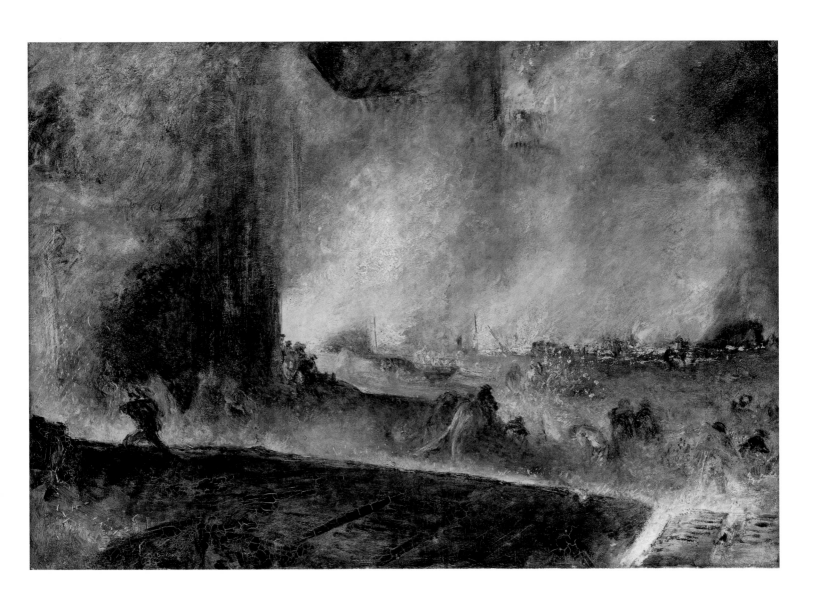

IRON WORKS, MIDDLESBROUGH 111

31

Tynemouth Pier: Lighting the Lamps at Sundown c.1865

Pen and sepia ink and wash, 27.1 x 38.1 cm; 10¹¹⁄₁₆ x 15 in

THIS SKETCH CORRESPONDS closely to the composition of the finished watercolour (cat. no. 32), and may have served as an intermediary stage between the hasty sketches made in the pocket sketchbooks that Hunt habitually carried (see cat. no. 33a), and the finished drawing. It is unimaginable that the artist would have been able to make more than the most perfunctory pencil notations in such a hazardous setting: the two oil-cloth clad figures who are attempting to light the warning beacon, but who are blasted with spray and who are bent by the wind off the sea, give some indication of how exposed the situation was, and it is remarkable that Hunt was permitted to go out to the construction site at all. It therefore seems unlikely that even the sepia sketch was made directly from the motif, but was perhaps done shortly after he had been out on the pier as an *aide-mémoire* and as a guide to the elements of the intended composition.

Provenance: Edwin Wilkins Field and by descent; Christie's, 18 November 1980 (76); Bill Minns Watercolours, from whom purchased

Yale Center for British Art, New Haven, Connecticut (Paul Mellon Fund, B1989.6)

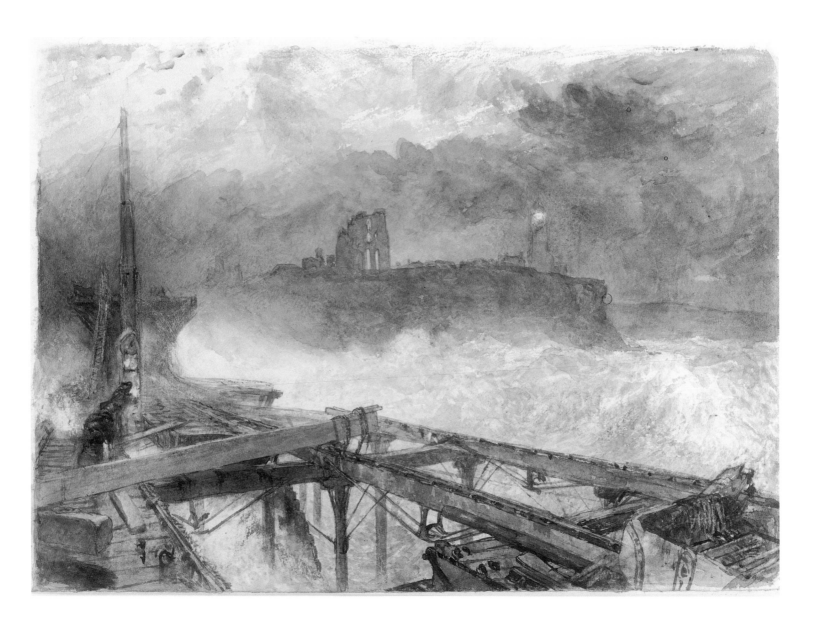

32

Tynemouth Pier – Lighting the Lamps at Sundown c.1865

Signed and dated: *AW Hunt 1868*[1]
Watercolour and bodycolour, heightened with gum Arabic, with scratching out,
37.1 x 54 cm; 14⅝ x 21¼ in

I N NOVEMBER 1865 Hunt embarked on what may be
regarded as among the most original and challenging proj-
ects of his career, the two finished drawings that he made of
the partially constructed piers at the mouth of the River Tyne.
Although he had already treated an industrial subject when
painting the ironworks of Isaac Lowthian Bell (see cat. no. 30),
in general he preferred pure landscape subjects or, where
buildings were included, settings which were softened and
made harmonious by the long passage of time. Here, however,
the viewer is confronted by the modern world, in the form of a
work of engineering that demonstrated the determination and
ingenuity of men of Hunt's own generation.

Turner, in about 1818, had drawn a view of the north shore
of the mouth of the Tyne, with Tynemouth Priory on the
headland above.[2] He, however, could not have imagined a pair
of piers – one of about 750 yards, the other nearly a mile long
– projecting out into the North Sea. These were built to give
protection for shipping as it entered and left the mouth of the
River Tyne, both from gales and from the notorious reefs
known as the Black Middens on the north shore, upon which
many vessels had foundered. The Tyne Improvement Act was
passed in 1852, and in 1855 contracts were made for the con-
struction of two piers. Work continued over a period of
decades, under the supervision of the Tyne Commissioners, a
body which included both Robert Stirling Newall and Isaac
Lowthian Bell.

Hunt's watercolour shows the construction site of the
north pier, which ran out into the open sea from the cliff face
just below Tynemouth Priory, on the Northumberland shore
of the Tyne. When Hunt was there, in November 1865, about
two thirds of the pier as it was eventually constructed had
been built, so the part represented in the foreground is

approximately a quarter of a mile from the shore. The con-
struction of the pier from stone blocks was immensely diffi-
cult; materials were carried out to the farthest part of the site
on wheeled carts that ran along tramlines; blocks were then
manipulated and placed in position on their foundations on the
seabed by mobile cranes – one of which is seen in the middle
distance on the left side. Beyond the point to which the con-
struction had reached (the end of the completed part of the
pier can be seen in the watercolour at the lower edge of the
composition about a third of the way across its width from the
left), iron piles were driven into the seabed, on which a super-
structure of wooden beams braced together with cables and
tie-rods was made. Upon this were laid extension rails, so that
the transport trucks and the mobile cranes could advance fur-
ther out to sea. All of this was explained by Hunt in a letter to
Humphrey Roberts, the first owner of this watercolour, on the
grounds that 'it does want a little explanation to all who are
not engineers or "Tyne Commissioners". To them I hope it
would be intelligible enough and effective, and so escape the
objection – a serious one to bring against a picture – that it
does not tell its tale easily to the eye'.[3] Work on the construc-
tion of the two piers went on over many years and through a
succession of catastrophes in which a number of men lost their
lives. Some time before Hunt was there a vessel, drifting under
the force of a storm, had collided with the construction. Hunt
explained: 'The great beam tied across with big chains was I
think, added to strengthen the whole thing after it had been
shaken very much by a wreck, which drove against it a day or
two before I saw it. The iron rails on the right were bits of the
tramway which had been bent and twisted and broken off by
this collision'.[4]

1 The inscribed date has been consistently read as 1868, and is indeed quite
 clear and legible. Even so, 1865 is the year in which Hunt is documented as
 having worked on the subject (see *Art Journal*, 1884, p. 221), and the present
 watercolour is undoubtedly identical with the work exhibited at the Old
 Water-Colour Society in 1866.
2 Wilton 1979 (545).
3 Hunt's letter was dated 4 January 1869. The original was once attached to
 the back of the watercolour, but appears now to be lost. A typed copy exists
 in Alan Fox-Hutchinson, while its text was also given in Liverpool 1897, pp.
 29–30.
4 Ibid.

Provenance: Humphrey Roberts,
by 1869; his sale, Christie's, 23
May 1908 (258) (145 guineas to
Gooden and Fox); William J.
Newall; his sale, Christie's, 30
June 1922 (28) (240 guineas to
Rienaecker); Victor Rienaecker;
sold through the Fine Art Soci-
ety to Norman D. Newall; his
sale, Christie's, 14 December
1979 (161), where purchased by
John Baskett on behalf of the
present owner

Exhibited: O.W-C.S., 1866 (281);
London 1878-9 (961); London
1884 (55); Manchester 1887
(1377); London 1896 (85);
London 1897 (94); Liverpool
1897 (152); London 1906 (199,
as 'Blue Lights, Tynemouth
Pier'); Dublin 1907 (444); New
Haven 1981 (91); New Haven
1992 (69)

Literature: *Athenaeum*, 19 May
1866, p. 676; *Art Journal*, 1884,
p. 221 (repr. in an engraving by
E. Brandard on facing page);
'The February Exhibitions in
London', *Art Journal*, 1897,
pp. 92–4; Hunt 1924–5, pl. 12;
Wilton 2000–2001, pp. 51–2,
fig. 29

Yale Center for British Art,
New Haven, Connecticut
(Paul Mellon Fund;
B1980.3)

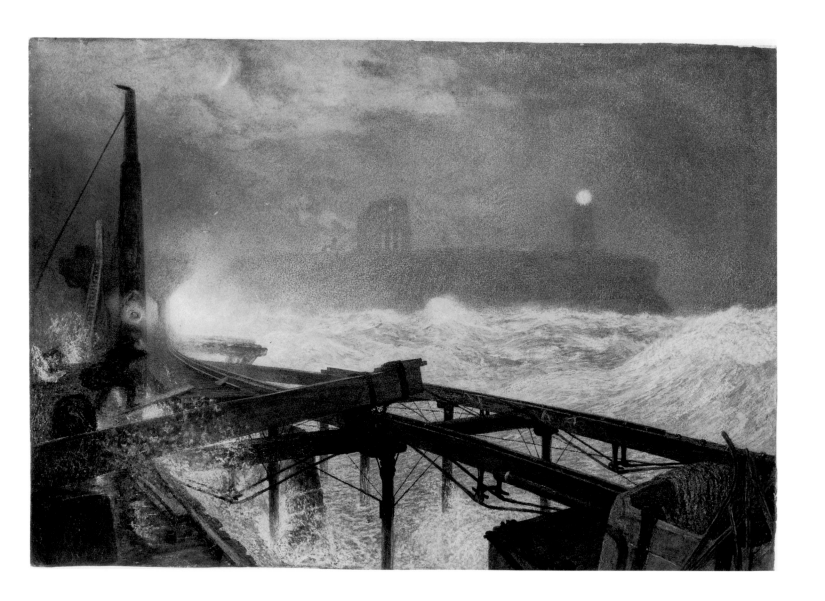

TYNEMOUTH PIER — LIGHTING THE LAMPS AT SUNDOWN

33

Travelling Cranes, Diving Bells & etc. at the Extremity of Tynemouth Pier c.1866

Watercolour, 31.8 x 26.7 cm; 12½ x 10½ in

As the title inscribed on an old label indicates, this watercolour shows a view from the most seaward point on one of the partially constructed piers, with a view through one of the mobile cranes – known as Goliaths – that were used on the construction sites to transport stone and other building materials. Clearly, Hunt was attracted to the abstract patterns of shape and colour to be observed in the subject. On the left is the diving bell also referred to in the title, a device apparently first used in 1866 to assist the accurate positioning of blocks of masonry on the pier foundations. The north pier itself is seen through a rising cloud of spray, with a lower part on the left with tramlines, and a raised walkway enclosed with railings on the right. In November 1867,

shortly after cat. no. 33 was first exhibited, six of the eleven sets of cranes working on the two piers were destroyed in severe gales.

If the two Tynemouth drawings celebrate the ingenuity of engineers in the service of the mid nineteenth-century commercial and industrial expansion of Newcastle, they also show more ancient landmarks. In the distance is Tynemouth Priory, mostly built from *c*.1190 on the site of the burial place of St Oswin in 651, with the east wall of the Early English presbytery standing virtually to its original height. On the left is Tynemouth Castle, and on the right on the same headland a lighthouse built in the seventeenth century but demolished after Hunt painted there.

33a *Studies of the Construction of Tynemouth Pier.* 1865.
Sketchbook no. 18.

Provenance: (…) Tom Rushworth (a picture-dealer based in Durham, who disposed of many drawings from the collection of John Wheeldon Barnes, F.S.A.); (…) with Anderson and Garland, Newcastle upon Tyne, *c*.1976; Moss Galleries, from whom bought by the present owner

Exhibited: O.W.-C.S., 1867 (274); Newcastle upon Tyne 1989 (57); London 1993 (175); London 2004 (123)

Literature: *Athenaeum*, 11 May 1867, p. 630; Newall 1987, p. 71, pl. 50

Private collection

Shown only at Oxford

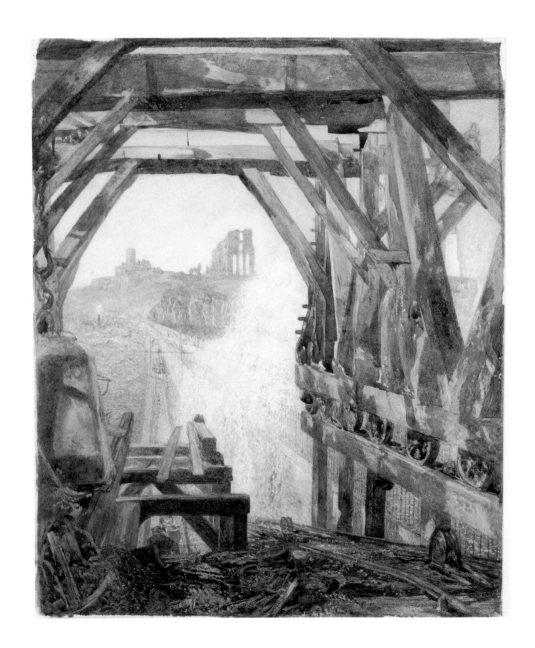

TRAVELLING CRANES, DIVING BELLS & ETC. AT THE EXTREMITY OF TYNEMOUTH PIER

34

A Mountain Stream 1865

Signed and dated: *AW Hunt / 1865*
Watercolour over graphite with scratching out, 27.3 x 38.8; 10⅞ x 15¼ in

T HE LOCATION OF this watercolour has not been iden-
tified, and Hunt's movements in 1865 are not document-
ed. However, the landscape is more typical of north Wales
than north Yorkshire.

Provenance: (…) Chris Beetles;
David Fuller; his sale, Christie's,
7 April 2000 (37)

The Fuller Collection

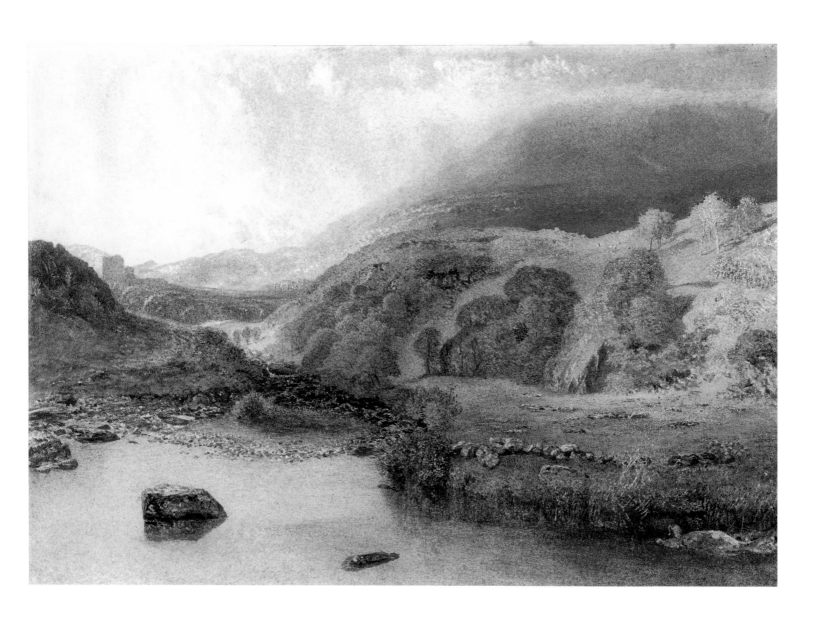

35

A November Rainbow – Dolwyddelan Valley, November 11, 1866, 1 p.m. 1866

"A stroke of cruel sunshine on a cliff, when all the glens are drown'd in azure gloom."

Alfred Tennyson

Watercolour, 49.5 x 74.9 cm; 19⅝ x 29½in

THIS CELEBRATED DRAWING has for its secondary title a quotation from Book IV of Tennyson's 'The Princess: A Medley'. It is one of the largest, most elaborate, and most richly coloured of all Hunt's watercolours, and, with *Tynemouth Pier* (cat. no. 32), one of the works upon which the artist's modern reputation stands.

Although in the late 1850s Hunt may have been tiring of the Cambrian landscape (see cat. no. 7), Welsh subjects occurred among his exhibited works over the next ten years (except in 1865), so he seems to have continued to visit those parts. The valley of the Lledr, in which lies the village of Dolwyddelan, is on the eastern side of the Snowdon range. The River Lledr flows from the heights of Moel Druman, and joins the Conwy just south of Betws-y-Coed. The precise vantage point of *A November Rainbow* is about a mile and a quarter to the west of Dolwyddelan, on the hill that forms the valley's southern flank, near the hamlet of Bertheos. In Hunt's panoramic vision, the river describes a wide arc, eventually flowing north before turning back to the east. In the distance on the right is Dolwyddelan Castle,[1] which stands on a small outcrop of rock in an opening on to the Lledr valley. The artist also observes a track or path, which bridges the Lledr at the extreme left of the composition and which then skirts the river

on its far bank, although cutting off the flattish ground on the inside of the curve of the river. This is now the route of the A470, from Betws-y-Coed, which rises to the south-west over the Crimea Pass, before reaching Blaenau Ffestiniog. In April 1856, Hunt had painted almost exactly the same view of Dolwyddelan but taken from a few steps further to the right (British Museum).

A November Rainbow shows a meteorological effect that was, according to one reviewer, the artist's 'favourite theme' – 'a rainbow among mountains, with his peculiarly hard, dark shadows and pale sunlight'.[2] The rainbow shows against a background of broken rock and scree, all of which is seen in three-dimensional relief as the gleam of low sunlight momentarily irradiates the central part of the landscape. The sky beyond, however, is purple with rain, while the foreground is likewise shadowed by storm clouds overhead. Indeed, rain has begun to fall – so that the cowherd clutches a bit of sacking over his head and round his shoulders, and the light of the rainbow produces glints of reflection in the wet surfaces of a dry-stone wall.

This was one of a group of works by Hunt owned by William Sproston Caine, a temperance reformer and Liberal M.P. for Barrow-in-Furness and later for Camborne.

Provenance: William Sproston Caine, M.P., by 1879 and until at least 1884; William J. Newall, by 1897; his sale, Christie's, 30 June 1922 (26) (130 guineas); Thos. Agnew & Sons, from whom purchased

Exhibited: O.W.-C.S., 1867 (16); Liverpool 1872 (656); London 1878–9 (962); London 1884 (58); Manchester 1887 (1357); Chicago 1893; Birmingham 1896 (170); London 1897 (102); Liverpool 1897 (66)

Literature: Athenaeum, 11 May 1867, p. 630; *Art Journal*, 1867, p. 147; Marillier 1904, pp. 161–2, repr. facing p. 162; Staley 2001, p. 199, pl. 159

Ashmolean Museum, Oxford. Purchased with the assistance of the National Art Collections Fund, 1922 (WA 1922.1)

1 A Welsh-built rather than Edwardian castle, but captured by Edward I in his campaign against the Welsh, and remodelled by his engineers to become part of the strategic ring of fortifications with which he held Wales.

2 *Athenaeum*, 11 May 1867, p. 630.

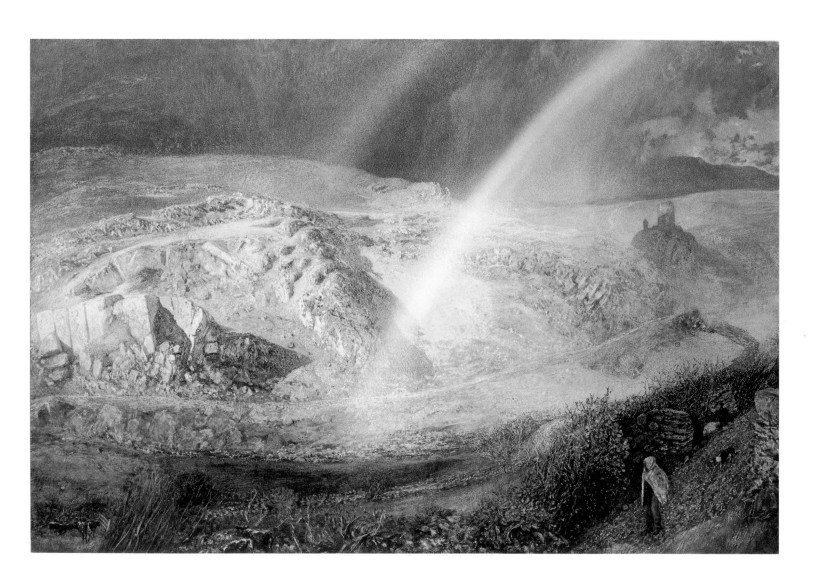

A NOVEMBER RAINBOW — DOLWYDDELAN VALLEY, NOVEMBER 11, 1866, 1 P.M.

36

Junction of the Rivers Conway and Lledr – Late Autumn 1866–7

Watercolour, 18 x 25.5 cm; 7¼ x 10⅛ in

THIS WATERCOLOUR SHOWS the broad expanse of water, known as the Tyn-y-Cae Pool, close to the confluence of the Lledr and the Conwy rivers in north Wales. The Lledr flows eastwards from Moel Druman, while the Conwy rises further to the south, and is also joined by the Machno River. The two rivers meet a mile and a quarter south of Betws-y-Coed, where Hunt was probably staying when he made the drawing.

Although not exhibited until the winter of 1867–8, and therefore possibly the outcome of a visit to Wales in the autumn of 1867, it seems likely that *Junction of the Rivers Conway and Lledr* was made on the same expedition that led to *A November Rainbow* (cat. no. 35) in 1866. Just as *A November Rainbow* was a reprise of a watercolour made as long before as 1856, in the *Junction of the Rivers Conway and Lledr* Hunt was looking again at a view that he had treated before. When the watercolour was shown at the Hunt memorial exhibition at the Burlington Fine Arts Club, visitors were recommended to compare it with a drawing entitled *Autumn: North Wales*,

dated '1856–7', which was presumably also a view of Tyn-y-Cae Pool.[1]

The drawing may be regarded as a sketch rather than a finished composition, and was exhibited at a winter, rather than summer, exhibition of the Old Water-Colour Society (the annual winter displays, of which that in 1867–8 was the sixth, were reserved for 'sketches and studies'). An even looser and more impressionistic version of the subject was part of the gift of works from the artist's studio to the Ashmolean in 1918 (WA 1918.7.86).

Junction of the Rivers Conway and Lledr was one of a large group of drawings by Hunt belonging to Daniel Oliver and his wife.[2] Oliver was a botanist and the director of the herbarium at Kew, who corresponded with Ruskin about plants and flowers. On 11 February 1875 Ruskin wrote as a postscript to a letter to Margaret Hunt: 'Heavens, that I could have ended without telling you what a sweet day I had at the Olivers' – and how I enjoyed Alfred's drawings there'.[3]

Provenance: Daniel Oliver, F.R.S., by 1884 and until at least 1897; (…) Arthur Jackson; Christie's, 30 November 1928 (28); (…) Christie's, 13 December 1977 (186), where purchased by the present owner

Exhibited: O.W.-C.S., 1867–8 (83); London 1884 (34, as 'Tyn-y-Cae Pool – Autumn Foliage'); London 1897 (51, as 'Junction of the Rivers Conway and Lledr. (Tyn-y-Cae Pool)')

Private collection

1 London 1897, cat. no. 55
2 The Olivers lent eight works to the Fine Art Society Hunt exhibition in 1884, and seventeen to the Burlington Fine Arts Club memorial exhibition in 1897.
3 Quoted Secor 1982, p. 82.

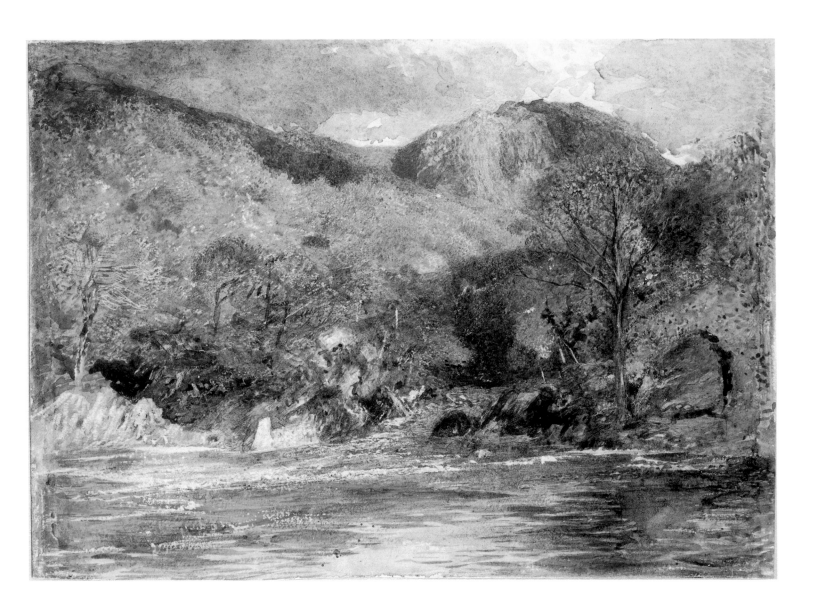

JUNCTION OF THE RIVERS CONWAY AND LLEDR — LATE AUTUMN

123

37

'Childe Roland to the Dark Tower came'
1866

" … Which, while I forded – good Saints how I feared
To set my foot upon a dead man's cheek.
Each step, or feel the spear I trust to seek."

Robert Browning

Watercolour, 45.2 x 68.2 cm; 17⅞ x 26⅞ in

T HE LITERARY THEME of this work is exceptional in Hunt's output. The subject was taken from Stanza XXI of Robert Browning's dramatic romance, 'Childe Roland', which describes the approach of a knight errant towards a Dark Tower. The poem was published in 1855 as part of Browning's collection *Men and Women*.

One of the strangest and most disturbing of all nineteenth-century works of poetry, 'Childe Roland' ends abruptly when the knight reaches the Tower and defiantly sounds his horn. The main theme also dwelt upon by Hunt in the watercolour, is the horror of the landscape that the knight must cross to reach his destination. The mood is one of a half-remembered nightmare, as the knight – himself the storyteller – carries out a mission, the purpose of which is unknown. The poem is a powerful allegory of the uncertainty and futility of life, and yet also speaks of man's willingness to carry on in the most unpleasant circumstances and to endure even when there seems to be no aim or likely outcome that might offer solace or encouragement. Robert Browning saw the present water-colour, when it was shown at the Old Water-Colour Society in 1866. He wrote to Hunt in complimentary terms: 'I feel proud indeed, and something better, that any poem of mine should have associated itself with the power which conceived and exe-cuted so magnificent a picture: – I weigh the word and repeat it. My own "marsh" was only made out of my head – with some recollection of a strange solitary little tower I have come across more than once in Massa-Carra, in the midst of the low hills'.[1] A friendship grew up between Hunt and Browning which lasted until the poet's death in 1889.

Provenance: Robert Stirling Newall, F.R.S.; William J. Newall, by 1897; his sale, Christie's, 30 June 1922 (27) (110 guineas); Hugh Frank Newall, F.R.S.; Norman D. Newall; his sale, Christie's, 14 December 1979 (177), where purchased by the present owner

Exhibited: O.W.-C.S., 1866 (121); London 1871 (Class II, 4); London 1897 (67); Liverpool 1897 (50); Newcastle upon Tyne 1989 (56)

Literature: Art Journal, 1866, p. 174; *Athenaeum*, 1866, p. 676; Hunt 1924–5, p. 30

Private collection

1 *New Letters of Robert Browning*, ed. William C. De Vane and Kenneth L. Knickerbocker, (New Haven, 1950), pp. 172–3.

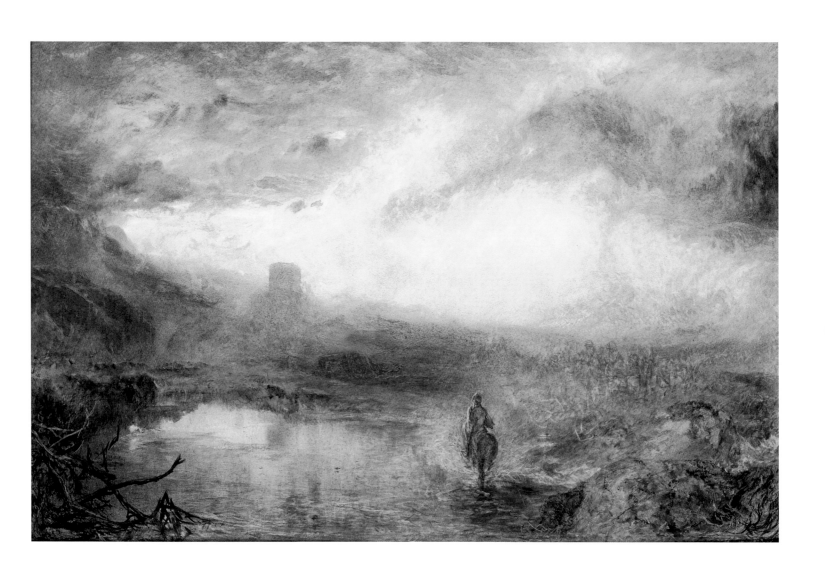

'CHILDE ROLAND TO THE DARK TOWER CAME'

38
A Bit of Old England Half Asleep c.1868

Watercolour, 34 x 51.8 cm; 13¼ x 20¼ in

A Bit of Old England Half Asleep was one of the first of Hunt's south-country views, representing a gentle river flowing through an open landscape. It shows the Thames at Pangbourne, with the White Swan public house in the distance. The river divides into various separate streams below the weir at Pangbourne, as is shown in the watercolour. Further to the west, the ground rises up, with the river flowing beside a steep bank on its south side, again as is seen in the distance in Hunt's view.

Among Hunt's other Old Water-Colour Society exhibits in 1868 were views at Pangbourne, Goring, and Streatley. These are villages on the Thames to the north-west of Reading, and each had previously attracted the attention of Hunt's friend George Price Boyce. Boyce himself had painted a view of the White Swan, although from a closer vantage point, in 1863–4,[1] and it is possible that he may have encouraged Hunt to visit the upper Thames valley. Boyce, and presumably Hunt as well, discovered how easy it was to travel out into the countryside to the west of London by train from Paddington.

Provenance: Robert Stirling Newall, F.R.S.; Frederick Stirling Newall; Sylvia Fergusson; Norman D. Newall; his sale, Christie's, 14 December 1979 (182), where purchased by the present owner

Exhibited: O.W.-C.S., 1868 (266); London 1884 (19); Newcastle upon Tyne 1887 (913); London 1897 (113); Liverpool 1897 (103)

Literature: *Athenaeum*, 9 May 1868, p. 667; *Athenaeum*, 27 September 1873, p. 408

Private collection

1 See Christopher Newall & Judy Egerton, George Price Boyce (exh. cat, Tate Gallery, 1987) (39).

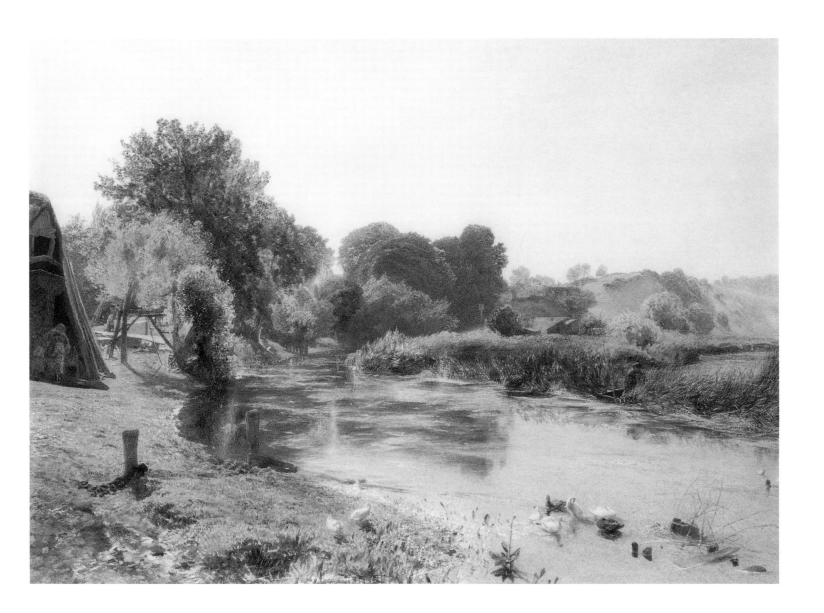

39
*Loch Torridon c.*1869

Watercolour, 12.7 x 26.7 cm; 5 x 10½ in

IN FEBRUARY 1860, Hunt discussed plans for the coming painting season in a letter to William Greenwell: 'Where are you inclined to go this summer? What do you say to Glen Nevis & Skye[?] For purely artistic reasons I should prefer Scotland to Wales – but I am afraid Wales it will be'.[1] In fact, the Scottish painting tour was postponed until 1868, when Hunt was invited to cruise on the west coast in a friend's sailing yacht.[2] Thus Scottish subjects first appeared at the Old Water-Colour Society winter exhibition of 1868–9. Hunt may have returned to the Highlands in the summer of 1869, perhaps painting the two views of Torridon and a work entitled *The Foundation of the Hills* (untraced) that he showed in 1870. Loch Torridon is a large sea-loch in Wester Ross, which opens onto the Inner Sound between Skye and the north-western Highlands coast.

Provenance: Daniel Oliver, F.R.S.; (…) Robert Stirling Newall, F.S.A., by whom bequeathed, 1978

Exhibited: O.W.-C.S., 1870 (210); London 1897 (119)

Literature: *Athenaeum*, 14 May 1870, p. 649

Ashmolean Museum, Oxford. Bequeathed by Robert Stirling Newall, F.S.A., 1978 (WA 1978.16)

1 Violet Hunt Papers.
2 Information from Alan Fox-Hutchinson.

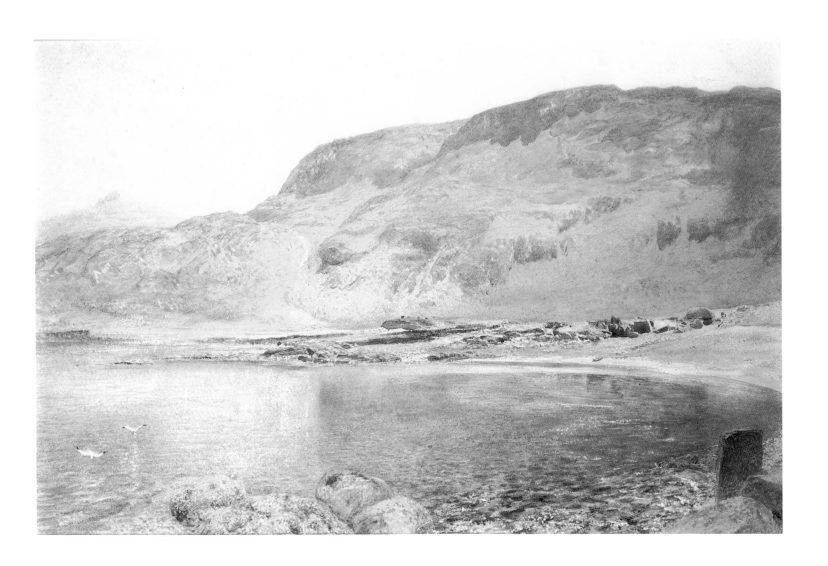

LOCH TORRIDON

40

A Land of Smouldering Fire c.1869–70

Pen and sepia ink and wash, 24.8 x 35 cm; 9⅞ x 13¾ in

ALFRED AND MARGARET HUNT made a long Mediterranean tour in the winter of 1869–70, as the guests of Sidney Courtauld. Plans for the journey were being made in October 1869, as is indicated by a letter from Ruskin to Margaret, which concludes: 'Here is the first wild winter day. May you soon be in fairer climate – & happy there'.[1] On 15 July 1870 correspondence between the Hunts and Ruskin resumed, when the latter wrote: 'My dear Hunt I am very sorry your letter has been so long unacknowledged. I have been in Italy, and forbid my letters to be sent to me. And you have been –

Everywhere! I am sure the notes in the little books will be very useful, whether realizable or not. – & the memories still more so'.[2] This is the compositional study, perhaps drawn directly from the motif in Naples or worked up from sketchbook studies, from which the finished watercolour of the subject (cat. no. 41) was made.

The Hunts had travelled with Courtauld on his yacht, the *Egidia*, and reached Constantinople and the coast of Palestine. They also visited Athens, where Hunt made drawings on the Acropolis.

Provenance: Daniel Oliver, F.R.S.; (…) Norman D. Newall; his sale, Christie's, 14 December 1979 (204), where purchased by the present owner

Exhibited: London 1897 (121)

Private collection

1 Quoted Secor 1982, p. 34.
2 Ibid., pp. 34–5.

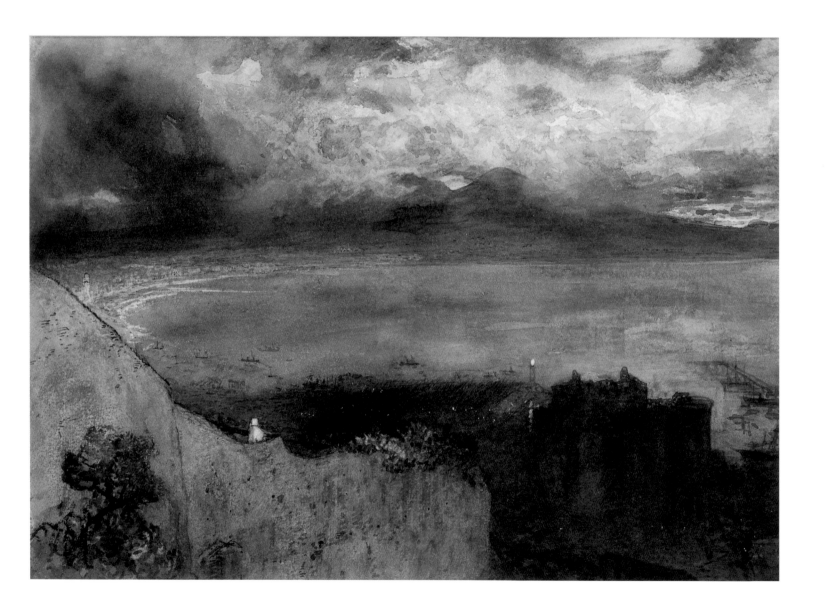

41
Bay of Naples – A Land of Smouldering Fire 1871

Signed and dated: *AW HUNT 1871*

Pencil and watercolour, with gum Arabic heightened with touches of bodycolour and with scratching out, 49.5 x 75.3 cm; 19½ x 29 ¾ in

H UNT'S GREAT VIEW of Naples was the outcome of the trip that he and Margaret made to the Mediterranean in the winter of 1869–70. It was presumably worked up from sketchbook studies and the larger sepia compositional sketch (cat. no. 40), and was finished in time to be exhibited in the summer of 1871. Although the view had been treated by countless artists and over several centuries, it is possible that Hunt's particular interest in the eastward view over the Bay of Naples towards the volcanic peaks of Vesuvius and Somma was inspired by the sight of a pair of drawings by Turner, entitled *Bay of Naples (Vesuvius Angry)* and *Bay of Naples (Vesuvius in Repose)*, which were sold at Christie's on 17 April 1869, and subsequently bought by Ruskin from the dealer Vokins.[1]

While Turner's views were taken from close to the shore, Hunt found an even more spectacular vantage point on the Vómero, the hill to the west of the medieval city, at the crest of precipitous slopes. The wall that runs across the left foreground of the composition is the south-west flank of the Castel Sant'Elmo, part of the system of fortifications built in the mid-sixteenth century by the Spanish viceroy Toledo (and to which a later viceroy retreated for safety during the uprising of Masaniello in 1647). The Certosa di San Martino stands immediately beside the Castel Sant'Elmo on the brow of the hill, out of view to the left. The great building towards the right, seen in outline against the waters of the bay, is the Castel Nuovo, the historic base of Angevin power in the city and a fortress that dates from 1279. Its five defensive

towers with machicolations are visible, in spite of the subdued effect of light. Further to the left are the quays and wharfs of the Bacino del Piliero, with a lighthouse marking its south-eastern corner, and with smoke rising from the funnels of a berthed ship. The eastern part of the city is glimpsed on the left side, leading beyond into the neighbouring towns of Portici and Ercolano (on the shore) and San Giorgio a Cremano (on the flank of the volcano).

Hunt's watercolour shows the Bay of Naples at the moment when there is a last gleam of light from the west. The tufa wall of the Castel Sant'Elmo is bathed in the dying radiance of the winter sun, and the clouds in the eastern sky and the plume of smoke rising from the crater of Vesuvius are still lit with the sun's rays. A series of eruptions occurred between December 1870 and April 1872, so that Hunt and the fellow members of his party may have observed Vesuvius with particular interest.

Bay of Naples was shown at the Old Water-Colour Society in 1871, together with what was presumably a Welsh subject entitled *A Land of Antique Slate* (untraced). A connection between the two was inferred by F.G. Stephens in his review in the *Athenaeum*, in their observation of landscapes in terms of their geological nature, and 'by the contrasted effects [of light] adopted'. Stephens continued that, 'apart from its power in rendering the subject, with all its grandeur and sentiment', *The Bay of Naples* was 'a masterpiece of chiaroscuro, [and] the best of Mr Hunt's watercolour pictures'.[2]

1 Wilton 1979 (698 and 699); now in the Williamson Art Gallery, Birkenhead, and a private collection respectively.
2 *Athenaeum*, 6 May 1871, p. 565.

Provenance: Humphrey Roberts, by 1884; his sale, Christie's, 23 May 1908 (254) (56 guineas to Dunthorne); (…) Christie's, 16 October 1981 (4); David Fuller; his sale, Christie's, 7 April 2000 (46), where purchased

Exhibited: O.W.-C.S., 1871 (70); Wrexham 1876 (690); London 1884 (30); Manchester 1887 (1268); London 1897 (76); Liverpool 1897 (150); Glasgow 1901 (987) London 1901 (139); London 1993 (176)

Literature: *Athenaeum*, 6 May 1871, p 565; Wedmore 1891, p 107; Wilton 2000–2001, fig. 30

Metropolitan Museum of Art, New York. Purchase, Florence B. Selden Bequest, 2000 (2000.318)
© The Metropolitan Museum of Art, 2004

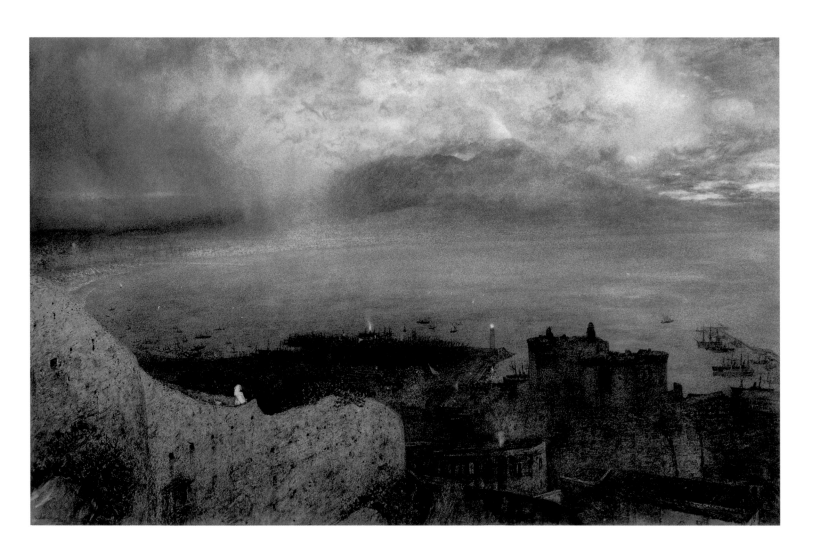

BAY OF NAPLES — A LAND OF SMOULDERING FIRE

42

Sunset off the Morea 1871

Watercolour , 27.3 x 54.4 cm; 10¾ x 21½ in

T HIS WATERCOLOUR DRAWS on Hunt's sketches and
memories of his Mediterranean tour of 1869–70. 'Morea'
was the name given in the Middle Ages to the peninsula that
forms the southern mainland of Greece, now called the Pelo-
ponnesus. The archaic place-name was still in use in the mid-
nineteenth century: William Leake's *Travels in the Morea* was
published in 1830, and H.J.G. Herbert's *Reminiscences of Athens
and the Morea* in 1869.

Provenance: William J. Newall,
by 1884; Mary Newall, by 1897;
Mrs Shearman; Robert Stirling
Newall, F.S.A., by whom
bequeathed

Exhibited: O.W.-C.S., 1873 (278);
London 1884 (13); London 1897
(16); Liverpool 1897 (109)

Literature: *Athenaeum*, 3 May
1873, p. 572; *Spectator*, 23 Janu-
ary 1897, p. 124

Ashmolean Museum,
Oxford. Bequeathed by
Robert Stirling Newall,
F.S.A., 1978 (WA 1978.14)

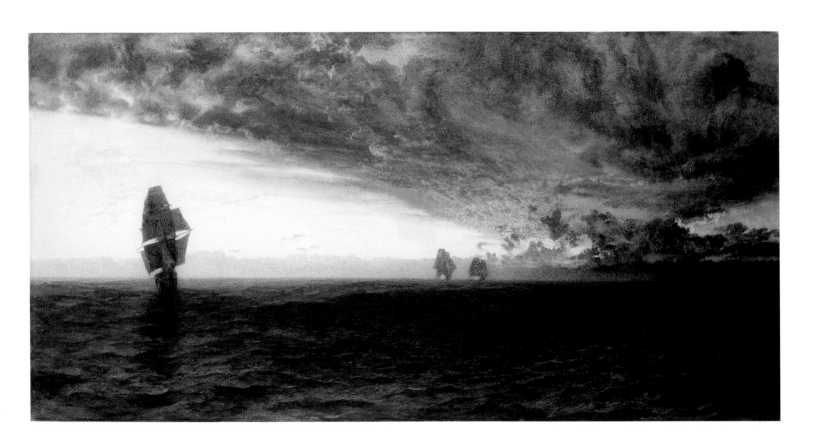

SUNSET OFF THE MOREA 135

43

Bamborough Castle 1871

Pencil and watercolour with gum Arabic, touches of bodycolour and scratching
out, 38.1 x 55.3 cm; 15 x 21⅞ in

H UNT'S VIEW OF BAMBURGH shows the castle in the
distance and to the south-east. His vantage point was
the Harkess Rocks, the reef that interrupts the sandy beaches
of the north Northumberland coast. Hunt made many views of
Bamburgh from this point, as well as various detailed fore-
ground studies of the patterns and colours of the rock forma-
tions. A beautiful summer's afternoon allows the castle to be
seen bathed in sunlight, while in the foreground children
clamber over the rocks and seaweed. On the far right is the
village of Bamburgh with its parish church, St Aidan's.

According to Alan Fox-Hutchinson, Alfred and Margaret
Hunt stayed with Robert Stirling Newall and his wife Mary in
a flat in the castle keep, which in the summer of 1871 had been
let to them by the trustees of Lord Crewe.[1] The building was
then still largely in its medieval condition, before its recon-
struction in the baronial style by Lord Armstrong. The visit
to north Northumberland, which was one of many undertaken
by Hunt in the early 1870s (on other occasions he stayed at the
Castle Inn in Bamburgh), led to works in oil and watercolour,
including *A Sea-fret hanging over Dunstanborough* (Ashmolean
Museum, Oxford) and *Moon rising over Bamburgh* (untraced),
both shown at the Royal Academy in 1872. With the present
Bamborough Castle at the Old Water-Colour Society in 1872
was a drawing entitled *Harkus Rocks, Bamborough* (untraced),
'Harkus' being a phonetic spelling of Harkess in the local
dialect.

Provenance: John Wheeldon
Barnes, F.S.A., by 1884; his sale,
Christie's, 7 April 1894 (132) (21
guineas to Mitchell); Norman
Charles Cookson, by 1897; Mrs
Shearman; (…) Norman D.
Newall; his sale, Christie's, 14
December 1979 (172); (…)
David Fuller; his sale, Christie's,
7 April 2000 (32)

Exhibited: O.W.-C.S., 1872 (229);
London 1884 (37); London 1897
(95, as 'Bamborough. Sunny');
Liverpool 1897 (117); Newcastle
upon Tyne 1953 (50)

Literature: *Athenaeum*, 27 April
1872, p. 531; *Athenaeum*,
6 November 1875, p. 616

The Fuller Collection

1 Alan Fox-Hutchinson

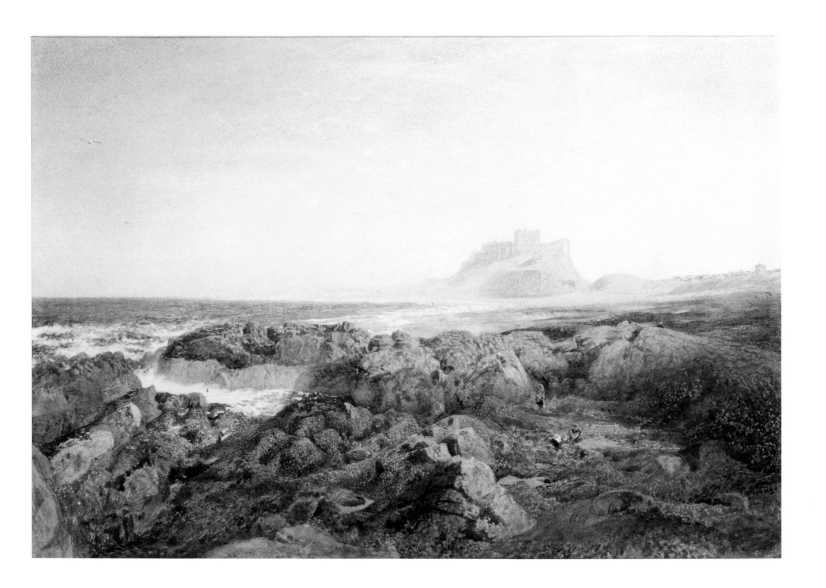

44

The Stillness of the Lake at Dawn 1873

Signed and dated: *AWH 1873*
Watercolour, 24.7 x 34.6 cm; 9¾ x 13 ⅜ in

THIS ETHEREAL WATERCOLOUR shows the view across Coniston Water towards the Coniston fells. On the horizon at the left is the peak of The Old Man of Coniston, while at the centre of the composition is Yewdale Crag. The artist's vantage point was at Parkamoor, about two miles south of Brantwood, Ruskin's Lakeland home, on the eastern shore of Coniston Water. Hunt was looking towards the north-west, and therefore had the rising sun behind his right shoulder.

Ruskin bought Brantwood, sight unseen, in 1871. In the early summer of 1873, plans were made for the Hunts' second daughter, Venetia, who was Ruskin's god-daughter and whom he renamed Venice, to spend a month or so at Brantwood. Alfred was to bring her up from London, find lodgings for himself in Coniston village, and use them as a base for painting expeditions. In excited anticipation of his visit, which was planned for the end of May, Hunt wrote to Ruskin: 'Coniston Old Man must have some nooks with yew trees, rocks and streams, and old farm buildings, which will serve me for my summer's work. It is many years since I was in that country … Only may there not be too much rain!'[1] Ruskin responded from Oxford on 21 May: 'I wish you could come sooner – I'm beginning to ask "when the day is" but Friday 30th will do'.[2] He went on to reassure Hunt that the Lakeland landscape would be up to his expectation: 'The scenery is – I think – the best in England – I don't know Wales. – But there are more subjects in any twenty furlongs than in twenty miles of other country. Only you don't care so much about hill cottages as I do. – As for moor or mountain – I have rocks within two miles of me as fine as the St Gothard'.[3]

The visit to Coniston, and his renewed exposure to Ruskin's criticism, seems to have been an uncomfortable experience for Hunt. We know little about what actually passed between the two men, but Ruskin was in a morose frame of mind, and disposed to find fault. Hunt, by then forty-three years old, may not have wanted to be cast in the role of pupil, but held Ruskin in such awe that he was prepared to defer to him. Hunt was a sensitive and vulnerable individual; wounded by Ruskin's lack of appreciation of what he was trying to do, it seems to have taken a few months before he could review the events of the summer. On 2 November, he wrote to Ruskin: 'I have been at home long enough now to regard my Coniston life from a proper distance – a distance of time which makes me know how happy I was there and how much your kindness did to make me happy. Perhaps I may have to thank you yet for something which won't make me happier – but that will be just as I use it – namely an advance in Self-knowledge[,] which makes me look back upon all old work with a very calm seriousness'.[4] On 6 November, Ruskin replied, perhaps with relief at finding that he was not accused of any malice: 'It is a great comfort to me to have this letter from you: and to know that you do not think of Coniston with pain, – although I know at times I must have inflicted a little on you'.[5] On another occasion he recalled the happy times that they had had together: 'I wish we [Ruskin himself, and Venetia Hunt] were in the boat and tumbling into the lake again – and that you were being looked for along the road'.[6]

The Stillness of the Lake at Dawn is unique in Hunt's work. Abstracted and indefinite in its forms, it conveys the rapturous feelings that he had for the lake and fells. When shown at the Old Water-Colour Society in 1874, F.G. Stephens described it as 'true, delicate and exquisite' and concluded that it was 'a sort of enchantment which the artist exercises when painting like this'.[7] Ruskin, however, continued to chide Hunt for the indefiniteness and absence of distinct outline in his work, two years later protesting to Margaret: 'Alfred can't rest in stipple and mist – still less in slobber; but yet he *won't* go through the strait gate'.[8]

1 Secor 1982, pp. 48–9
2 Ibid., pp. 49–50.
3 Violet Hunt Papers (Secor 1982, pp. 49–50 gives the entire text of the letter, from a copy in the Ford Madox Ford Papers, but with errors of transcription).
4 Secor 1982, p. 65.
5 Ibid., p. 67.
6 Secor 1982, p. 72.
7 *Athenaeum*, 25 April 1874, p. 566.
8 Secor 1982, p. 83.

Provenance: Humphrey Roberts; his sale, Christie's, 23 May 1908 (264); (…) Bill Waters, Cockermouth, from whom purchased by the present owner

Exhibited: O.W.-C.S., 1874 (288); London 1884 (95); London 1897 (25); Liverpool 1897 (148); Phoenix 1993 (12)

Literature: *Athenaeum*, 25 April 1874, p. 566; *Art Journal*, 1874, p. 168; Hewison 2000, p. 210, fig. 11

Private collection

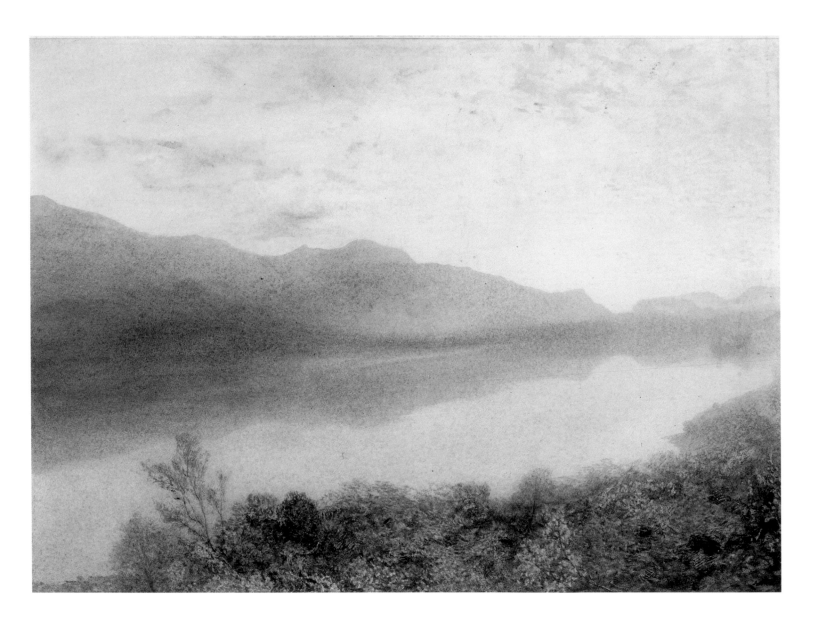

THE STILLNESS OF THE LAKE AT DAWN

45

Loch Maree – A Lifting of the Mists at Sunset 1876

Signed and dated: *AW Hunt 1876*

Pencil and watercolour, with gum Arabic and with scratching out, 33 x 52.7 cm; 13 x 20⅞ in

H UNT EXPLORED THE west coast of Scotland on one or more occasions in the late 1860s (see cat. no. 39). He showed a painting entitled *Loch Maree – sunset* (untraced) at the Royal Academy in 1871, where it was praised by Ruskin in a letter to Margaret: 'How well Alfred's Loch looks at the Academy – Almost the only pleasant picture there, except [J.C.] Hook's'.[1] Hunt may have returned to the west coast several times in the 1870s, as Scottish subjects occur regularly among his exhibits in this period.

Loch Maree, in Wester Ross, lies to the north of Loch Torridon, and unlike Torridon is a body of water closed to the sea. Hunt shows a level foreground, with steep mountainsides beyond. The loch itself, which is about thirteen miles long, is only suggested – at the left side of the composition – and lies concealed in a haze of light. It seems likely that the view was taken at the head of the loch, towards Kinlochewe, where various tributary streams gather. To the north of this southeastern end of the loch are the mountains Beinn Mhuinidh and Beinn Slioch.

This watercolour is a good example of Hunt's love of luminescent effects, seen as sunlight breaking through mist or cloud, and giving a great feeling of the constant fluctuation in the direction and quality of light in places where meteorological conditions are never constant. In May 1873, he responded to a friend who had previously described a particular landscape effect: 'Your letter makes me wish to get away from London and to mountains. That "transparent gloom" you speak of is the most lovely thing in nature, and the mere thought of it has the power to give me fresh energy for one more endeavour to represent it'.[2] Ruskin commented on Hunt's propensity, ever more marked as his career went on, to show the landscape suffused in veils of soft and nebulous haze, writing to Margaret early in 1876: 'It is true he sees things misty – no harm in that – but whatever he sees may be expressed simply instead of laboriously'.[3]

Provenance: Sir Thomas Rains; (…) Christie's South Kensington, 10 May 1982 (115); Chris Beetles; David Fuller; his sale, Christie's, 7 April 2000 (34)

Exhibited: O.W.-C.S., 1877 (17); New Haven 1992 (79)

Literature: *Athenaeum*, 28 April 1877, p. 552

The Fuller Collection

1 Violet Hunt Papers.
2 Hunt's letter to the Revd W. Knight of Dundee is in the Pierpont Morgan Library, New York.
3 Ibid.

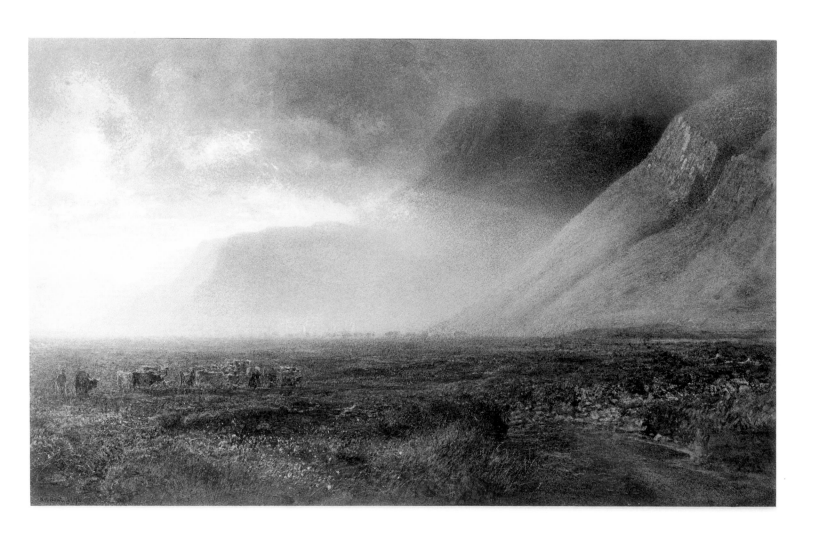

LOCH MAREE – A LIFTING OF THE MISTS AT SUNSET

46

Loch Maree 1876

Signed and dated: *AWH 1876*
Watercolour, 32.6 x 51.4 cm; 12⅞ x 20¼ in

BOTH OF HUNT'S Loch Maree watercolours (cat. nos. 45–6), the first of which was exhibited at the Old Water-Colour Society in 1877 and the second two years later, were enthusiastically received by F.G. Stephens in his *Athenaeum* reviews. Of the first, Stephens described 'a mystery of gold and fire-suffused air, [with] vapours rising slowly and glowing as they rise with subtle illumination, [and] which burn without shadows and without form, and yet fills the whole wide valley between the mountain sides'.[1] He characterised the second more simply as a drawing of 'wild grandeur'.[2]

Provenance: Humphrey Roberts; his sale, Christie's, 23 May 1908 (256), where purchased

Exhibited: O.W.-C.S., 1879 (287)

Literature: *Athenaeum*, 3 May 1879, p. 577

Victoria and Albert Museum, London (D. 1299–1908)

1 *Athenaeum*, 28 April 1877, p. 552.
2 *Athenaeum*, 3 May 1879, p. 577.

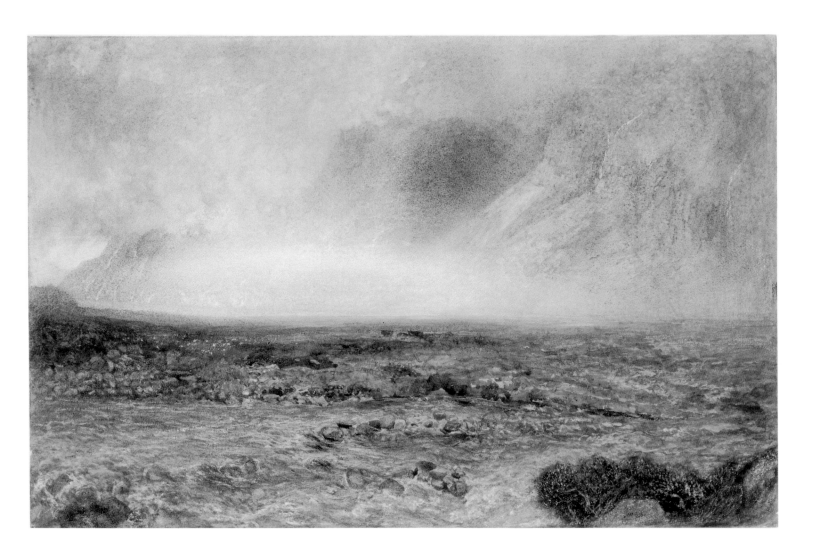

LOCH MAREE

47
*Mont St Michel from the Sands c.*1876

Watercolour, 26.5 x 34.5 cm; 10⅜ x 13⅝

T HIS IS ONE OF a series of sketches of the medieval
architecture of Mont St Michel. Here, the whole town,
with its abbey church at the highest point, is seen from a dis-
tant vantage point. Hunt made distant studies of Mont St
Michel in a sketchbook dated June 1876,[1] as well as further
sketches of the winding pathways through the town in another
sketchbook; the numerous other watercolours and studies of
this subject may be assumed to date from this visit. Hunt
clearly had great difficulty in finding a satisfactory viewpoint,
and both the sketchbooks and several aborted watercolours in
the Ashmolean show him looking at the ramparts from differ-
ent angles and distances. Indeed, he sent no finished drawing
of Mont St Michel to the exhibition of the Old Water-Colour
Society until 1884. However, he showed sketches of the site,

perhaps including cat. nos. 47–9, at the winter exhibitions of
1887–8 and 1888–9.

A small church had existed on a rock standing on the tide-
washed sands of the Sélune River since before the end of the
first millennium. In the eleventh century, Mont St Michel, by
then part of a Benedictine monastery, found itself on the west-
ern perimeter of the territory of the Duke of Normandy.
Because of its strategic importance, the town grew, and new
and more elaborate buildings were made. The nave of the new
church was complete by the time of the Norman invasion of
England, in 1066. The building of the town continued apace
into the twelfth century, encouraged by Henry II of England,
who was instrumental in the expansion of the monastery.

47a *Studies of Mont Saint Michel.* 1876. Sketchbook no. 173.

1 Sketchbooks nos. 43 and 173.

Provenance: as cat. no. 25

Ashmolean Museum,
Oxford. Presented by Mrs
W.A.S. Benson and Mrs
Fogg-Elliot, the artist's
daughters, 1918 (WA
1918.7.41)

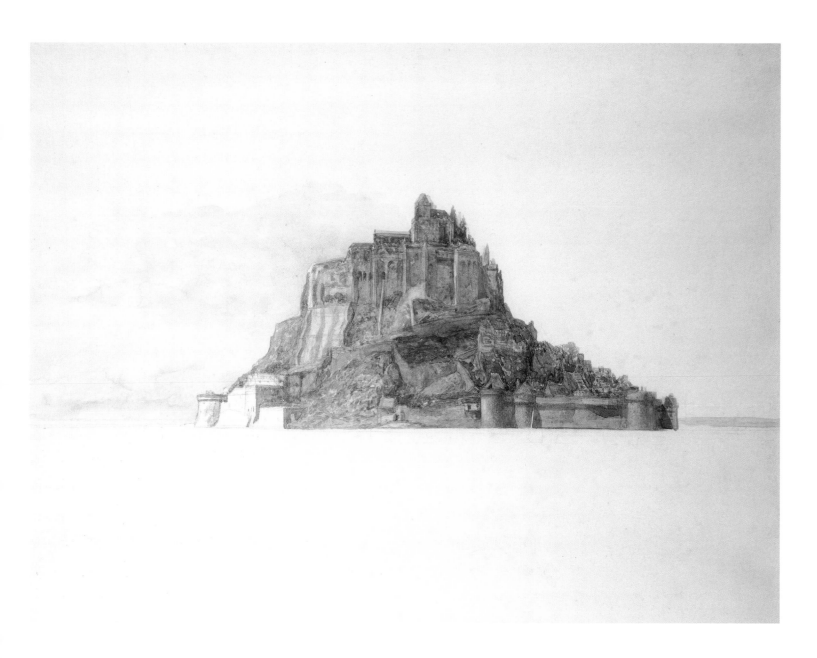

MONT ST MICHEL FROM THE SANDS

48

Mont Saint Michel: Le crypte de l'Aquilon
*c.*1876

Black, white and brown chalks with ink over graphite, 24.5 x 33.5 cm;
9¾ x 13¼ in

T HE CRYPT OF THE *Aquilon* lies beneath the *Salle des Hôtes*, beside the abbey church of Mont St Michel and on its south side. This was the place where alms were offered to visitors to the abbey or the poor of the community. The vaulted roof, supported by a single row of central columns, was built in 1112.

This is one of Hunt's rare interior views, and perhaps reflects both his fascination with the Mont St Michel itself, and his difficulty in finding a wholly satisfactory subject there.

Provenance: as cat. no. 25

Ashmolean Museum, Oxford. Presented by Mrs W.A.S. Benson and Mrs Fogg-Elliott, the artist's daughters, 1918 (WA 1918.7.44)

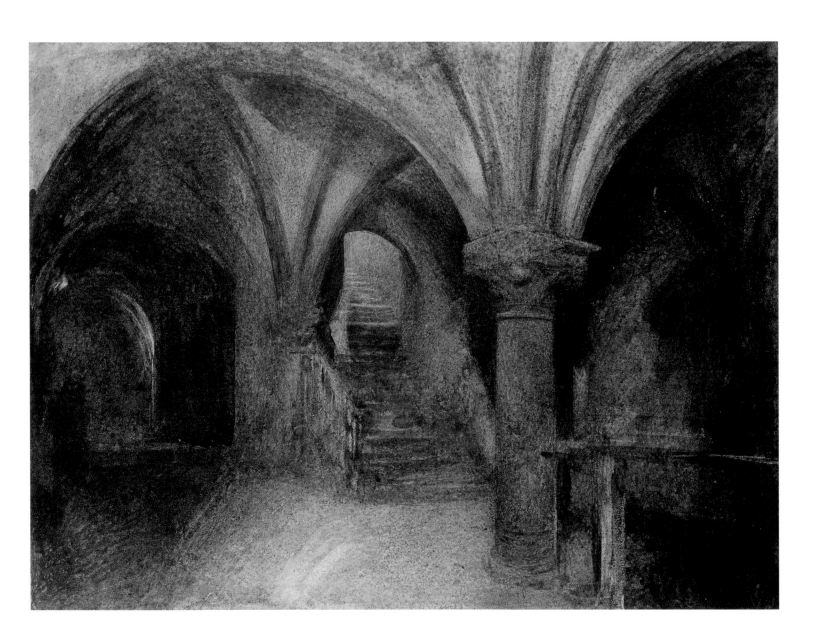

49

*The Ramparts, Mont St Michel c.*1876

Watercolour with gum Arabic and with scratching out, 28 x 38.7 cm; 11 x 15¼ in

A T THE FOOT OF the rock upon which Mont St Michel
is built is a barbican that protects the entrance to the
monastery. Fortification took place in the thirteenth century,
when the *Tour du Nord* was constructed. *The Tour Boucle*, oth-
erwise known as the *Bastillon*, was built at the beginning of
the fifteenth century, during the Hundred Years' War.

Hunt shows Mont St Michel as the tide advances. A cart on
the left side appears to be up to its axles in seawater.

Provenance: (…) Chris Beetles;
David Fuller; his sale, Christie's,
7 April 2000 (42)

The Fuller Collection

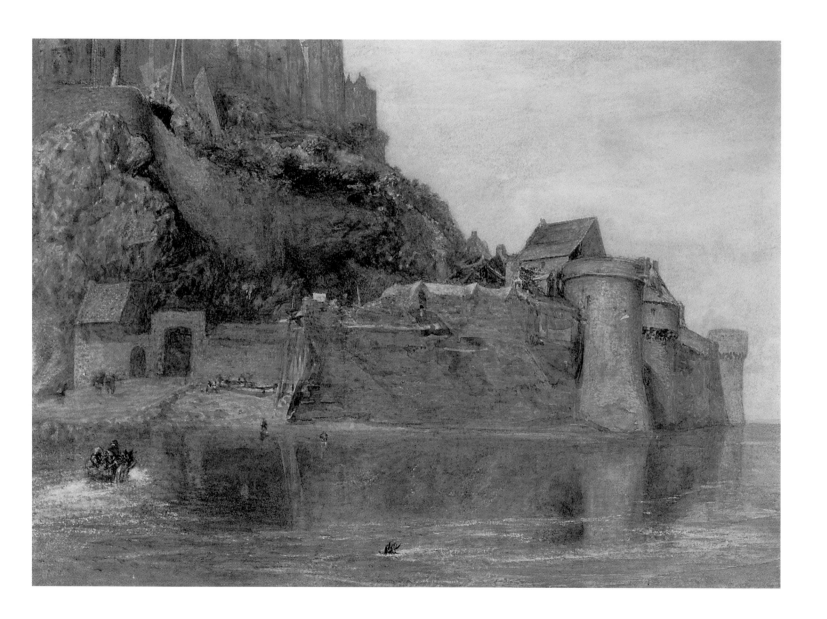

THE RAMPARTS, MONT ST MICHEL 149

50

Mont St Michel: The Walls and Bastions
*c.*1876

Watercolour, 18.1 x 27.3 cm; 7⅛ x 10⅝ in

Provenance: as cat. no. 25

Ashmolean Museum,
Oxford. Presented by Mrs
W.A.S. Benson and Mrs
Fogg-Elliott, the artist's
daughters, 1918 (WA
1918.7.42)

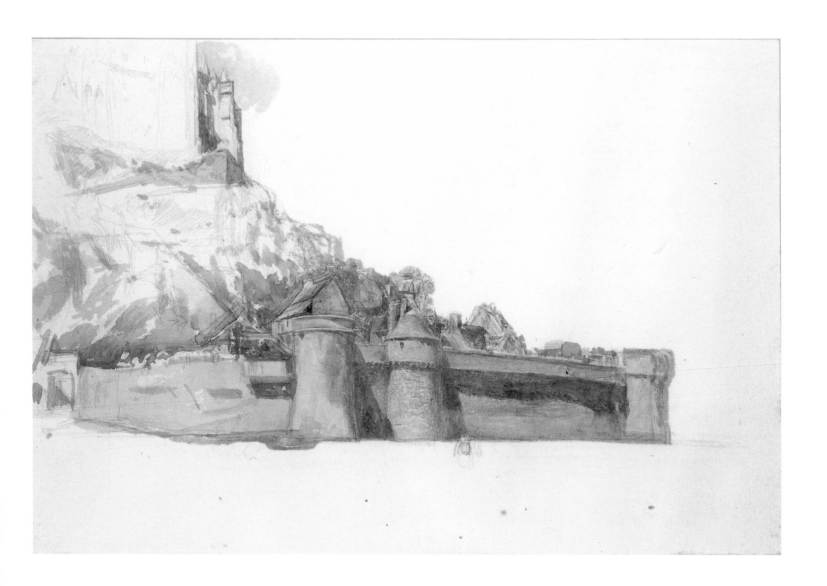

51

Mont St Michel: The Outer Gate c.1876

Watercolour, 19.4 x 27.5 cm; 7⅝ x 10⅞ in

Provenance: as cat. no. 25

Ashmolean Museum, Oxford. Presented by Mrs W.A.S. Benson and Mrs Fogg-Elliott, the artist's daughters, 1918 (WA 1918.7.43)

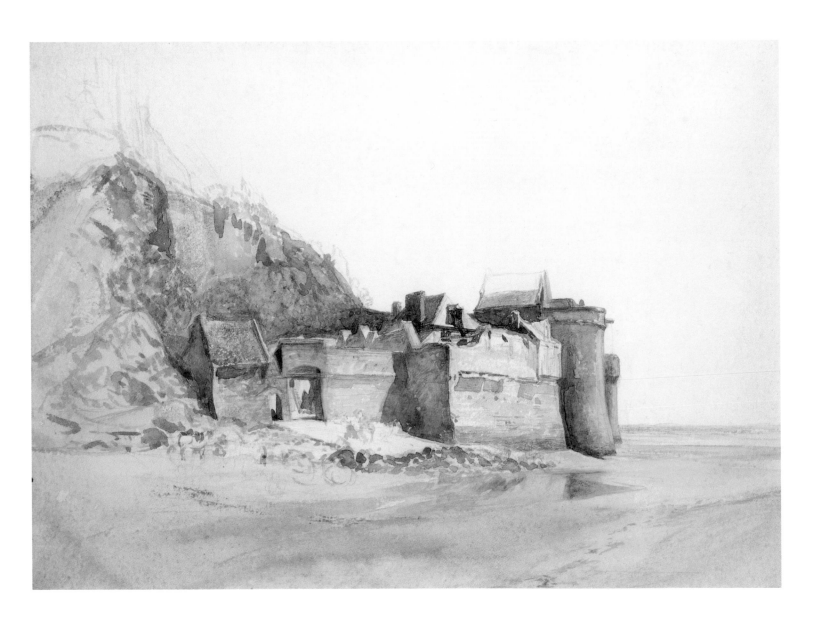

MONT ST MICHEL: THE OUTER GATE

52

Leafy June 1878

"A joy annihilating all that's made,
To a green thought in a green shade."

Oil on canvas, 87.5 x 122.4 cm; 34¾ x 48¾ in

T HE VERSE THAT accompanied this painting when it was shown at the Royal Academy in 1879 was adapted by Hunt from the last two lines of the sixth stanza of Andrew Marvell's poem 'The Garden'. The poem had been written in 1650–52, during the period that Marvell was tutor to Mary, daughter of the parliamentarian general, Thomas Fairfax, at Nun Appleton in Yorkshire. Marvell's poetry was little known in the nineteenth century, and only gained a wider appreciation following the publication in 1921 of Herbert Grierson's *Metaphysical Lyrics*.

This painting may be identified as a view on the River Greta, by comparison with drawings in sketchbook no. 52. The steep-sided and densely wooded banks of the Greta, from Rokeby, where the river joins the Tees, past the village of Brignall, lying to the south of Barnard Castle in County Durham, were among Hunt's favourite painting grounds. He first exhibited a Greta subject in 1859, at the Royal Academy, as well as an oil, *Brignall Banks* (see p. 17), at the Society of British Artists in 1860. Turner's watercolour *Junction of the Greta and Tees at Rokeby*,[1] of 1816–18, which belonged to Ruskin from 1856, was presumably known to Hunt.

Provenance: John Arthur Kenrick, by whom presented, 1925

Exhibited: R.A., 1879 (98); Manchester 1887 (31)

Literature: *Athenaeum*, 7 June 1879, p.734; *Athenaeum*, 19 January 1884, p. 94

Birmingham Museums and Art Gallery (1925.P.339)

1 Wilton 1979 (566).

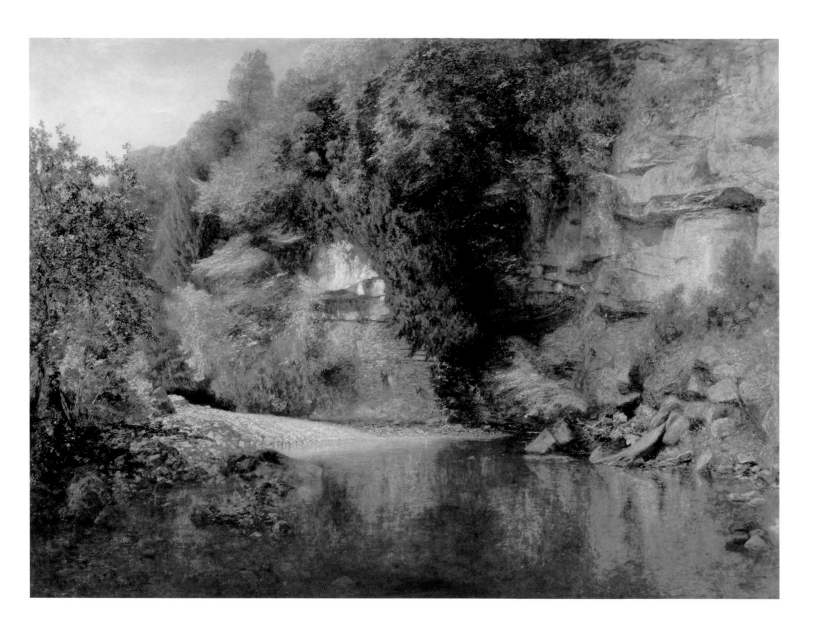

53

Low Tide on the Scaur, Whitby – 'A Case for Plimsoll' c.1875

Watercolour with scratching out, 49.3 x 74 cm; 19¾ x 29¼ in

THIS WATERCOLOUR shows the level slabs of rock and stony beach below the cliff headland at Whitby. The north-facing coastline between the mouth of the Esk and a rock promontory to the east called Saltwick Nab is now known as The Scar. This was a notoriously dangerous coastline, frequently swept by storms, and where many ships foundered. The watercolour shows the coast on a morning after a shipwreck; at the centre of the composition a group of figures gathers around the remains of the vessel. Turner's watercolour of a similar subject, showing Whitby Abbey and the headland from further along the coast to the north-east, dates from the late 1820s.[1] Hunt's drawing had its origins in sketches made in August 1875.[2] In her memoir of her father, Hunt's daughter, Violet, remembered assisting him at work close to Whitby: 'I have sat with him, holding his watch in my hand, among the anemones and rock limpets on Whitby Scaur, scanning its face every now and then, with an anxious eye to the incoming tide'.[3]

The second part of the title of Hunt's watercolour refers to the campaign led by Samuel Plimsoll for the greater regulation of merchant shipping to improve the safety of crews. Plimsoll, who was M.P. for Derby, issued a barrage of pamphlets and newspaper articles on the issue, and stood against the entrenched interests of the ship-owners. The Merchant Shipping Act passed through the Commons in 1876; the compulsory marking of ships' hulls with lines to indicate their level in the water and as a means of detecting vessels that were overloaded was part of this new law, the marks being known as 'Plimsoll lines' in his honour.

Hunt first painted at Whitby, on the north Yorkshire coast, in the mid-1870s, perhaps in 1874, and the town quickly became a favourite subject. His first exhibited Whitby drawing appeared in 1876, and in the following year, he showed a painting entitled *On the Coast of Yorkshire* at the Royal Academy. In the summer of 1878, cat. no. 53 was one of three Whitby views that the artist showed at the Old Water-Colour Society.

The present drawing is probably that entitled *Whitby Scaur* shown in the Hunt exhibition at the Fine Art Society in 1884. In the same exhibition was a watercolour entitled *Wreck Ashore – Yorkshire Coast* (no. 34). A version in oil of cat. no. 53 is in Birmingham City Art Gallery.

54a *Studies of Rigging and Wreckage.* August 1875. Sketchbook no. 42.

1 Wilton 1979 (905). 2 Sketchbooks nos.42 and 171.
3 Hunt 1924–5, p. 37.

Provenance: F.S. Teesdale, by 1884 (?); W.A.S. Benson, by 1897; (…) E.C. Dewick, by whom presented, 1919

Exhibited: O.W.-C.S., 1878 (130); London 1884 (20, as 'Whitby Scaur') (?); London 1897 (82); Liverpool 1897 (91); Ravenna 2004 (88)

Literature: *Athenaeum*, 11 May 1878, p. 611

Williamson Art Gallery, Birkenhead

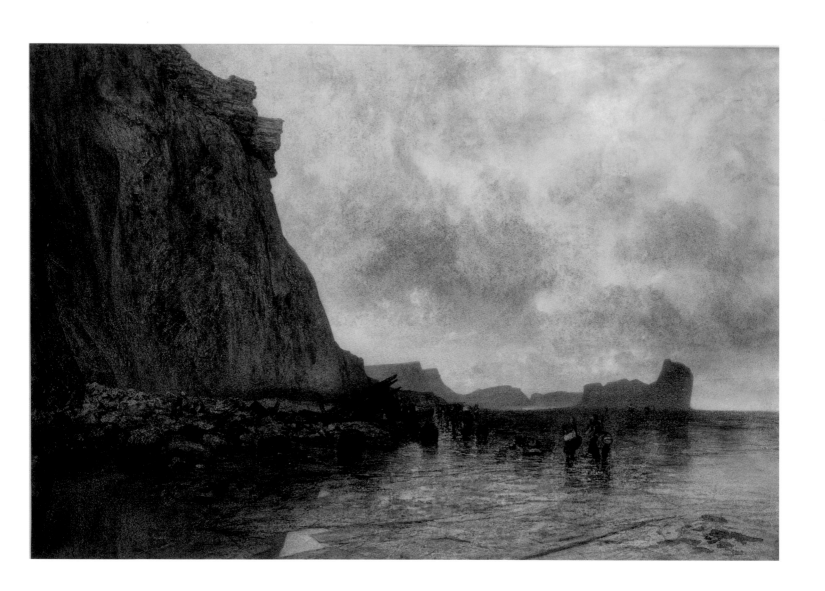

LOW TIDE ON THE SCAUR, WHITBY — 'A CASE FOR PLIMSOLL'

54

Whitby Harbour late 1870s

Pencil and watercolour with scratching out, 27 x 36.8 cm; 10⅝ x 14½ in

AFTER HIS FIRST VISIT to Whitby in *c.* 1874, Hunt returned frequently, and produced some two dozen exhibited views of the picturesque town and neighbouring coastline, as well as countless sketches and colour studies. This drawing was made from one of the artist's favourite vantage points, close to the railway station, or even perhaps from the station roof,[1] and with a view of the harbour and quays. On the headland above is the outline of Whitby Abbey.

Provenance: (…) Chris Beetles; David Fuller; his sale, Christie's, 7 April 2000 (28)

The Fuller Collection

1 Violet Hunt, in her memoir of her father, described his 'perch on the broad roof of Whitby station, overlooking the harbour, [to which he had access] by special arrangement with the station master' (Violet Hunt 1924–5, p. 36).

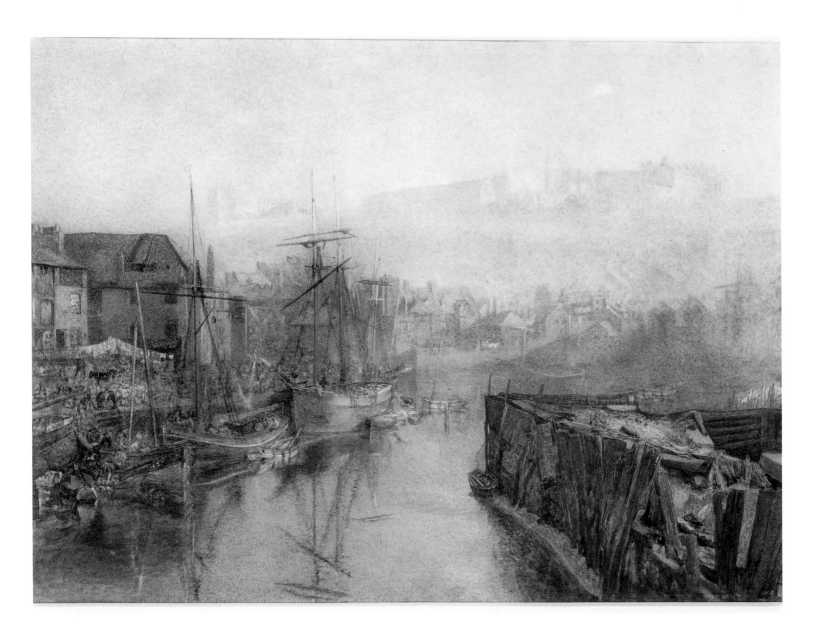

WHITBY HARBOUR

55
A Fine Evening at Whitby 1881

Signed, dated, and inscribed on reverse: *Fine evening at Whitby 1881 / A W Hunt*
Pencil and watercolour with gum Arabic and with scratching out,
39.4 x 55.9 cm; 15½ x 22 in

HUNT'S VIEW, one he treated on several occasions, was taken from the north-west, looking across the harbour and the mouth of the River Esk, towards the headland upon which stands Whitby Abbey. As the title of the drawing indicates, the weather was fine, with golden sunlight bathing the scene.

Whitby Abbey was founded by St Hilda in 657. In 664 it was the setting of the Synod of Whitby, when the decision was made on the part of the English Church to adopt Roman rather than Celtic religious ritual. Whitby was repeatedly attacked by the Danes; the entire monastery and church was destroyed in 867. The monastery was re-established in the late eleventh century. The construction of the Abbey as it exists today began in 1220 and was completed by the early fourteenth century.

Provenance: Mrs Dobson, by 1897; Victor Rienaecker; (…) David Fuller; his sale, Christie's, 7 April 2000 (25)

Exhibited: O.W.-C.S., 1881 (91); London 1897 (104); Liverpool 1897 (48); London 1993 (177)

Literature: *Athenaeum*, 23 April 1881, p. 564; Hunt 1924–5, pl. 10

The Fuller Collection

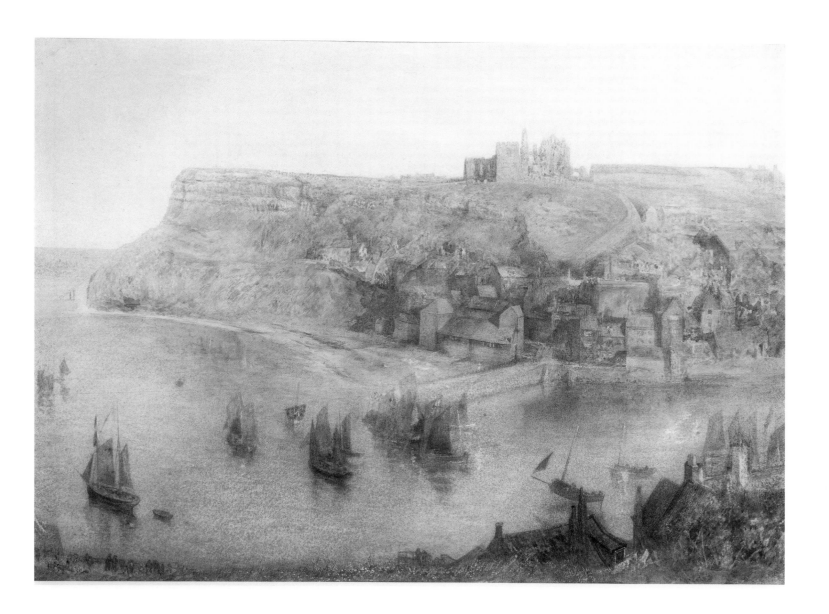

A FINE EVENING AT WHITBY 161

56

Robin Hood's Bay – Mending Nets c.1887

Watercolour, 27.2 x 38.6 cm; 10¾ x 15¼ in

T HE PICTURESQUE fishing village of Robin Hood's Bay lies about five miles to the south-east of Whitby. It occupies a wide bay, enclosed by the promontories of Ness Point and Old Peak (otherwise known as South Cheek). Hunt's view is from the south-east, and shows the way in which the streets and terraces of the town occupy a site that seems to cascade towards the sea.

Hunt showed two views of Robin Hood's Bay at the Old Water-Colours Society in 1887; the other was *Washing Day* (untraced).

Provenance: bought from the artist by William J. Newall; his sale, Christie's, 30 June 1922 (32), where purchased by Thos Agnew & Son on behalf of the present owner

Exhibited: O.W.-C.S., 1887 (227, as 'Mending Nets'); London 1897 (37, as 'Robin Hood's bay. Mending nets'); Liverpool 1897 (79)

Ashmolean Museum, Oxford. Purchased (Magdalen College Fund), 1922 (WA 1922.2)

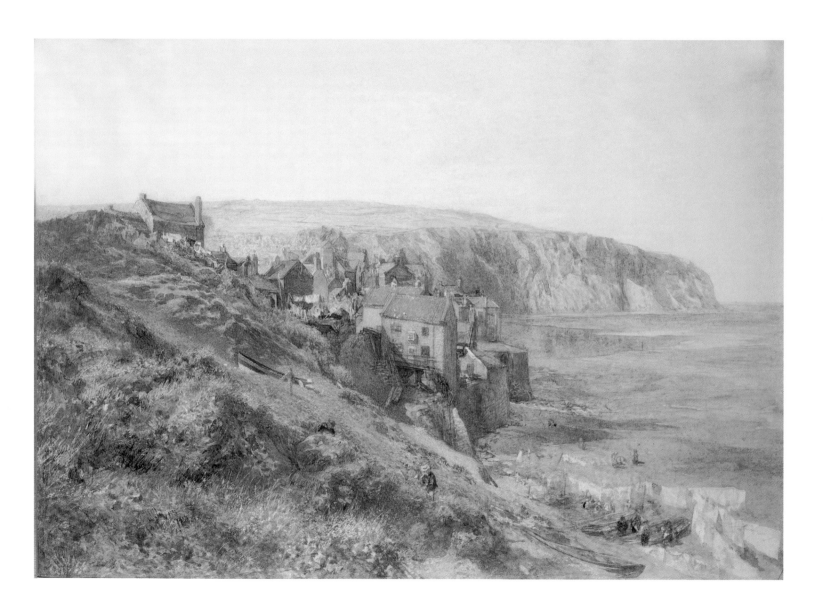

ROBIN HOOD'S BAY — MENDING NETS 163

57
Sonning Bridge c. 1882

Watercolour, 36.1 x 51.5 cm; 14¼ x 20¼ in

SONNING, ON THE Thames north-west of Reading, boasts a weir and a lock, as well as the fine bridge shown in Hunt's drawing. The bridge, which has eleven brick arches increasing in size towards the centre, dates from the late eighteenth century.

Hunt's interest in the Thames valley as a painting ground seems to have been kindled in about 1868 (see cat. no. 38), when he explored the villages and countryside along the river banks upstream from Reading. His visits to Sonning may have been made some years later: a sketchbook of Sonning views dates from May 1880,[1] while Hunt's first exhibited views of the village were shown in the summer and winter exhibitions of 1882.[2] The present sketch is one of two similar, and equally beautiful, drawings given to the Ashmolean as part of the mass of material from Hunt's studio by his two younger daughters.

Provenance: as cat. no. 25

Ashmolean Museum, Oxford. Presented by Mrs W.A.S. Benson and Mrs Fogg-Elliott, the artist's daughters, 1918 (WA 1918.7.56)

1 Sketchbook no. 119.
2 At the Royal Academy, a work entitled *Sonning: about mid-day*; at the Old Water-Colour Society, *Summer Afternoon, Sonning*, and at the Royal Birmingham Society of Artists, *Sonning Bridge*. A sketch of Sonning was shown at the Old Water-Colour Society winter exhibition in 1882–3.

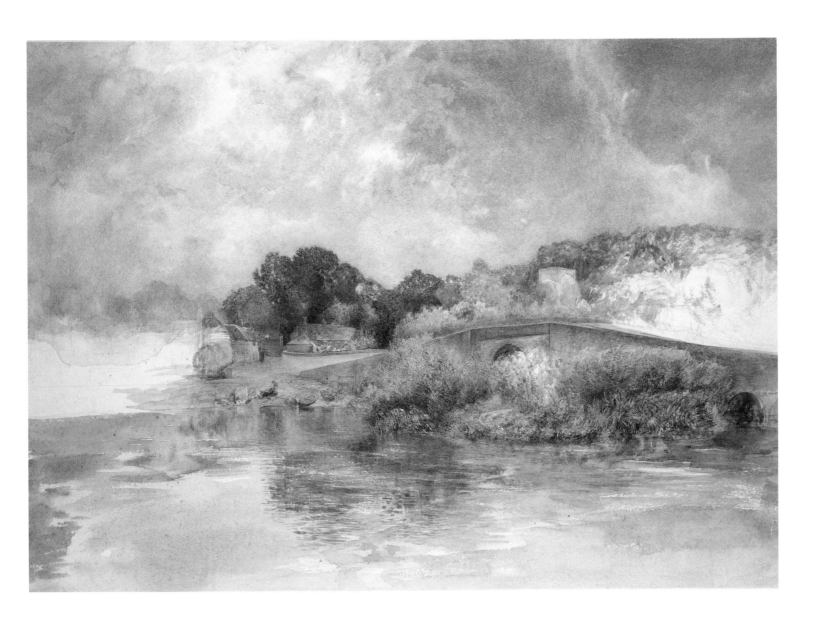

58

Holy Island Castle c.1882–3

Watercolour, 27.8 x 38.4 cm; 11 x 15¼ in

H UNT'S EXTRAORDINARY WATERCOLOUR of Holy Island shows him experimenting with a new technique, concerned with an abstract texture that stands for rather than attempts to give objective replication of the forms of nature. Holy Island Castle, properly called Lindisfarne, is a small but strongly built fortress, which stands on an abrupt outcrop of the Whin Sill, and which was constructed by the Crown in 1549–50, during the reign of Henry VIII. In the early years of the twentieth century Edwin Lutyens rebuilt the castle, on instruction from Edward Hudson, the proprietor of *Country Life*. Hunt would have known his late father-in-law James Raine's book describing Holy Island, *The History and Antiquities of North Durham* (1852).

Hunt made studies of Holy Island and Warkworth in sketchbooks in 1882 and 1883.[1]

Provenance: as cat. no. 25

Ashmolean Museum, Oxford. Presented by Mrs W.A.S. Benson and Mrs Fogg-Elliott, the artist's daughters, 1918 (WA 1918.7.166)

1 Sketchbooks nos. 62, 63 and 70.

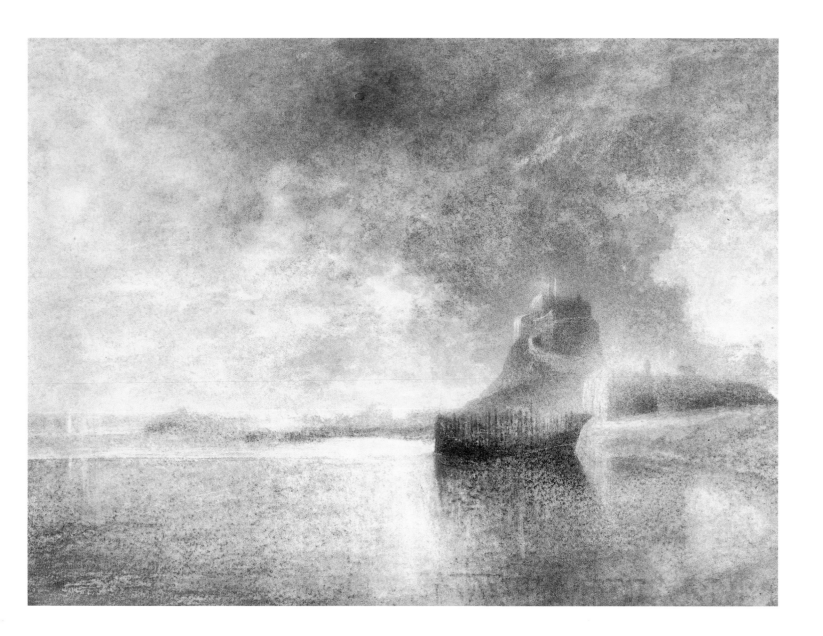

59

*Wind of the Eastern Sea c.*1888

Watercolour, 53.7 x 76.8 cm; 21¼ x 30¼ in

*W*ind of the Eastern Sea shows the great headland to the south-east of Whitby. The Scar, as seen in *Low Tide on the Scaur, Whitby – 'A Case for Plimsoll'* (cat. no. 53), lies at the foot of the sea-cliffs on the right. Whitby Abbey is here seen against the north-western sky. Two jetties project out to sea, providing protection for the daily traffic of fishing boats in and out of the entrance to Whitby harbour and the mouth of the Esk. The title of the drawing was adapted from the opening verse of Book III of Tennyson's 'The Princess: A Medley': 'Sweet and low, sweet and low, / Wind of the western sea, / Low, low, breathe and blow, / Wind of the western sea!'

Violet Hunt gave an account of the conditions that her father endured at Whitby, and her mother's concern for him: 'Poor Mamma pounds up Abbey Hill every afternoon to meet Papa sitting exposed on the windy hill behind the Abbey and fetch him back before he grows chilled to the bone. He will stay there till the Abbey stands out against the sunset and as he is a long way towards Saltwick Nab there is a long walk on the top of the cliffs before one begins to descend'.[1]

Provenance: Gilbert W. Moss, by 1892; Gertrude Emily Moss, by whom bequeathed, 1920

Exhibited: R.W.-C.S., 1888 (36); W.A.G., 1888 (824); Southport 1892; Liverpool 1897 (84)

Literature: *Art Journal*, 1888, p. 189; *Athenaeum*, 28 April 1888, p. 541; Hunt 1924–5, pl. 11; Secor 1982, pl. 10

Victoria and Albert Museum, London (p. 107–1920)

1 Ford Madox Ford Papers.

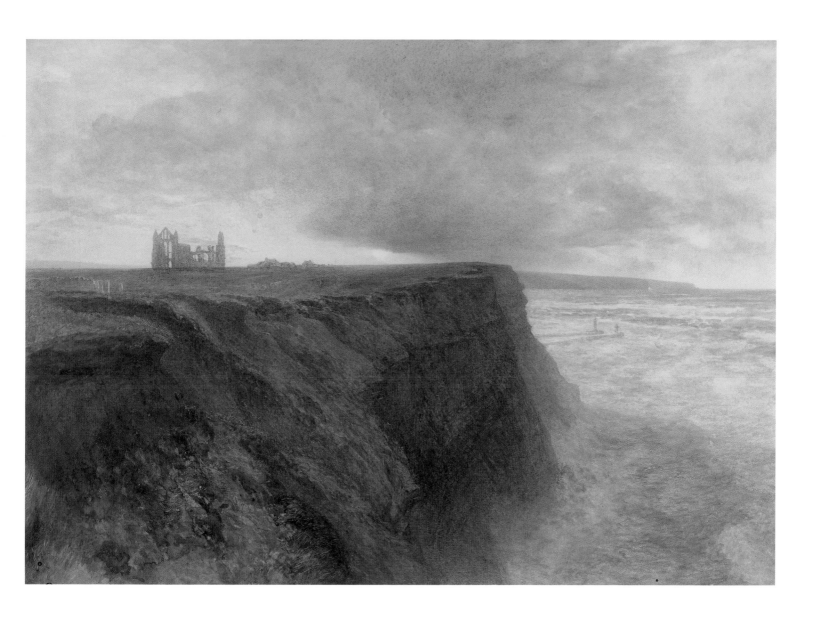

60
Windsor Castle 1889

Signed and dated: *AW Hunt 1889*
Watercolour, 48.9 x 76.2 cm; 19¼ x 30 in

THIS LARGE AND IMPRESSIVE watercolour shows Windsor Castle from the Eton side of the Thames, with St George's Chapel and the Round Tower conspicuous against the skyline. The stretch of river that runs alongside the Eton College boathouse is known as the Brocas.

Hunt first worked at Windsor in 1888, devoting many sketchbooks to studies of the town's historic architecture.[1] If this is the watercolour shown at the Royal Water-Colour Society in 1889, a further similar composition – but with a different quality of light – was shown the following year (probably the work now in Birmingham Museum and Art Gallery).

Windsor perhaps appealed to Hunt as a painting location partly because of the ease with which he could get there. Trains ran to the town either from Paddington or Waterloo, making day-trips feasible. In the summer of 1889 Hunt did not travel further afield: although he was only fifty-nine years old, he was already beginning to feel the strain of long periods away from home.

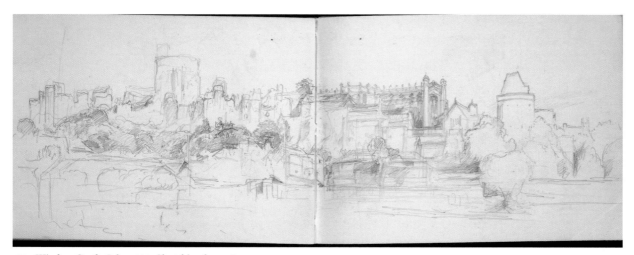

60a *Windsor Castle*. July 1889. Sketchbook no. 80.

Provenance: Sir Henry Tate, by whom presented, 1894

Exhibited: R.W.-C.S., 1889 (19) (?)

Literature: Secor 1982, pl. 9

© Tate London, 2004 (N01703)

1 Sketchbooks nos.75-6, 140–3, 159 and 179 show Windsor subjects.

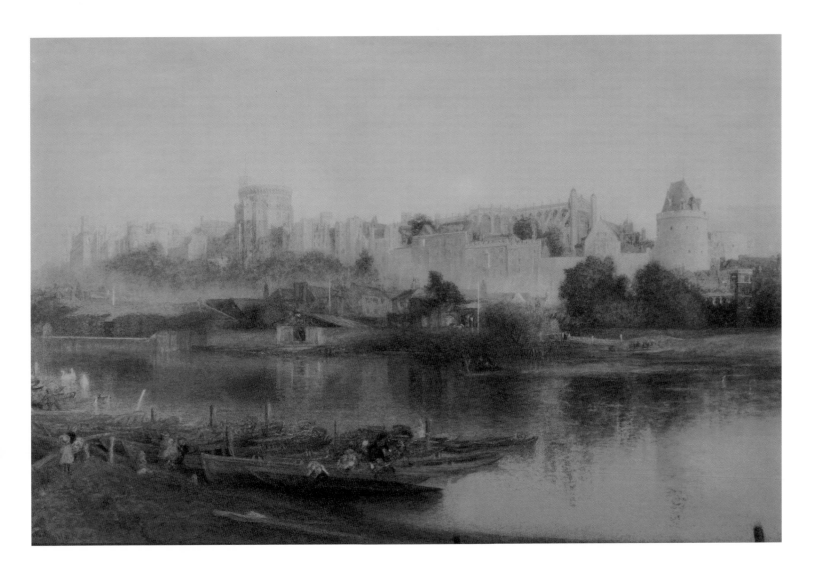

Appendix: The Sketchbooks of Alfred William Hunt in the Ashmolean Museum

COLIN HARRISON

AFTER HIS DEATH IN 1896, the contents of Hunt's studio were inherited by his three daughters. In 1918, the two younger daughters, Mrs W.A.S. Benson and Mrs Fogg-Elliott, presented to the Ashmolean most of the material in their possession, and, with the acquiescence of their elder sister, Violet Hunt, almost all Hunt's sketchbooks. These were arranged with Mrs Fogg-Elliott's help by C.F. Bell, the Keeper of the Department of Fine Art Sketchbooks.

The numbering of the sketchbooks begins chronologically according to size, but the sequence later becomes more haphazard. The dates are those inscribed on individual pages, and do not necessarily cover the whole range of dates the sketchbook was in use. In general, however, Hunt used one sketchbook at a time, and did not reuse old ones. His dates are not always accurate, and occasionally the days and dates do not correspond. Bell assigned dates to undated sketchbooks on the basis of exhibited works and comparison with related sketchbooks of similar format. Hunt used a wide variety of suppliers, but favoured Rowney and Roberson; only the names on surviving labels have been noted. Most of the drawings are in pencil, becoming increasingly summary as Hunt's confidence and visual memory improved. He rarely used pen and ink, and only in a few sketchbooks are there drawings in wash or watercolour. Unless otherwise stated, the paper is white or off-white. Occasionally, the leaves of the sketchbook as it now survives appear to have come from different sources.

Bell had a selection of the more finished pages removed and mounted separately, as noted in individual entries. Where pages were removed earlier, or torn, or left blank, this is not noted. Dimensions are given of the page size.

1 North Wales
July, August 1854
watermark 1851
33 ff. (fol. 3 mounted), 11.8 x 19 cm

2 North Wales
1855
watermark 1853
G.J. Keet, Liverpool; 38 ff., 12.8 x 17.7 cm

3 Wales: Trifaen, etc.
June 1857
watermark 1854
42 ff., 11.9 x 18.8 cm

4 North Wales
September 1857
watermark 1854
44 ff., 11.9 x 19 cm

5 Wales and ?Cumberland
c. 1857
watermark 1854
46 ff., 11.9 x 18.9 cm

6 Wales: Llyn Ogwen
c. 1855-7
44 ff., 11.7 x 19.1 cm

7 Rokeby
c. 1858
watermark 1856
Winsor and Newton; 37 ff., 14 x 18.8 cm (irregular)

8 Wales
23 October 1860
41 ff., 11.6 x 19 cm

9 Middlesbrough Blast Furnaces (Port Clarence), Durham, etc.
10 July [1861]
watermark 1854, 1858
60 ff., 11.9 x 18.9 cm

10 Tapping Blast Furnaces, Middlesbrough
c. 1861-3
11 ff., 18.4 x 12.9 cm

11 Caernarvon Castle, Harlech Castle, Byland Abbey, etc.
1861-2
watermark 1852, 1854
44 ff., 11.9 x 18.9 cm

12 Harlech
1862
watermark 1856
41 ff. (fol. 7 mounted), 12.8 x 18 cm

13 Durham and Wales
18 June 1864
watermark 1863
36 ff., 12.2 x 18.3 cm

14 Durham
c. 1860-65
E. Grindley, Liverpool; 36 ff., 12.4 x 17.3 cm

15 Durham and Rokeby
1859
26 ff. (fol. 20 mounted), 12.7 x 18.1 cm

16 Welsh Cromlech and Dolwyddelan Castle
1866, 1867
watermark 1861
Ellerbeck, Liverpool; 45 ff., 12.4 x 18.9 cm

17 Durham
11 July 1866
Winsor and Newton; 38 ff., 12.7 x 18 cm

18 Tynemouth
1865
37 ff. coloured paper, 12.5 x 17.8 cm

19 Scotland: Ben Slioch, etc.
16 August 1868
watermark 1864
10 ff., 13.9 x 19.4 cm

20 Scotland: Ardnamurchan, Loch Maree, etc.
1868
31 ff., 12.7 x 18.1 cm

21 Italy: Siena, Ruins in the Campagna, etc.
14 November [1871] 1869-70-71
watermark 1867
Edward Goodban, Florence; 33 ff., 12.9 x 19.1 cm

22 Yachting holiday: Marseilles, Genoa, Venice, etc.
30 November [1869]
Winsor and Newton; 29 ff., 12.9 x 18.3 cm

23 Yachting holiday: Naples, Sorrento
1869-70
watermark 1869
Winsor and Newton; 29 ff., 12.9 x 18.3 cm

24 Yachting holiday: Greece, Sicily, Tunis
1869-70
44 ff., 13.5 x 18.6 cm

25 Yachting holiday: Corsica
Spring 1870
35 ff., 12.5 x 17.9 cm

26 Scotland: Loch Hourn
1870
watermark 1868
Winsor and Newton; 34 ff., 12.8 x 18.1 cm

27 Bamburgh and Dunstanburgh
1871
watermark 1869
Winsor and Newton; 38 ff. (fol. 12 mounted), 12.6 x 18 cm

28 Wales: Capel Curig and Gallt y Glyn
1872
34 ff., 13.5 x 17.3 cm

29 Wales: Capel Curig
21 July 1872
watermark 1871
36 ff., 13.6 x 17.3 cm

30 North Wales
1872
watermark 1869
E. Grindley, Liverpool; 38 ff., 12.5 x 18.2 cm

31 Wales: Capel Curig
?1872
watermark 1871
32 ff. (fol. 20 mounted), 13.5 x 17.3 cm

32 Coniston
1873
38 ff., 12.7 x 17.7 cm

33 Coniston
1873
Roberson; 30 ff., 12.5 x 17.4

34 Coniston: Brantwood
1873
Roberson; 28 ff., 12.6 x 17.2 cm

35 Cumberland: ?Barnard Castle
?before 1861
watermark 1857
G.J. Keet, Liverpool; 45 ff. (some of coloured paper), 12.3 x 16.9 cm (irregular)

36 Coniston
1874
Roberson; 28 ff., 12.6 x 17.4 cm

37 Hastings
13 [?June 1874]
38 ff., 12.6 x 17.4 cm

38 Hastings
?1874
watermark 1874
37 ff., 12.6 x 17.3 cm

39 Whitby and Hastings
1874
watermark 1871
30 ff., 12.6 x 17.4 cm

40 Whitby
4 October 1874
watermark 1868
E. Grindley, Liverpool, 38 ff. (½ of fol. 22 mounted), 12.8 x 18.5 cm

41 Whitby and Robin Hood's Bay
1874
E. Grindley, Liverpool, 38 ff., 12.3 x 17.3 cm

42 Whitby
13 August 1875
37 ff., 12.6 x 17.4 cm

43 France: Mont St Michel, Falaise, etc.
28 June 1876
Deforge, Carpentier, Paris; 37 ff., 11.7 x 17 cm

44 Whitby
25 August 1876
Roberson; 30 ff., 12.5 x 17.2 cm

44 Whitby
24 September 1876
watermark 1875
30 ff., 12.5 x 17.3 cm

45 Whitby
23 October 1876
Roberson; 30 ff. grey-blue paper, 12.4 x 17.8 cm

46 Norway
12–13 June 1877
Roberson; 29 ff., 12.5 x 17.2 cm

47 Norway
27–9 June 1877
79 ff., 11.7 x 18 cm

48 Norway
5–14 July 1877
79 ff., 11.6 x 18 cm

49 Norway
27 July – 20 August 1877
80 ff., 11.6 x 18.3 cm

50 Whitby and Durham
21–5 September 1877
44 ff. (½ of fol. 1, ½ of fol. 2 mounted), 12.7 x 17.9 cm

51 Kepyer and Rokeby
15–26 June 1878
Roberson; 28ff., 12.7 x 17.5 cm

52 Rokeby
28 June – 7 July 1878
Roberson; 30 ff., 12.6 x 17.5 cm

53 Yorkshire: Richmond, Aysgarth, Bolton Abbey
31 May – 5 June 1879
Roberson; 30 ff., 12.6 x 17 cm

54 Kirkby Lonsdale, Rokeby, etc.
13–25 June 1879
29 ff., 12.5 x 17.4 cm

55 Marrick Abbey and Whitby
24 August – 30 September 1879
watermark 1877
30 ff., 12.2 x 17.4 cm

56 Rokeby
?c. 1879
Newman; 46 ff., 12.2 x 17.5 cm

57 Sonning and Warkworth
?1880
38 ff. coloured paper, 12.6 x 17.7 cm

58 Whitby
8 September 1880
30 ff., 12.5 x 17.5 cm

59 North Wales
c. 1880
36 ff., 13.5 x 17.3 cm

60 The Thames: Sonning and Shiplake
26 October [1881]
W. Benham, London; 32 ff. coloured paper, 12.6 x 17.6 cm

61 Wales
28 June [?1882]
37 ff., 12.5 x 17.5 cm

62 Warkworth and Holy Island
9 and 13 September 1882
watermark 1882
Roberson; 29 ff., 12.7 x 17.6 cm

63 Warkworth, Holy Island, Dunstanburgh
15 September [1882]
watermark 1881
Roberson; 26 ff., 12.6 x 17.4 cm

64 Durham and Warkworth
11, 20 and 28 July 1883
46 ff., 11.9 x 16.7 cm

65 Warkworth
11–20 August 1883
Roberson; 28 ff., 12.2 x 17.5 cm

66 Warkworth
7–26 August 1883
Roberson; 28 ff., 12.4 x 17.7 cm

67 Warkworth
31 August – 6 September 1883
Roberson; 25 ff., 12.2 x 17.5 cm

68 Warkworth
6 Sept 1883
Roberson; 29 ff., 12.2 x 17.5 cm

69 Warkworth
23–27 September 1883
Roberson; 28 ff., 12.3 x 17.6 cm

70 Warkworth and Holy Island
28 September – 7 October 1883
Roberson; 30 ff., 12.2 x 17.5 cm

71 Warkworth
3 November 1883
Roberson; 27 ff. (mostly blank), 12 x 17.7 cm

72 Robin Hood's Bay
28 September – 9 October 1886
44 ff., 13.2 x 18.3 cm

73 Robin Hood's Bay
28 October – 10 November 1886
Reeves; 31 ff., 12.7 x 17.7 cm

74 Whitby
11–25 October 1887
Reeves; 30 ff., 12.7 x 17.7 cm

75 Windsor
Wednesday 29 – Thursday 30 August 1888
20 ff., 12.5 x 17.6 cm

76 Windsor
25 August – 6 September 1888
18 ff., 12.3 x 17.3 cm

77 Windsor
21–4 May 1889
20 ff., 12.4 x 17.7 cm

78 Windsor
28–31 May 1889
21 ff., 12.5 x 17.9 cm

79 Windsor
5–30 June 1889
16 ff. (fol. 8 mounted), 12.4 x 17.8 cm

80 Windsor
2–8 July 1889
20 ff., 12.4 x 17.6 cm

81 Windsor
5 August 1889
81 ff., 12.4 x 17.7 cm

82 Windsor
21 August 1889
20 ff., 12.4 x 17.6 cm

83 Grasse and St Paul de Vence
31 May 1891
23 ff., 12.5 x 17.9 cm

84 ?Grasse
?1891
Roberson; 18 ff., 12.6 x 17.5 cm

85 Studies of Sky
?1891
Roberson; 8 ff. blue paper, 12.6 x 17.5 cm

86 Windsor
8 June – 5 July 1892
25 ff., 12.5 x 17.3 cm

87 Great Tangley Manor, near Guildford
26 September – 28 October [1892]
24 ff., 12.5 x 17.8 cm

88 Great Tangley Manor
28 October – 7 November
watermark 1884
Rowney; 38 ff., 12.6 x 17.9 cm

89 Windsor; Niagara Falls; SS Etruria
23 May – 4 September 1893
24 ff., 12.5 x 17.4 cm

90 Windsor
15 September – 7 October 1893
22 ff., 12.8 x 17.5 cm

91 Windsor
25 June – 11 July 1894
Rowney; 42 ff., 12.7 x 18.1 cm

92 Windsor
31 July – 21 August 1894
20 ff., 12.2 x 17.7 cm

93 Windsor and Church near Beauvilliers
27 September – 12 October 1894
19 ff., 12.2 x 17.7 cm

94 Durham and Kepyer
20 June – 7 October 1895
Winsor and Newton; 30 ff., 13.5 x 18.3 cm

95 Durham, Kepyer, and Birdoswald
4 July – 6 October 1895
Winsor and Newton; 30 ff., 12.4 x 17.8 cm

96 Durham
5 August – 8 September 1895
watermark 1893
Winsor and Newton; 30 ff., 12.8 x 17.9 cm

97 Durham, Kepyer and Gilsland
?3 May – 7 October 1895
Reeves; 24ff 12.8 x 18.4 cm

98 Durham and Kepyer
[1895]
Reeves; 24 ff., 12.8 x 18.3 cm

99 Cumberland, Durham, Rokeby
c. 1858–60
watermark 1857
G.J. Keet, Liverpool; 17 ff., 11.3 x 17.5 cm

100 Durham
c. 1860
watermark 1845
6 ff., 11.2 x 18.6 cm

101 Cumberland: The Lakes, etc.
c. 1858–60
22 ff., 11.5 x 19 cm

102 North Wales
probably 1860
watermark 1859
14 ff., 11.6 x 19 cm

103 Durham
c. 1861–5
watermark 1859
21 ff., 11.5 x 19 cm

104 Wales
c. 1866
watermark 1865
Roberson; 28 ff., 9.9 x 18.1 cm

105 Ovington, Rokeby, and Whitby
c. 1870–80
Newman; 38 ff., 10.2 x 18 cm

106 Coniston
1873
Roberson; 29 ff., 10 x 17.4 cm

107 Coniston
21 June – 2 August 1874
watermark 1872
Newman; 39 ff., 10.1 x 17.8 cm

108 Coniston
1874
watermark 1871
37 ff., 11 x 17.2 cm

109 Hawnby (North Yorkshire) and Coniston
1874
Newman; 36 ff., 11.4 x 17.6 cm

110 Whitby
1874
88 ff., 10.1 x 17.7 cm

111 Switzerland: Thun
? c. 1874–8
54 ff., 11.2 x 17.3 cm

112 Norway
May–June 1877
Newman; 37 ff. (fol. 37 mounted), 10.2 x 18.4 cm

113 Norway
14 June 1877
Newman; 38 ff., 10.1 x 17.5 cm

114 Norway
26 June 1877

Roberson; 31 ff. coloured paper, 9.8 x 17.1 cm

115 Norway
29 June, 3–4 July 1877
watermark 1876, 1877
31 ff., 10.2 x 17.6 cm

116 Norway
24 July 1877
Roberson; 30 ff., 10.2 x 17.6 cm

117 Whitby
22 October – 4 November 1878
44 ff., 11.1 x 18.1 cm

118 Whitby
18 October 1879
44 ff., 11.2 x 17.9 cm

119 Sonning and Pangbourne
31 May 1880
42 ff., 11.2 x 18 cm

120 Pangbourne
c. 1880–81 (or 1870?)
watermark 1866
Roberson; 28 ff., 9.9 x 17.9 cm

121 Sonning, Shiplake, and Kepyer
21 June 1880
Roberson; 30 ff., 10.2 x 17.6 cm

122 Warkworth
30 July 1880
17 ff., 11.5 x 17.8 cm

123 Warkworth
?July 1880
18 ff., 11.5 x 17.8 cm

124 Sonning (?) and Warkworth
29 July – 8 August (?) 1880
38 ff. coloured paper, 10 x 17.7 cm

125 Whitby
24 September 1880
43 ff., 11.2 x 18 cm

126 Sonning, Dorchester, Whitby
13 May – 4 June [1881]
27 ff., 11 x 18.2 cm

127 Sonning
11 May – 3 August 1881
Roberson; 27 ff., 10.1 x 17.7 cm

128 Sonning and Bagshot
27–8 August [1881]
watermark 1880
27 ff., 10.1 x 17.6 cm

129 Sonning
15 October 1881
Roberson; 27 ff., 10 x 17.6 cm

130 Durham and Holy Island
? 1882–3
Roberson; 28 ff., 9.9 x 18 cm

131 Warkworth
? 1882
watermark 1878
Roberson; 27 ff., 9.1 x 17 cm

132 Rokeby
June [? 1884]
Roberson; 28 ff., 12 x 17.6 cm

133 Rokeby
10 October 1884
Roberson; 28 ff., 11.9 x 17.4 cm

134 Rokeby and Durham
15 October 1884
Roberson; 27 ff., 12 x 17.5 cm

135 Robin Hood's Bay
2, 14–16 July 1886
Roberson; 28 ff., 10.3 x 17.8 cm

136 Robin Hood's Bay
31 July 1886
watermark 1885
Roberson; 26 ff., 10.3 x 17.7 cm

137 Robin Hood's Bay

Sunday 14 November [1886]
Roberson; 28 ff., 10.3 x 17.7 cm

138 Robin Hood's Bay
?1886 (includes studies for *Washing Day*, exh. 1887)
Reeves; 37 ff., 9.6 x 17.7 cm

139 Robin Hood's Bay and Hayburn Wyke
7–14 June 1887
Roberson; 28 ff., 10.2 x 17.8 cm

140 Windsor
19 June – 8 September 1888
Roberson; 27 ff., 10 x 17.7 cm

141 Windsor
26 September 1888
watermark 1885
21 ff., 11 x 17.5 cm

142 Windsor
2–5 October 1888
watermark 1885
23 ff., 11.1 x 17.6 cm

143 Windsor
21–3 October 1888
watermark 1888
Roberson; 26 ff., 10.1 x 17.6 cm

144 Great Tangley Manor, near Guildford
10–23 October 1892
watermark 1890
Roberson; 28 ff., 10.2 x 17.7 cm

145 Voyage to America
25–29 June – ?October 1893
watermark 1893
Roberson; 28 ff., 10.0 x 17.7 cm

146 Niagara Falls and voyage home
14 July 1893
watermark 1893
Roberson; 28 ff., 10 x 17.7 cm

147 Liverpool, Handsworth, Tewkesbury, Oxford, Sound of Kerrera, Argyleshire, etc.
c. 1848
Superior Paper memorandum book, 48 ff., 7.4 x 12.4 cm

148 Cumberland
16 September – 10 October 1853
Smith's memorandum book; 65ff. (ff. 35, 42, 44, 49 mounted), 8 x 13.9 cm

149 Capel Curig, Devon, and Cornwall
c. 1857
74 ff., 8.2 x 14.1 cm

150 Mortlake, the Destruction of Temple Bar, etc.
14 October – 24 November 1878
45 ff., 6.8 x 11.5 cm

151 Durham and Warkworth
2–25 July 1880
35 ff., 8.5 x 14 cm

152 Durham, Warkworth, Holy Island
22 September [1882]
Smith's memorandum book; 40 ff., 7.9 x 14.2 cm

153 Durham, Robin Hood's Bay
29 July – 9 August 1885
Roberson; 28 ff., 8.3 x 12.4 cm

154 Robin Hood's Bay
3 October 1885
Roberson; 25 ff., 8.3 x 12.4 cm

155 Stoup Brow and Robin Hood's Bay
8 July 1886
Roberson; 16 ff., 7.9 x 12.5 cm

156 Robin Hood's Bay
8–21 September 1886
Roberson; 22 ff., 8.3 x 12.2 cm

157 Robin Hood's Bay and
Hayburn Wyke
22 June – 4 July 1887
Roberson; 26 ff., 8.3 x 12.2 cm

158 Robin Hood's Bay
15 July – 1 September 1887
Reeves; 38 ff., 8.7 x 13.2 cm

159 Rokeby, Windsor,
Warkworth
1–31 July 1888
Henry Penny's patent book; 74 ff., 8.2 x
14.2 cm

160 Scotland: Loch Hourn
27 May – 25 June 1870
Winsor and Newton; 30 ff., 8.8 x 13.3 cm

161 Bamburgh
10, 13 July [1871 or 1872]
Roberson; 30 ff., 8.8 x 13 cm

162 Bamburgh
?1871
Winsor and Newton; 30 ff., 8.7 x 12.9 cm

163 Capel Curig
1872
Roberson; 30 ff., 8.9 x 12.4 cm

164 Coniston
5 September 1873
Newman; 38 ff., 8.8 x 12.1 cm

165 Coniston
October [?1873]
32 ff., 8.9 x 12.9 cm

166 Coniston
1873
Newman; 38 ff., 8.7 x 12.2 cm

167 Coniston
1873
Roberson; 29 ff., 9 x 12.4 cm

168 Hastings
c. 1874
Newman; 36 ff., 8.7 x 12.3 cm

169 Whitby
13 June – 2 July 1875
Roberson; 29 ff., 8.8 x 12.4 cm

170 Whitby
5–21 July 1875
Roberson; 28 ff., 8.8 x 12.4 cm

171 Whitby
13 August 1875
Newman; 38 ff., 8.8 x 12.2 cm

172 Whitby
5 September – 6 October 1875
37 ff., 8.8 x 13 cm

173 Mont Saint Michel
16 June 1876
Roberson; 30 ff., 8.5 x 12.1 cm

174 Mont Saint Michel and Le
Havre
1876
Roberson; 30 ff., 8.5 x 12.2 cm

175 Rouen
1876
22 ff., 8.6 x 12.9 cm

176 Rokeby
1884
Roberson; 30 ff., 8.5 x 12.5 cm

177 Rokeby
16 September, 25 September – 7 October
1884
Roberson; 30 ff., 8.5 x 12.5 cm

178 Durham
6, 20–22 May [?1886]
18 ff., 8.6 x 12.7 cm

179 Windsor
4–20 August 1888
Roberson; 30 ff., 8.7 x 12.5 cm

180 Whitby and Windsor
3–19 October 1890
Reeves; 37 ff., 8.8 x 12.8 cm

181 Grasse
3–12 May 1891
watermark 1889
Roberson; 30 ff., 8.9 x 12.9 cm

182 Durham, Kepyer and
Windsor
14–20 August 1891
Roberson; 29 ff., 8.7 x 13 cm

183 Durham and Windsor
May – 8 June 1892
38 ff., 8.6 x 12.6 cm

184 Great Tangley Manor, near
Guildford
4 September – 6 October 1892
Urquhart, Notting Hill; 22 ff., 8.8 x 12.7
cm

185 Windsor
30 June 1892, 19 July – 30 September
1894
Urquhart, Notting Hill; 21 ff., 8.9 x 12.8
cm

186 Wales: Caernarvon, Harlech,
etc.
c. 1855–7
watermark 1853, 1854
41 ff., 11.3 x 14.5 cm

187 Capel Curig
21 April 1856
46 ff., 11.6 x 14.8 cm

188 North Wales
14 May – June 1857
watermark 1852
40 ff., 11.4 x 14.4 cm

189 Switzerland: Lucerne, etc.;
the Rhine: Rotterdam
10 May 1860
92 ff., 10.3 x 14.7 cm

190 Pont de Claix near Grenoble
13 April ?1870
48 ff. (some buff), 8.6 x 14.7 cm

191 Whitby
1875 or 1872
44 ff. (fol. 12 mounted), 11 x 13.5 cm

192 Whitby
19 September – 29/30 October 1876
29 ff., 11.3 x 13.5 cm

193 Sonning
27 September 1881
Benham, Notting Hill Gate; 32 ff., 11.3 x
14.5 cm

194 Whitby
1 September 1885
Roberson; 30 ff., 9.4 x 15.2 cm

195 Robin Hood's Bay
18 September 1885
Roberson; 30 ff., 9.4 x 15.6 cm

196 Robin Hood's Bay,
Warkworth
22 September, 26 October – 4 November
1885
Roberson; 30 ff., 9.4 x 15.6 cm

197 Whitby
probably 1885
Roberson; 30 ff., 9.4 x 15.2 cm

198 Windsor
9–15 July 1889
Roberson; 30 ff., 9.4 x 15.2 cm

199 Windsor
14–24 July 1889
Roberson; 30 ff., 9.4 x 15.2 cm

200 Windsor
18–30 September 1889
Roberson; 30 ff., 9.4 x 15.2 cm

201 Windsor
28 September – 19 October 1889
Roberson; 30 ff., 9.4 x 15.2 cm

202 Windsor
29 October – 13 November 1889
Roberson; 54 ff., 9.1 x 15.5 cm

203 Windsor
3 August – 2 October [1891]
Roberson; 30 ff., 9.3 x 15.1 cm

204 Windsor
? c. 1888–94
24 ff., 7.8 x 16.8 cm

205 Sonning
20–26 July [1881]
Roberson; 28 ff., 13.2 x 22 cm

206 Warkworth, Durham, Kepyer
26 June, 8 July – 6 September [1881]
Roberson; 91 ff., 12.3 x 21.1 cm

207 Rokeby
6 July 1883
12 ff., 11.6 x 20.7 cm

208 Warkworth, Dunstanburgh
7 October – 3 November 1883
37 ff., 11.8 x 21.1 cm

209 Robin Hood's Bay
30 August – September 1885
Roberson; 77 ff., 12.4 x 21 cm

210 North Wales
c. 1854–7
watermark 1854
40 ff., 13 x 21.4 cm

211 Cwm Trifaen, Harlech, Gallt y Glyn
7–11 October 1856
watermark 1853
43 ff., 13 x 21.4 cm

212 Harlech
12 February – 10 March 1857
watermark 1853
44 ff., 13 x 21.4 cm

213 Cwmbychan (near Welshpool), Bowdon (Cheshire), etc.
21 February 1857
watermark 1850
G.J. Keet, Liverpool; 22 ff., 14.1 x 22.4 cm

214 Scotland
20 September – 2 October 1868
watermark 1862, 1862, 1864, 1867
covers from a Roberson sketchbook; 49 miscellaneous ff., 14 x 19.7 cm (irregular)

215 Cumberland: Borrowdale, etc.
29 September – 10 October 1853
Cowan and Co. Drawing Book; 24 ff. (fol. 9 mounted), 14.3 x 22.6 cm

216 Barnard Castle
29 August [? 1862]
watermark [186]2
22 ff., 13.9 x 23.3 cm

217 Durham
(?) 1862
20 ff., 13.8 x 23.2 cm

218 Whitby
1877
watermark 1875
29 ff., 13.8 x 22.5 cm

219 Rokeby and The Destruction of Temple Bar, London
5 October 1878
S.J. Brown, London; 38 ff., 14 x 23 cm

220 Rokeby and Durham
1870 or 1880
32 ff. (and 1 f. loosely inserted), 15.2 x 24.3 cm

221 Pangbourne and Streatley
1870 or 1881 (cf. 128–9)
35 ff., 15.5 x 23.7 cm

222 Pangbourne and Streatley
1870 or 1880
22 ff., 13.9 x 20 cm

223 Dunstanburgh
(?) 1883
Roberson; 42 ff. coloured paper, 13.8 x 22.6 cm

224 Lucerne and Rokeby
c. 1860
watermark 1853
G.J. Keet, Liverpool; 17 ff., 7.6 x 26.3 cm

225 Norway
1877
Newman; 20 ff., 17.5 x 25.5 cm

Bibliography and Abbreviations

SOURCES

Information about the artist's career derives from three principal primary sources.

The first is the collection of 226 sketchbooks (many with inscriptions and dates in the artist's hand, and thus an invaluable source of biographical information), unfinished drawings, and other material, which was presented to the Ashmolean Museum in 1918 by the artist's daughters, Mrs W.A.S. Benson and Mrs Fogg-Elliot.

The second is the mass of Hunt family correspondence and papers at Cornell University, New York. This consists of two main bodies of papers, one that had belonged to Ford Madox Ford, and the other to Violet Hunt, A.W. Hunt's eldest daughter. Ford Madox Ford and Violet Hunt had a long standing love affair; the papers that each of them had accumulated from their parents' and grandparents' generation (Ford Madox Ford was the grandson and biographer of Ford Madox Brown) were mixed together and confused. Ford's papers were acquired by Cornell in 1964–88. Material in the Ford collection provided the basis of Secor 1982. The Violet Hunt Papers were acquired by Cornell in 1966. Quotations from the unpublished material in the Violet Hunt Papers and Ford Madox Papers are by courtesy of the Division of Rare and Manuscripts Collections, Cornell University Library.

The third principal source of information about Hunt is a typescript essay by the late Alan Fox-Hutchinson.

Other first-hand accounts include Gosse in London 1884; Wedmore 1891; Dibdin 1897; Monkhouse in London 1897; and Hunt 1924–5.

ARCHIVAL SOURCES

Alan Fox-Hutchinson
 Alan Fox-Hutchinson, 'Alfred William Hunt, R.W.S.' (unpublished TS in the possession of Christopher Newall)
Ford Madox Ford Papers
 Ford Madox Ford Papers, Cornell University
James Leathart Papers
 James Leathart Papers, University of British Columbia
Violet Hunt Papers
 Violet Hunt Papers, Cornell University

HUNT'S OWN WRITINGS

Hunt 1880
 Alfred William Hunt, 'Modern English Landscape-Painting', The Nineteenth Century (May, 1880), pp. 778–94
Hunt 1891
 Alfred William Hunt, 'Turnerian Landscape – An Arrested Art', The Nineteenth Century (February, 1891), pp. 214–24

BOOKS AND PERIODICALS

Dibdin 1897
 E. Rimbault Dibdin, The Liverpool College Old Boys' Magazine, vol. I, no. 2, (August, 1897), pp. 31–5
Hewison 2000
 Robert Hewison, Ruskin, Turner and the Pre-Raphaelites (exh. cat., Tate Britain, London 2000)
Hunt 1924–5
 Violet Hunt, 'Alfred William Hunt, R.W.S., 1830–1896', Old Watercolour Society's Club, II (1924–5), pp. 29–47
Lago 1981
 Burne-Jones Talking – His Conversations 1895–1898 preserved by his Studio Assistant Thomas Rooke, ed. Mary Lago (London, 1981)

Marillier 1904
 H.C. Marillier, The Liverpool School of Painters – An Account of the Liverpool Academy, from 1810 to 1867, with Memoirs of the principal Artists (London, 1904)
Morris & Roberts 1998
 Edward Morris and Emma Roberts, The Liverpool Academy and Other Exhibitions of Contemporary Art in Liverpool 1774–1867 (Liverpool, 1998)
Newall 1987
 Christopher Newall, Victorian Watercolours (Oxford, 1987)
Peattie 1990
 Selected Letters of William Michael Rossetti, ed. Roger W. Peattie (Pennsylvania, 1990)
Powell 1995
 Cecilia Powell, Turner in Germany (exh. cat., Tate Gallery, London, 1995)
Ruskin 1903–12
 The Works of John Ruskin, ed. E.T. Cook & Alexander Wedderburn, 39 vols (London, 1903–12)
Secor 1982
 Robert Secor, John Ruskin and Alfred Hunt: New Letters and the Record of a Friendship, English Literary Studies, monograph no. 25 (Victoria, B.C., 1982)
Staley 2001
 Allen Staley, The Pre-Raphaelite Landscape, rev. edn (New Haven & London, 2001)
Wedmore 1891
 Frederick Wedmore, 'Alfred Hunt', Magazine of Art, 1891, pp.104–8
Wilton 1979
 Andrew Wilton, The Life and Work of J.M.W. Turner (London, 1979)
Wilton 2000–2001

Andrew Wilton, 'The Legacy of Turner's Watercolours', in Turner: The Great Watercolours (exh. cat., Royal Academy of Arts, London, 2000–01)

EXHIBITIONS

Annual exhibitions at which Hunt was represented
L.A.
 Liverpool Academy
O.W.-C.S
 Society of Painters in Water-Colours
P.G.
 Portland Gallery (National Institute of Fine Arts)
R.A.
 Royal Academy of Arts
R.B.S.A.
 Royal Birmingham Society of Artists
R.W.-C.S.
 Royal Water-Colour Society
S.B.A.
 Society of British Artists
W.A.G.
 Walker Art Gallery, Liverpool

Other exhibitions
Paris 1867
 Exposition Universelle, Paris, 1867
London 1871
 International Exhibition, London, 1871
Liverpool 1872
 Liverpool Library and Museum, 1872
Wrexham 1876
 Art Treasures Exhibition, 1876
London 1878–9
 Winter Exhibition, Grosvenor Gallery, London, 1878–9
London 1884
 Pictures and Drawings of Mr Alfred W. Hunt, Fine Art Society, London, 1884
Berlin 1886-8

Newcastle upon Tyne 1887
Royal Mining, Engineering and Industrial, Exhibition, Newcastle upon Tyne, 1887
Manchester 1887
Royal Jubilee Exhibition, Manchester, 1887
Southport 1892
Southport Centenary Exhibition, Southport, 1892
Chicago 1893
Exhibition of British paintings, Chicago, 1893
London 1896
Loan Exhibition of Watercolour Drawings, Guildhall, London, 1896
London 1897
Exhibition of Paintings and Drawings in Watercolour by Alfred William Hunt, Burlington Fine Arts Club, London, 1897
London 1897a
Exhibition of works by recently deceased members of the O.W.-C.S., Royal Water-Colour Society, London, 1897

Liverpool 1897
Memorial Exhibition of Pictures by Alfred W. Hunt, R.W.S., Walker Art Gallery, Liverpool, 1897
Glasgow 1901
Glasgow International Exhibition, 1901
London 1901
Winter Exhibition of Works by British Artists Deceased since 1850, Royal Academy of Arts, London, 1901
London 1906
Royal Academy of Arts, *Winter Exhibition*, Royal Academy of Arts, London, 1906
Dublin 1907
Irish International Exhibition, Dublin, 1907
Newcastle upon Tyne 1953
Coronation Exhibition, Laing Art Gallery, Newcastle upon Tyne, 1953
New Haven 1981
Works of Splendor and Imagination: The Exhibition Watercolor, 1770–1870, Yale Center for British Art, New Haven, 1981

London 1983
Landscape in Britain – 1850–1950, Hayward Gallery, London, 1983
Newcastle on Tyne 1989
Pre-Raphaelites – Painters and Patrons in the North-East, Laing Art Gallery, Newcastle upon Tyne, 1989
New Haven 1992
Victorian Landscape Watercolors, Yale Center for British Art; Cleveland Art Museum, Birmingham Museums and Art Gallery, 1992–3
Phoenix 1993
John Ruskin and the Victorian Eye, Phoenix Art Museum, Phoenix, Arizona, 1993
Munich 1993
Viktorianische Malerei – Von Turner bis Whistler, Neue Pinakothek, Munich, 1993
Madrid 1993
Pintura Victoriana – De Turner a Whistler, Museo del Prado, Madrid, 1993

Tokyo 1993
John Ruskin and Victorian Art, Isetan Museum of Art, Tokyo, and other locations in Japan, 1993
London 1993
The Great Age of British Watercolours 1750–1880, Royal Academy of Arts, London, and Washington, National Gallery of Art, 1993
London 2000
Ruskin, Turner and the Pre-Raphaelites, Tate Britain, London, 2000
London 2004
Pre-Raphaelite Vision: Truth to Nature, Tate Britain, London, 2004
Ravenna 2004
La grande stagione dell'Acquarello da Turner a Burne-Jones – dalla Collezione Williamson Art Gallery and Museum di Birkenhead, Museo d'Arte della città Ravenna, 2004